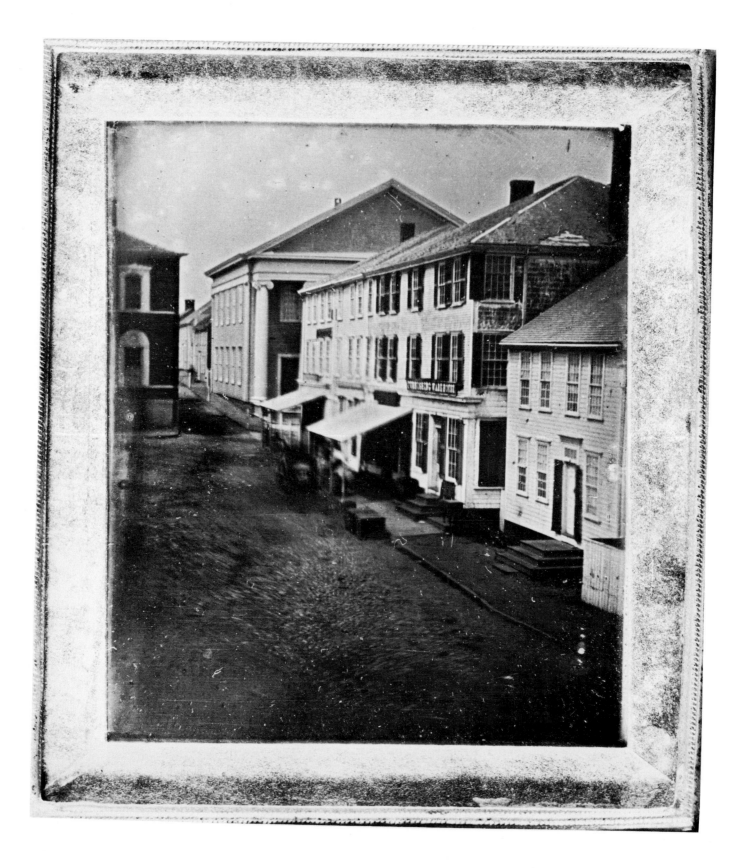

NANTUCKET
YESTERDAY & TODAY

John W. McCalley

Dover Publications, Inc.

New York

This book is dedicated to
RICHARD E. DEUTSCH
whose love of Nantucket
and devotion to the cause of preservation
facilitated its writing and production.

FRONTISPIECE: Reproduced from a ⅙-plate daguerreotype, this is the first known photograph of Nantucket. It dates from sometime between 1840 and 1846. This scene, looking west up Main Street with the Pacific Bank and the Methodist Church in the background, could be mistaken for no other place, even though all the buildings on the north (right) side of the street, marked by their awnings, were destroyed in the great fire of 1846. The bank and the church are there today, unchanged; the house on the right, although lost, is a typical Nantucket Quaker house. Even the burned-out buildings were replaced after the fire with new commercial buildings of similar scale. In spite of time and tribulation, Nantucket has preserved her past better than any other community in the United States.

Published in Canada by General Publishing Company, Ltd., 30 Lesmill Road, Don Mills, Toronto, Ontario.
Published in the United Kingdom by Constable and Company, Ltd., 10 Orange Street, London WC2H 7EG.

Nantucket Yesterday and Today is a new work, first published by Dover Publications, Inc., in 1981.

International Standard Book Number: 0-486-24059-2
Library of Congress Catalog Card Number: 80-68225

Manufactured in the United States of America
Dover Publications, Inc.
31 East 2nd Street
Mineola, N.Y. 11501

Contents

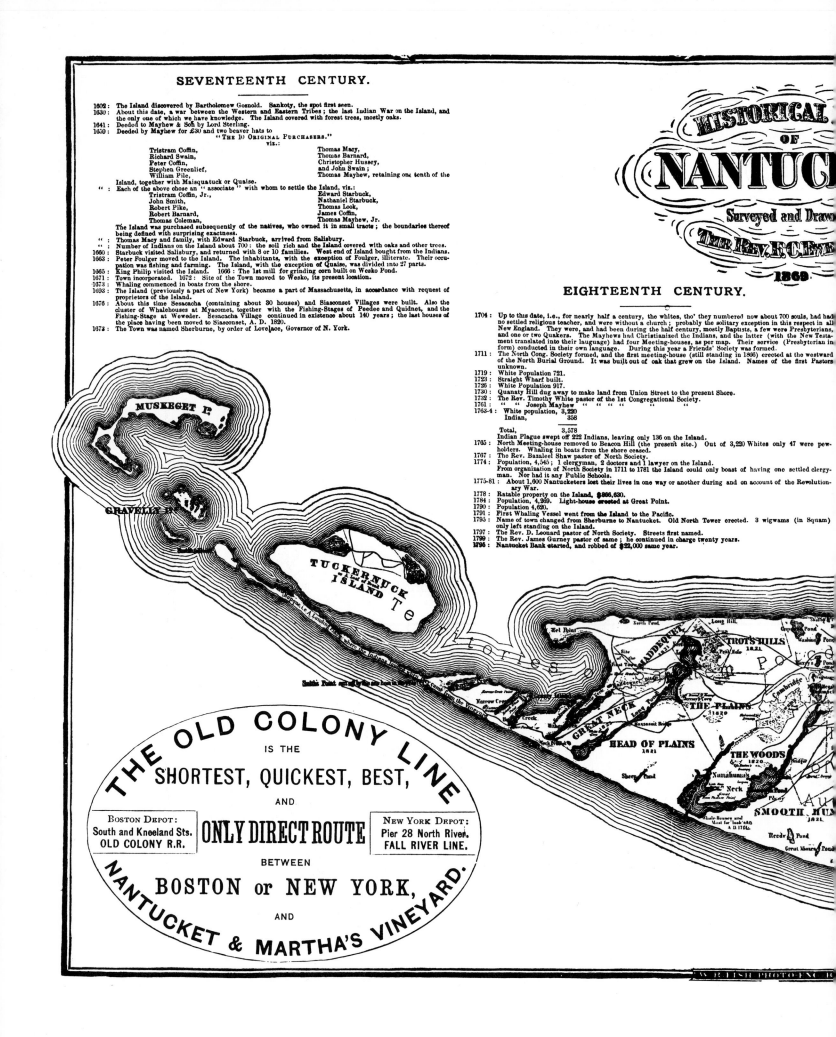

SEVENTEENTH CENTURY.

1602 : The Island discovered by Bartholomew Gosnold. Sankoty, the spot first seen.
1630 : About this date, a war between the Western and Eastern Tribes ; the last Indian War on the Island, and
 the only one of which we have knowledge. The Island covered with forest trees, mostly oaks.
1641 : Deeded to Mayhew & Son by Lord Sterling.
1659 : Deeded by Mayhew for £30 and two beaver hats to
"THE 10 ORIGINAL PURCHASERS."
viz.:

Tristram Coffin, Thomas Macy,
Richard Swain, Thomas Barnard,
Peter Coffin, Christopher Hussey,
Stephen Greenlief, and John Swain ;
William Pile, Thomas Mayhew, retaining one tenth of the

Island, together with Maisquatuck or Quaise.
" : Each of the above chose an " associate " with whom to settle the Island, viz.:

Tristram Coffin, Jr., Edward Starbuck,
John Smith, Nathaniel Starbuck,
Robert Pike, Thomas Look,
Robert Barnard, James Coffin,
Thomas Coleman, Thomas Mayhew, Jr.

The Island was purchased subsequently of the natives, who owned it in small tracts ; the boundaries thereof
being defined with surprising exactness.
" : Thomas Macy and family, with Edward Starbuck, arrived from Salisbury.
" : Number of Indians on the Island about 700 : the soil rich and the Island covered with oaks and other trees.
1660 : Starbuck visited Salisbury, and returned with 8 or 10 families. West end of Island bought from the Indians.
1663 : Peter Foulger moved to the Island. The inhabitants, with the exception of Foulger, illiterate. Their occu-
 pation was fishing and farming. The Island, with the exception of Quaise, was divided into 27 parts.
1665 : King Philip visited the Island. 1666 : The 1st mill for grinding corn built on Wesko Pond.
1671 : Town incorporated. 1672 : Site of the Town moved to Wesko, its present location.
1673 : Whaling commenced in boats from the shore.
1693 : The Island (previously a part of New York) became a part of Massachusetts, in accordance with request of
 proprietors of the Island.
1676 : About this time Sesacacha (containing about 30 houses) and Siasconset Villages were built. Also the
 cluster of Whalehouses at Myacomet, together with the Fishing-Stages of Peedee and Quidnet, and the
 Fishing-Stage at Weweder. Sesacacha Village continued in existence about 140 years ; the last houses of
 the place having been moved to Siasconset, A. D. 1820.
1673 : The Town was named Sherburne, by order of Lovelace, Governor of N. York.

HISTORICAL OF NANTUCKET

Surveyed and Drawn

The Rev. F. C. Ewer

1869.

EIGHTEENTH CENTURY.

1704 : Up to this date, i.e., for nearly half a century, the whites, tho' they numbered now about 700 souls, had had
 no settled religious teacher, and were without a church ; probably the solitary exception in this respect in all
 New England. They were, and had been during the half century, mostly Baptists, a few were Presbyterians,
 and one or two Quakers. The Mayhews had Christianized the Indians, and the latter (with the New Testa-
 ment translated into their language) had four Meeting-houses, as per map. Their service (Presbyterian in
 form) conducted in their own language. During this year a Friends' Society was formed.
1711 : The North Cong. Society formed, and the first meeting-house (still standing in 1866) erected at the westward
 of the North Burial Ground. It was built out of oak that grew on the Island. Names of the first Pastors
 unknown.
1719 : White Population 721.
1723 : Straight Wharf built.
1726 : White Population 917.
1730 : Quanaty Hill dug away to make land from Union Street to the present Shore.
1732 : The Rev. Timothy White pastor of the 1st Congregational Society.
1761 : " " Joseph Mayhew " " " " "
1763-4 : White population, 3,220
 Indian, 358

 Total, 3,578
 Indian Plague swept off 222 Indians, leaving only 136 on the Island.
1765 : North Meeting-house removed to Beacon Hill (the present site.) Out of 3,220 Whites only 47 were pew-
 holders. Whaling in boats from the shore ceased.
1767 : The Rev. Bazaleel Shaw pastor of North Society.
1774 : Population, 4,545 ; 1 clergyman, 2 doctors and 1 lawyer on the Island.
 From organization of North Society in 1711 to 1781 the Island could only boast of having one settled clergy-
 man. Nor had it any Public Schools.
1775-81 : About 1,600 Nantucketers lost their lives in one way or another during and on account of the Revolution-
 ary War.
1778 : Ratable property on the Island, $366,630.
1784 : Population, 4,269. Light-house erected at Great Point.
1790 : Population 4,620.
1791 : First Whaling Vessel went from the Island to the Pacific.
1795 : Name of town changed from Sherburne to Nantucket. Old North Tower erected. 3 wigwams (in Squam)
 only left standing on the Island.
1797 : The Rev. D. Leonard pastor of North Society. Streets first named.
1799 : The Rev. James Gurney pastor of same ; he continued in charge twenty years.
1795 : Nantucket Bank started, and robbed of $22,000 same year.

MUSKEGET I.

GRAVELLY P.

TUCKERNUCK ISLAND

Territories

TROTS HILLS

MADDEQUET

THE PLAINS

GREAT NECK

HEAD OF PLAINS

THE WOODS

SMOOTH HUM

W. R. FISH PHOTO-ENG. B

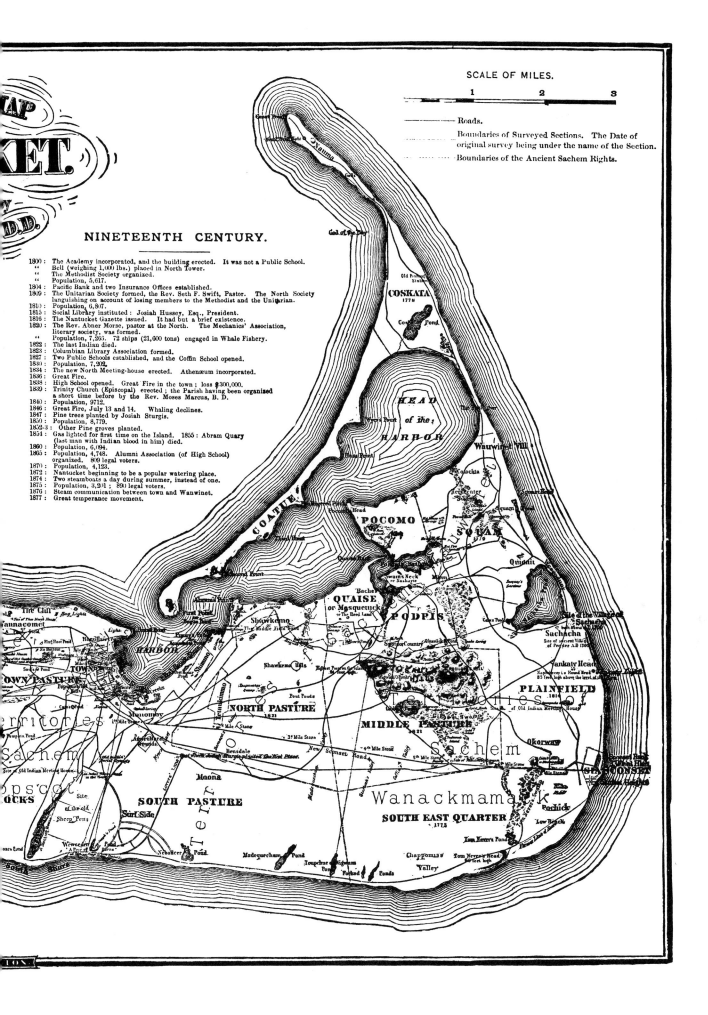

NINETEENTH CENTURY.

1800 : The Academy incorporated, and the building erected. It was not a Public School.
" Bell (weighing 1,000 lbs.) placed in North Tower.
" The Methodist Society organized.
" Population, 5,617.
1804 : Pacific Bank and two Insurance Offices established.
1809 : The Unitarian Society formed, the Rev. Seth F. Swift, Pastor. The North Society languishing on account of losing members to the Methodist and the Unitarian.
1810 : Population, 6,807.
1815 : Social Library instituted : Josiah Hussey, Esq., President.
1816 : The Nantucket Gazette issued. It had but a brief existence.
1820 : The Rev. Abner Morse, pastor at the North. The Mechanics' Association, literary society, was formed.
" Population, 7,266. 72 ships (21,600 tons) engaged in Whale Fishery.
1822 : The last Indian died.
1823 : Columbian Library Association formed.
1827 : Two Public Schools established, and the Coffin School opened.
1830 : Population, 7,202.
1834 : The new North Meeting-house erected. Athenæum incorporated.
1836 : Great Fire.
1838 : High School opened. Great Fire in the town ; loss $300,000.
1839 : Trinity Church (Episcopal) erected ; the Parish having been organized a short time before by the Rev. Moses Marcus, B. D.
1840 : Population, 9712.
1846 : Great Fire, July 13 and 14. Whaling declines.
1847 : Pine trees planted by Josiah Sturgis.
1850 : Population, 8,779.
1852-3 : Other Pine groves planted.
1854 : Gas lighted for first time on the Island. 1855 : Abram Quary (last man with Indian blood in him) died.
1860 : Population, 6,094.
1865 : Population, 4,748. Alumni Association (of High School) organized. 809 legal voters.
1870 : Population, 4,123.
1872 : Nantucket beginning to be a popular watering place.
1874 : Two steamboats a day during summer, instead of one.
1875 : Population, 3,201 ; 890 legal voters.
1876 : Steam communication between town and Wanwinet.
1877 : Great temperance movement.

Roads.
Boundaries of Surveyed Sections. The Date of original survey being under the name of the Section.
Boundaries of the Ancient Sachem Rights.

Foreword

Nantucket has been fortunate that its rich heritage has been recorded by able historians such as Obed Macy, Alexander Starbuck, Henry B. Worth and Douglas-Lithgow, and by talented artists such as Eastman Johnson, William Swain, George Fish and James Walter Folger. Along with these gifted people were the early photographers—Josiah Freeman, Henry S. Wyer, Henry Platt—who captured the scenes of the town and island and retained them for the future enjoyment of all who appreciate Nantucket's unusual story.

In this book John McCalley has presented another facet of the story, one which offers the unique experience of viewing the past and present through the use of photographic studies of the same scene, taken many years apart. We may gaze at a photograph taken a hundred years ago and, adjacent, find a modern view of the same location, usually photographed from the same angle. Many of the junctions of streets within the town, through which we have passed every day, take on a new significance when we see them as they looked one hundred years ago. Our first reaction is to note how little changed the views are; they do not offer a contrast but rather a comparison. The churches, the Main Square, the public buildings, the historic buildings, Main, Orange, Union and Mill Streets—all show vividly how little the passage of time has altered the homes or the sweep of the thoroughfares.

There are also scenes which dramatically show marked changes. For example, the panorama from the North Church tower showing the Brant Point area in 1875 and the same view today (p. 33). These demonstrate how a development over a longer period of time can be much more adaptable to the island than the modern trends.

John McCalley's timely photographic study tells its own story. It presents Nantucket's good fortune in experiencing so little change over the years—emerging from its nineteenth-century depression to enter a new economic phase geared to "summer business," and now on the threshold of another era, one which would insure its future if it can repulse the developer and the exploiter.

This documentary is an important contribution to the full story of Nantucket. Quite aside from his skill as a photographer, John McCalley has brought into a sharper focus many of the little-known periods of the island's past such as that treated in "The Hotel Era," and helps clarify some of the aspects that have governed its growth. All who are interested in Nantucket's future will find this volume both intriguing and instructive. It provides another dimension to the history of a town and island which played such a major role in the larger story of this nation.

Edward A. Stackpole
Historian, The Nantucket Historical Association

Nantucket
1980

Introduction

NANTUCKET IN PHOTOGRAPHS

If, by some magic of time and destiny, a whaleship which left Nantucket Island in the middle of the nineteenth century should return today, the officers and men would face a familiar sight. Approaching the island they would take their bearings on the two church steeples which remain the dominant structures on the skyline. It would not seem as if their town had grown much for, indeed, it has not. They would be pleased to note that the government has at long last built two jetties, making the entrance to the harbor safe in any weather or tide. And as they closed the inner harbor they would see Brant Point light signaling a landlocked refuge as it has since 1746.

Perhaps no other city or town in the United States has changed so little as has Nantucket. Its heritage from the colonial period through the first half of the nineteenth century has been preserved in commercial, public and residential structures. And even the outlying areas—the moors, ponds, woods and beaches—are easily recognized today in photographs made a century ago. The preservation of Nantucket has made it a unique and delightful place both to live in and to visit. In fact, Nantucket teaches a lesson that might well be studied by other communities that have let most of their heritage drown in that sinkhole of commercialism called "progress."

This book is a photographic documentary. It shows what Nantucket has preserved of its past and what is new and changed. Old photographs, many 100 years old, are printed side-by-side with modern pictures made especially for this book. The old pictures were printed from the original negatives; no attempt was made to restore them in any way. When possible, the new pictures have been taken from the exact same viewpoint as the old. Therefore, correspondence in perspective is as identical as it is possible to make them.

In many ways photographs are our best historical documents. Unlike accounts written from memory, they are very hard to distort without leaving telltale evidence.

They rarely lie; it is all there in black and white. If grass was growing in the streets of the town during a period of depression, you will see it. If a beautiful old home has been ravaged for commercial use, the photographs show precisely what has taken place. But best of all, when the past has been carefully preserved, the photographs dramatically demonstrate this fact in a way that no narrative could ever do. Not only does one see clearly exactly what has been retained from the past, but it becomes strikingly evident why it is important that the best of our past be preserved. We can see in the new photographs the role of the past in a modern community, and the value of our heritage is beyond question.

But while documentary photographs present facts objectively and attempt to minimize illusion, they nevertheless have a point of view. Since each photographer must exercise selection and sees each scene through preconditioned eyes, any collection of documentary photographs will carry the stamp of its creator.

The problems that arise from the process of selection and preconditioning are somewhat reduced in this collection. In the first place, the old pictures were made by several different photographers so no single point of view dominates. The subject matter and perspective of the pictures were dictated by old photographs. While such a procedure may restrict innovation, it is useful for historical comparison, for photographs often provide the best means of determining what has changed in a community over a period of a century.

Photography came to the United States as an enterprise in 1840 in the form of the daguerreotype. Silver-coated copper plates were exposed in a camera and developed in mercury vapor, producing sharp, brilliant images. Photographers set up shop in every corner of the country, including Nantucket, within the first few years of the introduction of the craft. Portraits were all the rage. Heretofore, only the wealthy could afford hand-painted portraits, but the daguerreotyper could furnish small,

handsome likenesses for less than a dollar. Many Nantucketers took advantage of this new, economical process and the Nantucket Historical Association has a fine collection dating back to this earliest period.

Daguerreotype portraits are common, but street scenes are very rare. Only one view of Nantucket taken before the great fire of 1846 is known to exist (see frontispiece). Reproduced many times, it shows the Pacific Bank and the Methodist Church, both of which escaped the conflagration, and some of the commercial buildings on the north side of Main Street which were destroyed. Outdoor photographs taken in the first decade of photography are rare for two reasons: very long exposures were needed, and any movement in a scene would blur the image; perhaps more important, the image was reversed. While people did not seem to mind this reversal in portraits, the mirror image of a street scene could not be reconciled in the viewer's mind. Therefore, in taking street scenes it was necessary to attach a prism to the camera lens to reverse the image in the camera. Prisms were scarce and most of the early photographers did not use them.

Most of the recorded photographic history of Nantucket begins in the 1870s, just as the island began its renaissance as a resort community. Glass-plate negatives and paper prints had by then superseded the daguerreotype. The new process was much more sensitive to light and outdoor photographs could be made easily. Moreover, although the negative was still reversed, making a positive paper print from the negative rectified it. However, photography a century ago was by no means a snapshot activity. Glass plates had to be coated with the sensitive emulsion in a darkroom, placed while wet in plate holders, carried to a camera firmly attached to a tripod and immediately exposed. Then the exposed plate had to be carried back to the darkroom and developed before it dried out. While this process presented no great difficulties in a studio with an attached darkroom, when outdoor pictures were made a portable darkroom had to be carried along with the camera and other paraphernalia. Despite these difficulties many fine photographs of Nantucket were taken during the last half of the nineteenth century. Fortunately, a large number of these old prints and negatives have been acquired by the Nantucket Historical Association, assuring their preservation.

Perhaps the most dramatic fact revealed by the old photographs of Nantucket is that the "Golden Age" is a myth. As Nantucket's whaling prosperity came to an end, the town and island were not an attractive environment. Man has a proclivity to repress the unpleasant and ugly in his past, to venerate the achievements of his forebears, to extol his home, his school, his community and his country. Sometimes he does so modestly, but more often with mindless chauvinism. We deceive ourselves with myopic dreams about "the good old days" that actually never were.

Old photographs, especially good documentary works, bring us up short and face us with reality. Although most of the old pictures were made sometime after the peak of Nantucket's prosperity, the town had changed little except for the amount of commercial and industrial activity. Nantucket had been an industrial town with few amenities. Most of the streets were unpaved, there were

few sidewalks, street lighting was not considered a public responsibility and many streets and alleys were clogged with uncollected trash and garbage. Homes had no lawns or flower gardens; an outhouse stood in each back yard. The unpaved streets of the town were at least serviceable, but the "roads" out of town were at best nothing but cart tracks. Water was supplied from numerous individual wells and, in some areas, from community wells. Backing up the impressions gained from the old photographs, the town's records indicate that the public schools were grossly inadequate, sewage was a pressing problem and there was no hospital, only a pesthouse. Epidemics of diphtheria, yellow fever, smallpox and cholera swept the island. No doubt it required much stamina to survive the air pollution from tryworks, candle factories, rotting fish, discarded scallop shells, coal fires and open sewers.

The history revealed in the photographs does not jibe entirely with past accounts of the island's development, and especially with the myths and "grandfather stories" that have been repeated time and again until accepted as fact. What effect did Nantucket's isolation from the mainland have on its economic and social life? Why did Nantucket's first industry, the woolen textile industry, fail? Did whaling actually produce the community wealth that has been claimed for it? Why did the whaling industry fail on Nantucket when it went on to even greater prosperity elsewhere? After the failure of the whaling industry, why did it take more than two decades before even a start was made in the resort industry? Why did Nantucket's population remain essentially unchanged from 1860 to 1960—a period of a whole century when income rose to levels even higher than at the peak of whaling prosperity? What role did the resort business have in the preservation of the island's past? From the time Nantucket was settled in 1659, what took place to cause it to be so different from most other places in the country? And how did so much of the past come to be preserved when our acquisitive society destroyed it elsewhere? The photographs demand a reinterpretation of Nantucket's past and the economic and social forces that must have been at work over a period of more than three centuries.

A comparison of the old and new photographs strikingly illustrates that much of Nantucket has been preserved over the last century and that the majority of the changes to be seen are those that tend to enhance the aesthetic qualities of the community. The streets are now lined with trees. Cherry trees have recently been planted to replace elms lost to the Dutch elm blight. Their blossoms each spring herald the beginnings of another season as a resort dear to the hearts of thousands. The islanders' homes are well-kept and graced with fences and gardens. The many miles of beaches surrounding the whole island are preserved and clean, inviting sun worshipers, bathers, fishermen and beachcombers.

All the island moors and ponds are little changed, presenting an unequalled opportunity for the nature lover. Certainly no other community that has been settled since the seventeenth century offers so much. The new photographs show no traffic lights, no neon signs, no billboards, no tall buildings. Only the hospital and one hotel

have elevators. People can ride bicycles all over the island; on the island of Nantucket the pedestrian is not yet an endangered species, as he is in many American cities.

Nantucket proves that we can live with our past in comfort, aesthetic pleasure and tranquillity. The past can be preserved without diminishing the present or the future. Not only can the past be preserved, but it can function in the world today. There is nothing in the modern world that makes old homes, buildings, streets and their relationships obsolete. Even that despoiling monster, the automobile, can be brought under control if there is a will to do so.

No book such as this can be the effort of the author alone. Many have given valuable assistance. Special mention should be made regarding the unselfish time and effort provided by Edouard A. Stackpole, who made available the resources of the Foulger Museum and its fine collection of old negatives. Without his assistance, there could have been no documentary. Mr. Stackpole's unequalled knowledge of Nantucket's history made it possible to identify and date many of the old photographs. Our discussions of the island's past brought to light considerable data unavailable in the usual source books. Robert C. Caldwell provided many of the old negatives, particularly those made by J. H. Robinson, and his enthusiasm for this project in its early days was instrumental in overcoming much discouragement. Clay Lancaster, whose wide knowledge of Nantucket's architecture and history provided me with considerable information not otherwise to be had, read parts of an early draft. His suggestions and criticisms were most welcome. Edgar A. Anderson, a teacher of English and the author of several novels, was kind enough to edit the first draft of this book and make suggestions for improvements. The late Professor Robert T. Minshall of Cape Cod Community College, an authority on the archaeology and lore of Nantucket, read the first draft and kept me from straying too far from what can be substantiated empirically. The enthusiasm and aid provided by Mrs. Leeds Mitchell helped keep this project moving in its early days when its completion was doubtful. Finally, it should be pointed out that a majority of the old photographic negatives belong to the Nantucket Historical Association, whose willingness to let me make prints made this documentary possible.

All errors of omission and commission are mine alone and the opinions expressed which depart somewhat from other histories of the island were derived from a different point of view. Nantucket's background, the whaling industry in particular, has been viewed as a part of the American saga and anecdotal narratives have been minimized.

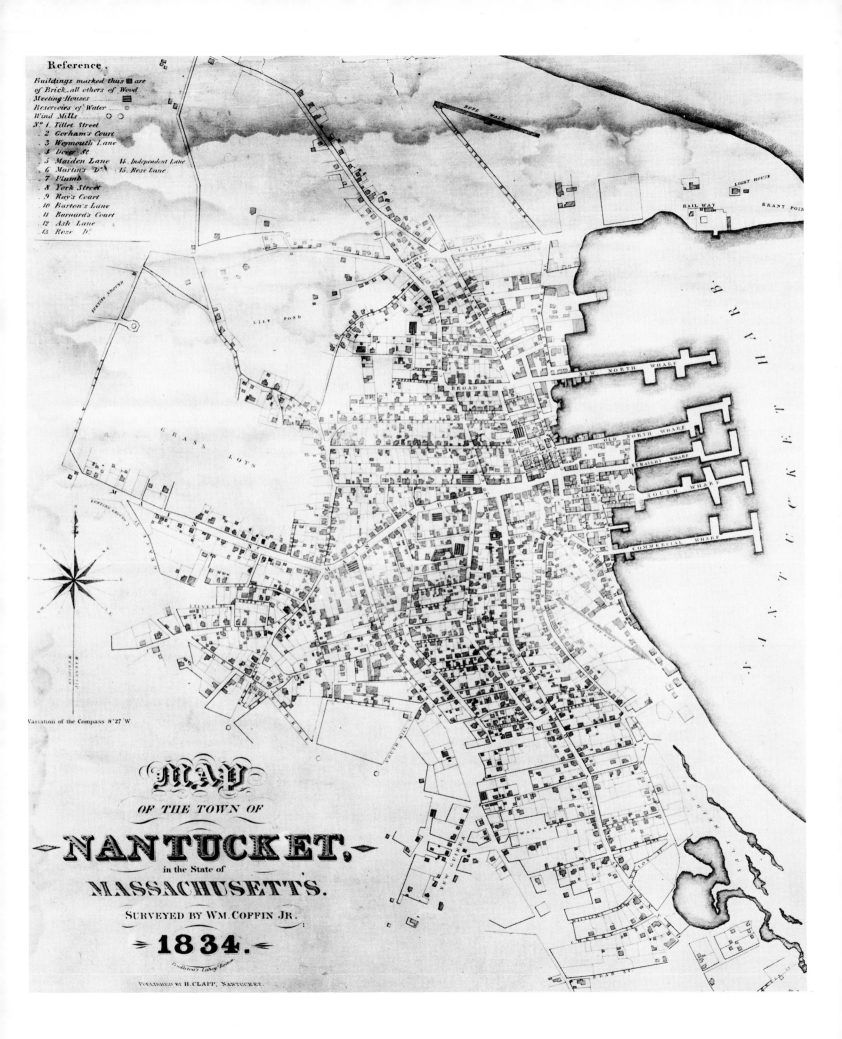

Reference.

Buildings marked thus ▣ are of Brick, all others of Wood
Meeting-Houses ▬▬▬
Reservoirs of Water ◉
Wind Mills ◯ ◯

Nº 1. Tillet Street
2. Gorham's Court
3. Weymouth Lane
4. Dove St
5. Maiden Lane 14. Independent Lane
6. Martin's Dº 15. Rose Lane
7. Plumb
8. York Street
9. Ray's Court
10. Barton's Lane
11. Barnard's Court
12. Ash Lane
13. Rose Dº

Variation of the Compass 8°27′ W

MAP
OF THE TOWN OF
NANTUCKET,
in the State of
MASSACHUSETTS.
SURVEYED BY WM. COFFIN JR.
1834.

PUBLISHED BY H. CLAPP, NANTUCKET.

Chapter I

NANTUCKET BEFORE THE AGE OF PHOTOGRAPHY

Nantucket is not like the rest of the United States. It never was. All islands are special, for they belong to the sea which isolates them and determines the destiny of their inhabitants. Nevertheless, the general cultural patterns that have governed Nantucket over the last three centuries are not unlike those that prevailed elsewhere. To generalize, most early English settlements in the New World were efforts to establish roots. For 200 years most of the population of America was concentrated in a narrow strip along the Atlantic coast that could be served by the sea and the navigable rivers flowing into it. Whether it was the farming and trading communities of the North or the large plantations based on slavery south of the Delaware River, there was little interest in the wilderness west of the Appalachian Mountains. Even as late as the first decade of the nineteenth century, President Jefferson had to send an exploring party to the Pacific to determine what it was we had bought from Napoleon. The culture, economics and expectations of America in the first two centuries were those of an outpost of Europe—that was precisely what England wanted of her colonies.

It was not until these two centuries of establishing roots had passed that Americans turned to pioneering. Only at the end of the eighteenth and beginning of the nineteenth century were there enough people west of the Appalachians for new states to be formed. But then, as the old ties with Europe faded away, the pioneer spirit took over the land and the push westward was on. Nantucket, too, followed this pattern. On the island the early period of consolidation and the later period of pioneering differed somewhat in kind and timing, but they were evident.

After the Civil War America finally reached her boundaries on the Pacific and developed an acquisitive, industrial plutocracy. Since Nantucket never entered this last stage of American cultural development, she now stands as a refuge from it. The most frequent adjective used to describe Nantucket is "unspoiled." And this is the source of her resort business—her only raison d'être.

The first white settlers of Nantucket Island chose to isolate themselves from the society of Puritans, among whom they had been living in the Massachusetts Bay Colony. It is one of our historical myths that the Puritans fled England to avoid religious persecution and gain religious freedom. The truth is quite the reverse. The Puritans were a fundamentalist sect which regarded pleasure and luxury as sinful. Unsuccessful in their attempts to force conformity on the more liberal and prosperous English Protestants, Puritans sailed to the New World to establish a theocratic dictatorship.

In contrast to seventeenth century England, the Puritan Massachusetts Bay Colony was a reactionary society in which all life—social, economic and personal—was ruled by a morality in which conformity was insured by frequent and severe physical punishment. The quintessence of this theocracy was reached at Salem in 1692 when 20 nonconformists were hanged or crushed to death. It was from this society that the first Nantucket settlers escaped to a 50-square-mile island 20 miles south of Cape Cod.

Practical economic considerations motivated the early settlers. The first Nantucketers wanted to enhance their wealth and they chose the method that was currently most successful in England. The lifeblood of England was the wool textile industry. She raised her own sheep on enclosures, spun the wool and wove the cloth with English labor and exported the finished product in English ships to all her colonies. In return England received food, raw materials and gold and silver. It was the perfection of precapitalist mercantilism. It was only reasonable that the early settlers of the island might emulate England and raise sheep to develop a woolen textile industry.

The geography of Nantucket was ideal for sheep raising. The open pastures sheep need for grazing were pro-

vided in England by the enclosure of common lands into sheep pastures. The landowning aristocracy of England persuaded Parliament to pass "enclosure acts" which forced the peasants off the land into factories and provided large open tracts for sheep pasturage. But sheep could not be raised profitably in most of New England because the land was heavily forested in the seventeenth century, and what land was cleared was needed for food crops. Moreover, fences were expensive. Nantucket island, however, was a natural sheep pasture. The land was generally clear and without forests, the surrounding ocean made a perfect fence and numerous ponds provided potable water. Here sheep could be turned loose to grow the raw material for a domestic textile industry.

The economic advantage of raising sheep on Nantucket and Martha's Vineyard was seen in earliest colonial times by Thomas Mayhew, a Watertown merchant who bought Nantucket, Martha's Vineyard and the Elizabeth Islands from the original royal proprietor. Mayhew and his son set about Christianizing the Indians on the islands. The missionary spirit ran high in the New World: a priest stood behind every conquistador and a preacher backed up every pilgrim. It was all very practical. For instance, how could Thomas Mayhew let his sheep run loose on the islands unless the native Indians were respectful of the white man's private property and would refrain from devouring the sheep?

In 1659 Mayhew sold Nantucket to nine defectors from the Bay Colony while keeping a tenth share for himself. In that same year ten other families were recruited to settle Nantucket. Their economic plan came from their feudal European past. This small company of less than 20 families determined to own the island in common, establish a society based on feudal property arrangements and develop a textile industry which they hoped would be as profitable as that in the old country. But unlike European feudal societies, which were church-ridden, the Nantucketers left their religion behind them in the Bay Colony. They were decidedly set against establishment religion and none existed on the island for the first half century. The only practicing Christians were the Indians!

The settlers not only paid Thomas Mayhew for his rights to the island, they also had to buy the island from the Indians who were, of course, the true owners. This was easily done. The principal failure (from the point of view of historical outcome) of the North American Indians was their inability to understand the institution of private property. It was a completely alien concept. When Indians sold their land they thought of the transaction as being the granting of use-rights, never dreaming that the purchaser could force them from the land. Only about a year after settling on Nantucket the white men succeeded in deeding most of the island to themselves, and the docile native population was henceforth treated with benign neglect. Alcohol and contagious diseases soon eliminated any threat of expropriation.

While the first settlers kept most of the island in common, they set off "house lots" of 60 square rods (about 22 acres) for each family. The islanders estimated that 1½ acres could support one sheep and that the common lands could support 19,440 sheep. By 1670 there were 27 proprietors (or shares) and each could run 720 sheep. While raising sheep was a relatively simple matter, developing a profitable woolen textile industry required resources that were in short supply on the island.

Nantucket's land was poor and sandy; the growing of food crops required fertilizer and was thus expensive. But the greatest handicap was the lack of a source of energy. The textile industry in England had a good supply of waterpower from its numerous streams and rivers and, when steam engines were introduced in the eighteenth century, she had a bountiful supply of coal to fuel the boilers. Industrial development in New England was also greatly aided by a substantial supply of energy. The forests were used for fuel and prime construction material, and there was an abundance of waterpower. But Nantucket had nothing. The island had few trees; all that could be useful were long since cut down for firewood. There was not a single stream or creek worthy of name on the whole island. All the major ponds were at or near sea level and, hence, not a source of power. The few attempts made to use pond runoffs for mill power were not successful.

Lacking other sources of energy, the islanders had to resort to wind power (of which they had suffice) to work their mills. Wind power, however, has very restricted uses because it cannot be stored up like water in a millpond. Most industrial operations require a steady, dependable source of power. The fickle wind could best be used in those processes, such as grinding grain and pumping water, where discontinuous power is not a severe handicap. Consequently, Nantucket never developed a textile industry. Island wool was shipped to the mainland for processing, leaving the islanders in the role of raw-material producers, usually the least profitable part of any industry.

For the first half century of the island's history, there is little evidence of achievement. The homes that have survived from that period are modest and plain; they are totally lacking in ornament and luxury of any kind. The islanders' income from raising sheep and selling wool must have been quite small; they made ends meet by growing their own vegetables, by making their own clothes and by fishing in the ocean surrounding them.

Any hopes of developing a prosperous woolen industry on Nantucket were dashed in 1699 when Parliament passed an act that forbade the colonists to trade in woolen goods anywhere, including among themselves. England had a monopoly of the wool trade and she intended to protect it. If the Nantucketers were to continue to raise sheep, they would have to eat their own animals and use the fleece to make homespun for themselves alone. England was very serious about protecting her monopoly—she detailed a special fleet of warships to blockade the ports of Ireland to prevent her from developing a woolen textile industry. The handwriting was on the wall: it would be impossible to pursue the textile trade in the colonies. To survive, Nantucket would have to find another source of income. The attempt to establish roots along the lines proven successful in the old country had failed.

Nantucket ended the seventeenth century still a feudal agricultural commune. Fishing was not of great economic

importance before 1700, as evidenced by the lack of any quays, wharves and docks, and the absence of any land assigned to fishing activities. In fact, the only assignment of lands in the seventeenth century was the "Wesco" lot assignment of 1678. But these lots were from their shape obviously rundales intended for agriculture. It was another 40 years before land designated as "fish lots" was assigned on Nantucket's waterfront.

While whaling was not a significant industry in the American colonies in the seventeenth century, other countries were involved in commercial whale fishery. There are reports of whaling in France as early as 875, and the Basques fished for whales in the Bay of Biscay in the eleventh century. Through the fourteenth, fifteenth and sixteenth centuries the Norwegians, British, Dutch and Spanish fished the Arctic waters from Spitsbergen to Iceland and Greenland and then on to Newfoundland. Short, intensive hunts were made during the summer months when fishing could be carried on around the clock. The whales were carried back to the mainland and processed there. A town on Spitsbergen was known as Smeerenburg (Blubbertown). Obviously, this was a cold-climate activity.

Like all islanders, the Nantucketers fished the waters around their island, just as the native Indians had done before the white man arrived. Fish added protein to a diet of homegrown vegetables. In the seventeenth century whales were sighted from shore lookouts and pursued in small boats. When killed, they were processed on the beaches, the oil and baleen extracted being used domestically. No significant export market existed. The islanders did not engage in offshore whaling as did the Europeans.

In the first quarter of the eighteenth century, Nantucket was in a state of transition from an agricultural commune to an industrial community based on whaling. Forced out of the wool trade by the English monopoly, the islanders began to pioneer whaling in order to survive. In 1712 a Nantucket whaler killed a sperm whale whose oil commanded a premium price. Soon the advantages of pursuing and harvesting sperm whales became evident. Homes that had been scattered for the most part in the western end of the island were taken apart and moved to the harbor area. Land adjacent to the harbor was subdivided into "fish lots." By the third decade of the eighteenth century the Nantucketers had built a wharf to accommodate substantial vessels. A new industry was built whose raw material was taken from all the oceans of the world. Pioneering the oceans after the whale, Nantucket ships charted unknown waters, discovered Pacific islands and traded around the world.

It is perhaps difficult for anyone living in the late twentieth century to realize that before the discovery of petroleum in the middle of the nineteenth century, whaling was *the* oil industry. Directly, it provided oil for illumination (oil lamps and candles) and lubricating oil for machinery. And like petroleum today, there were many by-products, such as soap, cosmetics, glycerin, varnish and other industrial products. In addition, baleen was used when a waterproof, flexible construction material was needed.

Whaling had all the potential for a very profitable enterprise if the right combination of factors could be brought together. Circumstances would have to engender a pioneering spirit to cope with the dangers and travail of whaling. Those engaged in the industry would have to be imbued with a communality that could accept and rationalize the exploitation which characterized the industry. Finally, there would have to be an economic arrangement that could provide the very substantial profits needed in such a hazardous enterprise. In a way not to be found in other colonial seaports, Nantucket had all these requisites which provided the underpinning of the island's development of the whaling industry. This special combination of circumstances did not, however, last beyong the middle of the nineteenth century.

Perhaps the most unusual characteristic of the Nantucketers was their communality in the early part of the eighteenth century. The early settlers' rejection of authority, both secular and religious, and their establishment of a society dependent on communal property could only have led to an interdependence reminiscent of the tribe. As time went on, intermarriage was an enforcing factor. Finally, the Quaker religion became a unifying force that tended to rationalize the Nantucketer's deep-dyed convictions.

In the early 1700s various religious groups tried to get a foothold on Nantucket. By then the Nantucketers had gained a well-founded reputation for industry and frugality. The idea of having to support a churchman who would do nothing six days a week didn't float with these parsimonious isolationists. Missionaries from the mainland, except for the Quakers, found barren ground. It is quite ironic, however, that the islanders who had defected from the ascetic theocracy of the Bay Colony would, in their simplicity, parsimony and assiduity, prove especially receptive to that very quintessence of Protestantism, the Society of Friends.

The Quakers wore plain clothes and abhorred changes dictated by fashion. They abominated the clergy and priest-ridden orders. They employed an old-fashioned English using "thee" and "thou." They espoused a simple life of industry and frugality; they had no churches, but plain meetinghouses. But best of all, as far as the islanders were concerned, they did not require the community to support a priest or minister to interpret the Bible or guard their morality from the depredations of demons. The Quakers soon gained many converts and, by the time of the Revolution, the Society of Friends could count Nantucket as one of their strongholds along with Philadelphia. This influence no doubt enforced the traits already evident among the islanders, and it lasted until the Quakers broke up into dissident factions early in the nineteenth century. Thus the Nantucketers had a community élan which was coupled with a strong Protestant ethic to help them overcome the obvious disadvantages of the whaling industry.

Whaling was not a particularly prosperous industry in other American ports. The hard and dangerous business caused crews to be scarce, necessitating extra incentives over and above the rewards to be had in the merchant marine or the navy. This brought about a special economic arrangement in the whaling industry known as the "lay system," in which each participant in a venture re-

ceives a share of the receipts instead of profits or wages. The origin of the lay system is not certain. Characteristically, it is a socialist, not a capitalist, institution. Its probable origin was in the piratical enterprises including the infamous, but ubiqitous, letters of marque which were used without much restraint from the sixteenth through the nineteenth centuries. Under piracy, when the whole loot of a voyage was divided among the ship's company, the lay system must have been an ideal paradigm of wealth distribution. But when this system passed into the world of legitimate commerce and industry a large share was claimed by the owner of the vessel. The problem of determining "just" shares must have led to considerable controversy and conflict.

During the period of Nantucket's participation in the whaling industry, it was customary to divide the income from a voyage approximately as follows: captain, 6–7%; mate 4–5%; foredeck hand, 2%; and cabin boy, 1%. The share alloted to the ship's company as a whole averaged about 25% of the total. The remainder, about 75%, accrued to the owner of the ship. This system was satisfactory to the Nantucketers because Nantucket whalers, unlike those from other ports, were financed, captained, crewed and provisioned by Nantucketers. The lion's share did not go to anonymous, absentee owners but to neighbors and relatives. Moreover, the crews were the youths of the island. Boys shipped out at 12 or 14, expected to be officers at 20 and hoped to retire with a fortune at 40. And many did in the eighteenth century when the pioneering spirit ran high, when the tribal feeling was pervasive, and when the voyages were relatively short so that there was not too long a time between indenture and reward.

The combination of pioneering spirit, a strong communal feeling and profits which were reinvested in the industry were the special circumstances which combined on Nantucket before the Revolution to make the whale fishery possible and moderately profitable. But the social milieu created by these conditions was far from ideal. J. Hector St. John Crevecoeur, in his *Letters from an American Farmer*, writing about conditions on Nantucket shortly before the Revolution, noted that the islanders had developed an austere culture, that they abhorred inebriation, "and music, singing, and dancing are held in equal detestation . . ." and he might have added art and ornament. He notes that there was nothing for the youths to do (still a grievance today) but seek employment at sea in whaling ships and marry at an early age. Crevecoeur warns that Nantucket "is not the place where gay travelers should resort, in order to enjoy that variety of pleasures the more splendid towns of this continent afford . . ." because when Nantucketers become wealthy, " . . . opulence, instead of luxuries and extravagances, produces nothing more than an increase in business. . . ." Apparently it was primarily the island's women who suffered: Crevecoeur notes that most of them relieved their physical hardships and assuaged their loneliness efficatiously—through the daily application of opium!

According to Michael Hugo-Brunt's *An Historical Survey of the Physical Development of Nantucket* (Cornell University, Ithaca, New York) "Quaker Nantucket was as grim as any other eighteenth-century town, but being an island settlement its society suffered from curiosity, pettymindedness, gossip and over-zealous personal supervision. The very nature of whaling accentuated these problems. Since most of the ablebodied men were at sea, the town was run by the elderly, while the home was governed by the Matriarch. The nature of the religious beliefs, the too frequent intermarriages, the rejection of educational and scientific advances, nullified much of what was sound, and resulted in an overall mediocrity."

Shortly before the Revolution a dramatic change occurred in the whaling industry. The tonnage of whalers increased substantially and Nantucket's population, which had been growing very slowly, showed a marked expansion. Obed Macy reports in his history that whaling in the American colonies from 1770 to 1775 "increased to an extent hitherto unparalleled." And another historian, Alexander Starbuck, stated that whaling in the colonies was "in full tide of success." Obviously there had been a significant change.

In this case it was a technological revolution. Like most such changes, the one that brought prosperity to Nantucket seems so simple. One is given to ask: why didn't they think of that before? In about 1760, American whalers began to install tryworks on their vessels which were by then large enough to accommodate such devices. Instead of hauling the whale carcass to shore to render the oil (which required a short voyage in a cool climate) the oil was tryed out on board and stowed in barrels in the hold. This meant that the only limitation on the length of any whaling voyage was the endurance of the crew. Whalers could go any distance and into any ocean—including the tropics. Since their variable costs were minimal, there was no reason to return to the home port until the hold was filled to capacity, regardless of how long that might take. Hence, every voyage was likely to be successful.

The ability to sail anywhere and for long periods of time greatly increased the supply of whales. Also, onboard tryworks reduced production costs since the men not actually engaged in fishing were put to work processing the product. The combination of a greater supply and lower production costs soon began to engender handsome profits.

At the same time that Nantucket whalers ranged into the South Atlantic and then into the Pacific Ocean, it became increasingly difficult to obtain crews. When the American Revolution broke out, whalers were easy prey to British men-of-war, and Nantucket lost a large portion of her fleet—to say nothing of the sailors who were impressed (or, in some cases, volunteered) to serve the Tory cause. Nantucketers were sympathetic to Britain's desire to hold the empire together, and they wanted to remain a part of it. This is understandable: London was the principal market for whale oil and, since Nantucket ships were British ships, they paid no duty for marketing oil in England. Furthermore, it was of great importance that Nantucket ships, wherever they might sail, have the protection of the British navy in an age when piracy was rampant. Hence, Nantucket was caught in the middle between England's need for men and ships and the colonist's loathing of traitors to the cause of the Revolution.

Just as the whaling industry was beginning to boom, it was cut down by the Revolution, and it was never the same again on the island.

The eighteenth century saw Nantucket slowly transformed from a largely self-sufficient agricultural commune to an industrial town with all the advantages and problems that characterize such a change. Private property, of course, was grafted onto the older share system of land ownership. The old system continued to diminish in importance until it was abandoned in the nineteenth century. Dwellings, shops, crafts and cottage industry all came to be grouped closely around the harbor. Homes were built on the street line with little space between them, but the town house (or row house) that dominated many cities of the times never caught on in Nantucket. Nearly all the homes were single-family dwellings regardless of how small or large they were.

Although the eighteenth century was one of growing prosperity for Nantucket, it was not a period of great affluence. Without exception, all the homes built in this century are plain and modest, and many are quite small. All are of wood-frame construction; none is of brick or stone. It has been argued that Nantucket's simple dwellings reflect the domination of Quakers and their conservative taste in architecture. While it is true that the Quakers might have had much to say regarding simplicity in style, they would have been hard put to determine or control the size of dwellings. Certainly the wealthy in other parts of the colonies found ways to display their prosperity, even in such Quaker-dominated communities as Philadelphia.

The reason why dwellings tell so much about the economy of the eighteenth century is that there was very little else on which to spend money. There were no yachts, private rail carriages or foreign travel for pleasure. Just about the only outlet for conspicuous consumption was the home. When it became large enough, servants were hired and quartered in the house. None of Nantucket's eighteenth-century dwellings has provision for servants. Although some families may have employed live-out help, this is always indicative of relatively modest income.

The only-moderate income provided by the whaling industry in the eighteenth century is also shown by the population figures and the emigrations during those times. Although the birthrate for Nantucket during the eighteenth century is not known, a most conservative estimate would indicate that the island's population should have been at least twice what it was. In other words, at least half of those born on Nantucket must have emigrated to the mainland. To this it is necessary to add the known emigrations of groups and associated families to other places. As early as 1761, about 100 families moved to Barrington, Nova Scotia. After the Revolution, when England imposed a high duty on the importation of whale oil, much of the industry moved to Europe under the leadership of William Rotch of Nantucket. Whaling was carried out from Dunkirk and Milford Haven. These emigrations so depleted Nantucket seamen that few men capable of going to sea were left. Since Nantucket still owned many ships, it became necessary to resort to the continent for a large portion of each crew. Young Nantucketers were replaced by Indians and blacks, changing the character of the industry.

The period after the Revolution and through the first half of the nineteenth century were the years of Nantucket's prosperity. But by then whaling was no longer a pioneering venture; the technology of the industry had become fixed and conventional and no innovations were to be introduced in America. Nor was whaling any longer a communal activity; Nantucket shipowners and merchants sent ships to all corners of the world crewed by "foreign" impressed labor. And profits depended on exploitation.

During this period the Nantucketers freed themselves from the constraints of the ascetic Quakers as the more liberal Protestant sects took over and built the imposing churches that to this day dominate the town's skyline. Despite setbacks during the War of 1812 (which the islanders opposed) the whaling industry expanded rapidly and profits multiplied. By 1830 Nantucket was the third-largest town in Massachusetts, and the affluent lined the principal streets with large, splendid homes, not a few of which were constructed of imported bricks. Nantucket was already entering the early stages of the acquisitive industrial society that developed on the mainland a few decades later.

Slavery took more than one form in the United States. Everyone is familiar with the fact that blacks were slaves by definition unless proven otherwise. But there were also "indentured servants" who were temporary white slaves, and they existed in all the states including those of New England. The navy, the merchant marine and the whalers all made use of "impressed men" who were in all but name slaves without human rights of any kind. Until the second half of the nineteenth century, when steam took over from sail, ships were often crewed, particularly on long voyages, by men who had been shanghaied—beaten insensible, kidnapped and forced into compulsory service aboard ships. Hard, brutal labor was elicited from them by threats of the whip, incarceration, and even capital punishment. It was another form of slavery.

In the nineteenth century, whaling ships in particular had an infamous reputation. The work was brutal, bloody, greasy and filthy. Merchant mariners had a saying that you could smell a whaler before you could see her. The living conditions for the crew aboard whalers were wretched: the cramped and stinking forecastles were exceeded in malevolence only by the rotten grub regularly served the captive crew. These conditions, together with the existence of shanghaiing, is indicative of a breakdown of the incentive aspects of the lay system.

In the nineteenth century the feeling of community spirit on Nantucket also broke down. The Quakers disintegrated into dissident sects and lost their moral influence on the island. The division between the wealthy owners and the crews that worked the ships became nearly complete. As whalers ventured into the Pacific on voyages often consuming four years or longer, the lay system became an engine of exploitation. The profits of the voyage could always be enlarged if the crew could be forced to jump ship, thus relinquishing any claim to the proceeds of the voyage. By the middle of the nine-

teenth century, whalers rarely returned to their home ports with the same crews that began the voyages.

During this period of Nantucket's greatest prosperity, when most energy was being directed to the accumulation of wealth, moral concerns tended to become individualistic. Consequently, the social problems of the growing community were neglected. The population expanded to over 10,000 and a black community of ex-sailors developed in the south part of town, many of its residents working as domestics for the wealthy. Most of the streets were still unpaved and without the benefit of shade trees. Many "grog shops" crowded the waterfront and the young were accused of vandalism. A new jail had to be built to confine an increasing criminal element.

In the late 1830s and early 1840s the town budget was miserly in the extreme: just a little over $3 per capita. Nevertheless, it was so difficult to collect taxes that the town was forced to engage in deficit financing while the selectmen called for retrenchment in public services. The town still had no sewer system, the harbor was polluted and the Lily Pond was an open cesspool.

Education, such as it was, was provided only by a mixture of church schools, private schools and the Coffin School until the 1830s. The Coffin School was established and funded by Admiral Issac Coffin to educate descendents of his own family. Fortunately, there were a lot of Coffin relatives on the island and the school opened in 1827 with 250 students. Although Massachusetts passed a public-school law in 1789, Nantucket ignored it. It was not until 1818 that the town appropriated a niggardly $1,000 (less than $1 per child per year) to support free schools. Apparently even this appropriation was never spent because Nantucket continued in its failure to establish public schools until 1827 when, under indictment of a grand jury, the town provided $2,500 to open a public school. However, this was so inadequate that only children over nine years of age could be accepted.

Public parsimony and the decline in social responsibility were eventually to bring disaster to Nantucket. The town lacked a fire department and depended rather on a hodgepodge of public wardens, private companies and paid watchmen. In spite of serious fires in 1836 and 1838, the town was unwilling to spend tax money for adequate public fire protection, and continued to rely instead on private enterprise; the practice kept taxes low. An individual property owner subscribed to a private company to protect his property. In case of a fire, he had to call his own company. If a fire occurred at an uninsured property, the owner was faced with haggling over the price with several companies competing for the job. In the case of a more general conflagration, it was not unusual for fire companies to argue among themselves as to whom the privilege belonged. In the meantime, the whole town might burn down as, indeed, Nantucket nearly did in 1846.

The great fire of 1846 destroyed over 400 buildings in the center of town. It also revealed that, while some Nantucketers were piling up private fortunes, the moral spirit of their society had indeed declined. A public commission was created to investigate the causes of the fire and make recommendations. A month after the fire the com-

mission filed its report, stating that it wished "to bestow a sentence of censure upon these individuals, who possessed of wealth and influence, pressed into their private service large bodies of dependent laboring men—in effect hiring them to surrender the residue of the town to its fate—who otherwise, without reward or incentive, could have wrought successfully against the desolating elements and materially circumscribed the sphere of its [the fire's] action". In other words, the disaster of the 1846 fire could have been mitigated except for the perfidy of those of wealth and influence.

In the 1850s whaling on Nantucket went into a rapid decline. The population fell from about 10,000 to only 4,000 in one generation. A number of explanations have been given for the decline, none of them very satisfactory. The conventional explanations are: that the bar outside the harbor built up, preventing whalers entrance; that the great fire of 1846 discouraged industry; that the discovery of gold in California in 1848 siphoned off ships to the West Coast; that the discovery of petroleum and the refining of kerosene replaced whale oil; and finally, that the Civil War drained resources from the island, including ships.

Any reasonable analysis can show that none of these "causes" had much, if anything, to do with the decline of whaling on Nantucket. As a matter of fact, the bar outside the harbor did not build up. It was always there, just as it is today. What actually happened was that the tonnage and draft of whalers increased substantially after tryworks were installed aboard ship and voyages were extended into the Pacific. Various devices like floating dry docks were employed to overcome the problem, but they were costly and cumbersome. The real cause for the abandonment of Nantucket as a port, however, was the rise of railroad transportation. By the middle of the century, railroads were beginning to dominate transportation and no island community could compete with mainland ports, such as New Bedford, which had deep harbors and rail connections with major markets. Although the fire of 1846 was an economic disaster, there is no evidence that it affected the whaling industry, for by that time whaling was already in a decline at Nantucket. At most, the fire was a coup de grace. Actually, the burned-out sector of the town was rapidly rebuilt, indicating that there was confidence (unrealistic as it may have been) in the future of whaling and that there was sufficient capital available to finance future growth.

It is true that the discovery of gold in California siphoned off ships to San Francisco. But these were unemployed ships, desperately looking for cargoes of any kind. It was only after the whaling industry had declined that Nantucket ships were diverted to San Francisco. Gold was not a cause of the failure of the whaling industry, nor was the discovery of "black gold." While it is true that kerosene eventually supplanted whale oil for illumination, the first commercially productive oil well was drilled near Titusville, PA, in 1859, long after whaling at Nantucket was decimated. Moreover, kerosene was not refined in commercial quantities until after the Civil War. And the Civil War could have had no effect on Nantucket's whaling industry because by the time the war started, whaling was dead. The decline began in the

1820s, and by 1857 Nantucket had only four whalers left. Four years later, when the Civil War broke out, Nantucket was out of the whaling industry forever.

Three factors combined to bring about an early end to whaling on Nantucket. As noted above, the growth of railroads from 1830 on made it possible for mainland ports to dominate the domestic market. Nantucket was left with only its traditional customer: London. But as early as 1810 the English began to install gaslights in homes and factories. Within a very few years gas lighting proved less costly and more efficient than whale oil and candles. Factory owners were particularly delighted with gas lighting because they could extend the workday during the winter months when daylight was scarce. As England's factories, streets and the homes of the affluent came to be illuminated by gas, which was manufactured from abundant domestic coal supplies, Nantucket's market for whale oil and candles collapsed. Simultaneously with the market collapse, the cost of whaling voyages rose. As steam began to take over from sail the extreme exploitation of labor and the gross inequality of the division of income began to be somewhat mitigated. By the 1840s shanghaiing had come into disrepute, and American sailors were demanding wages, not shares, to improve their lot. As the lay system died out, ship-owners could no longer count on postponing labor costs to the end of a voyage or even avoiding such costs altogether. Nantucketers found it all but impossible to crew their ships.

The claims of prosperity and affluence brought to Nantucket by the pursuit of the whale probably have been exaggerated, and the wealth that was attained was enjoyed by a small minority. Emigration from Nantucket continued even during the periods of population growth and so-called prosperity. In 1783 a number of Nantucket families moved to the Hudson Valley north of Poughkeepsie and established the town of Hudson. They moved lock, stock, and barrel, even taking their houses with them. Then, in the period from 1771 to 1775, when whaling was supposed to be in a surge of prosperity, a large number of families emigrated to Guilford County, North Carolina, and took up farming. In the 1840s, when fortunes were being made in whale oil, a substantial colony of Nantucketers moved to Ravenna, Ohio. Twenty-one of the heads of families were sea captains!

The best evidence we have today of the amount of wealth and its distribution on the island are the homes that have been so well preserved since the seventeenth century. As has been mentioned, the homes of the eighteenth century were modest and without provisions for servants. In the nineteenth century many fine homes were built on the island, not a few of which were built of brick. But these homes of the wealthy number only about 100. And when it is remembered that Nantucket had a population of nearly 10,000, the housing pattern would indicate that substantial wealth came to about one person in 100.

Every visitor to Nantucket is always shown with pride all the captain's houses lining the principal streets. But if someone inquired, "where did the foredeck hands live?" he would not likely receive an answer. The truth of the matter is that they did not live on the island. In the eighteenth century, when whaling at Nantucket was a family affair, the crews comprised the youth of the island, and they had no homes but their parents'. In the nineteenth century, during the time of Nantucket's affluence, the crews were impressed men from the continent, Indians and blacks, and later blacks from the Portugese Azores and Madeira Islands as well as other foreign parts. One unusual consequence of this was that Nantucket never suffered from the blight of slum neighborhoods which are all too prevalent in American cities and towns. The lack of an industrial slum eventually made it easier for Nantucket to develop a resort industry in the last quarter of the nineteenth century.

Chapter II

THE HOTEL ERA

After the collapse of the whaling industry on Nantucket in the mid nineteenth century the islanders struggled through two decades of deep depression while trying to survive on marginal fishing and farming. Most of them did not make it; the island lost nearly two-thirds of its population to the mainland. With such an emigration it is surprising that Nantucket did not become a ghost town. Other prosperous American communities which lost their resources either vanished completely, as did many Western mining towns, or became insignificant backwater settlements, as did Williamsburg, Virginia, when the capital was moved to Richmond. But Nantucket had many hidden resources, including a past that could be called up to serve the future, a climate and geography that would be in demand by vacationers, and some Nantucketers had an unmitigated determination to remain on their island and revitalize it.

But neither the nation nor Nantucket was ready for a resort business in the 1850s and 1860s. Travel was still too difficult, expensive and inconvenient to support recreational activities more than a few miles beyond population centers. Although railroads were expanding, speeds were quite slow (about 15 miles per hour), and a journey of only 50 miles could require a whole day. Travel on steamboats was even slower. Before the Civil War, the United States was largely an agricultural economy with a small middle class. Most farmers could not afford vacations and worked their longest hours in the summer. Wage earners were not entitled to any time off (not even Sundays in some industries) and they were paid only subsistence wages so they could save nothing. The very wealthy had country estates where they spent their leisure time. Then the 1860s was a decade dominated by the Civil War that tore the nation apart and provided no encouragement to resort development.

In the United States no industrial town is a resort. Nantucket had lost her industry, so the first step had been taken toward the birth of a resort business. But much more had to be done. No resort can be established in an unhealthy, poor and ugly environment. The town and island would have to be improved and beautified. There would have to be better public health and education. The population would have to be kept employed. If they were to make their island a resort, they would have to create an environment that could support such a venture.

Whenever private enterprise fails to provide an adequate living, a society can resort to public enterprise to fill the gap. Often public enterprise may make the difference between survival and collapse of the whole community. Just as our nation made a large investment in human and material capital through public investment during the Great Depression of the 1930s, so did Nantucket in the 1850s and 1860s during her time of travail.

When compared with Nantucket's budgets during her years of greatest prosperity, public spending during the depressed years increased. Appropriations were made for the relief of the poor and unemployed. Increased spending was authorized for enlarged education facilities and personnel, including the construction of a high school. Improvements in public health were undertaken through the construction of sewer drains, and a program of smallpox vaccination was initiated. Many capital improvement projects were advanced, including the planting of shade trees, paving of streets, the installation of street lighting (including gas lights) and improved fire protection.

The larger town budgets needed to pay for such social improvements had to come from a declining tax base. Thus, the town budgets in this period of depression represented a substantial increase in per capita spending. Nantucket soon had to engage in deficit spending with the funds being borrowed from various sources. In addition, believing that it is better to put a man to work on public projects than to provide a dole, the town permitted citizens to pay their taxes by working for the town. It is to their credit that the people of Nantucket, who refused to leave their island, saw fit to undertake these capital

improvements even though it meant going into debt. If they had retrenched and cut back public spending, Nantucket might have become a ghost town. Instead, the islanders laid the foundation for the resort business that was born in the 1870s.

After the Civil War the country entered a period of expansion and prosperity. The industrial revolution was in full swing. Sparked by the revolution in transportation which saw an enormous growth in railroads and steamships, the United States began to exploit its coal and iron resources, and mechanization was introduced to most industries. With the opening of the flat, clear farmlands of the Middle West, farm machinery could be used profitably. The reaper, the harvester and binder, the mechanical planters and gang plows all combined with rail transportation to change agriculture from a subsistence life to a profitable industry. The change in farming released manpower to work the factories and mines and to provide human services. One social result of this change was the creation of a middle class of white-collar workers and professional people who had both the time and resources to take summer vacations. Another result was the expansion of the upper class, the owners of the oil wells, railroads, steamships, mines, mills and factories—the class that could afford to take long vacations and to build summer homes.

Nantucket was ready for the vacationers. There was a heritage of hundreds of fine old homes dating all the way from the simple farmhouses and fish shacks of the 1680s to the elegant mansions of the period of whaling prosperity. The open beaches and moors were waiting to be enjoyed by the people crowded into the fast-growing Eastern cities. And Nantucket was blessed with an average summer temperature about 6°C below the adjacent hot and humid mainland. Having gotten rid of its industry, improved its health and environment, the island now had all the requisites of a successful "watering place."

The first step in Nantucket's recovery and the development of the resort business was the conversion of many large surplus homes into hotels and rooming houses. During the previous two decades of depression, homes were sold at very low prices. Many were abandoned to creditors. Most of the larger homes were easily converted to hotel use. Usually the only major investment was the installation of a large kitchen in the basement capable of providing meals for the guests. Without exception, these hotel conversions were all in the town, and none could be called a true resort hotel. In their advertisements these new hotels touted Nantucket's "health-giving sea breezes," their cuisine and their comfortable accommodations. While it is doubtful that these Nantucket hotels provided their guests with better food or lodging than did mainland watering places, the air was cooler and, in the days before air conditioning, that was a large asset. So the summer vacation business was born on the island.

Most of these converted homes have been preserved. Some, such as the Ship's Inn on Fair Street and the Roberts House on Lower Pearl Street, are still operating as hotels today, little changed from the 1870s except for the addition of bathrooms. Others, such as The Bay View House and the Sherburne House, both on Orange Street,

have been reconverted to private residences and they serve their present owners as gracious dwellings that preserve Nantucket's past. Jared Coffin built a fine mansion on Broad Street just before the great fire, but he lived in the house only one year before he and his family emigrated to Boston. Within two years of its construction this fine home became a hotel owned by the steamship company that served the island. In the beginning, the Jared Coffin House was Nantucket's most impressive hotel, but when the true resort hotels were constructed, these converted homes became second-class hostelries. The Jared Coffin House ran into hard times and a succession of owners until it was acquired in 1961 by Nantucket's Historical Trust. The Trust completely restored the building to its former elegance, supplied it with antiques and handcrafted furnishings, and equipped it with modern service facilities. It is now one of the country's outstanding hotels.

Recreation as we know it today was quite foreign to the vacationers of the 1870s and 1880s. There was no such thing as "sport clothes." All activities were conducted in the standard business suits of the day or their female equivalent, a floor-length, activity-restricting dress. Nantucket had no golf course, tennis courts, yacht club or public beaches. Sailing was a commercial activity, not a sport. Swimming consisted for the most part of merely wading up to one's knees in the calm waters of the north shore. To fish, one hired a commercial fishing boat (mostly catboats) for the day and went out to catch sharks or cod. Hired catboats took excursionists four miles up harbor to Wauwinet where lunch was served by the Wauwinet House Hotel, which was then more a picnic facility than a hotel. Ladies were sometimes seen being rowed in the harbor while protecting themselves from the summer sun with dainty parasols. The vacationers of this period must have spent most of their time writing letters, playing cards and idling in rockers on porches while waiting for the next meal to be served. To accommodate this indolent life many hotels added porches which considerably disfigured the original designs of the converted homes. Americans had not yet learned to play.

In the old photographs the only concessions to recreation visible on the whole island are some private bathhouses in the vicinity of the Jetties Beach and what was known as "Haydon's Bath Room." In the 1870s the latter was a small frame building standing on pilings at the tide line between the present Nantucket Yacht Club and what is now the Children's Beach. At first it probably provided nothing more than locker space for those daring enough to wade in the waters of the harbor. Later it was somewhat enlarged, provided with a boiler to heat hot water for baths; facilities for swimming, including a pier, were also added. When hotels were constructed fronting on the water, and indoor, private bathrooms were introduced, Haydon's Bath Room failed. Following Nantucket's tradition of saving old buildings, when Haydon's Bath Room was taken down parts of the building showed up elsewhere. One part was moved onto the property of the newly formed Nantucket Athletic Club (now Yacht Club) where it serves today as a utility building and dormitory for summer employees.

As soon as summer visitors began to make the newly

converted hotels prosper, land speculators descended like vultures to "develop" the island through the subdivision of the land. Not all of these speculators were from the mainland; some were island residents of long standing. The north end of the Cliff was divided into house lots as early as 1873. In the same decade, Surfside was also subdivided; 3,000 lots were laid out at Madaket; and 1,700 lots were subdivided along the south shore of the island between Hummock and Long Ponds. Fortunately for Nantucket, all of these ventures by land despoilers failed. Nantucket's development took another course, and it would be a whole century before the island would succumb to ravishment by large-scale land speculators. In the 1870s and 1880s even those who could afford to build and maintain summer homes chose to rent accommodations.

The activity of the land speculators on Nantucket had one unusual outcome: a railroad. One syndicate of land vandals had chopped up an area of Nantucket's south shore into house lots. This area, later known as Surfside, was then in the boondocks, and the lots did not sell because no one wanted to drive a horse and buggy three or four miles over a sandy, rutted road to a place that had no amenities whatsoever. So the speculators built a narrow-gauge railroad in 1881 from the head of the Steamboat Wharf across the island to the south shore. It was a nice curiosity, but still the lots remained unsold. The next move was to supply the amenities. A wooden hotel building (which had proven a white elephant) was bought in Rhode Island and reerected at Surfside. The hotel was not a booming success and failed to generate enough traffic to pay for the railroad. So the tracks were extended along the beach to Siasconset on the east shore where there was a substantial summer colony developing. It was hoped that by connecting the towns of Nantucket and Siasconset enough revenue would be produced to keep the railroad solvent even if no lots were sold. Storms repeatedly wiped out the roadbed built on sand, but not before the railroad had become a tourist attraction. Eventually, the line was rebuilt running overland directly between Nantucket and Siasconset and bypassing Surfside altogether. The railroad struggled on, running in the summer months as a tourist attraction, until World War I when it was dismantled and shipped to France as part of the war effort.

The more affluent summer visitors not only eschewed the Surfside Hotel but they began to demand larger and more luxurious facilities than could be offered by the homes converted to use as hotels, housing a dozen guests perhaps a half mile from the water. They wanted recreation facilities and a view of the water. So in the 1880s and 1890s the era of the true resort hotels began. The Nantucket Hotel was built on Brant Point right on the beach, and the Springfield (now Harbor) House and the Point Breeze (now Gordon Folger) Hotel were built just a short distance from what is now the Children's Beach. The Sea Cliff Inn was constructed on the bluff north of town with a magnificent view overlooking Nantucket Sound. To facilitate bathing, the Sea Cliff Inn built a long boardwalk from the hotel to the beach at the west jetty so their guests would not have to trudge through the sand dunes. More modest hostelries were erected along the

ocean on the south shore at Tom Nevers Head and on the east coast at Siasconset. The Wauwinet House, which had opened in 1876, was enlarged to accommodate a substantial number of guests.

These new resort hotels had large staffs of maids, porters, waiters, cooks, concierges and other servants to cater to the wants of the nouveaux riches. Both employment and income rose sharply on the island in this period. Since these hotels boasted dining rooms that could provide a wide choice of entrées, wines and liquors, and advertised that they had fresh, new accommodations with water views, and because they had large public rooms for social activities such as dancing, professional entertainment, theatricals and parties, the hotels attracted not only the rich but the convention business as well. With the coming of these resort hotels the real foundation of Nantucket's summer business was secured. From then on, fishing and agriculture became secondary, subsistence industries.

But unlike the homes converted to hotel use, nearly all of which have been preserved, many of the old resort hotels have disappeared. A few, such as the Gordon Folger and the Harbor House, carry on a tradition catering to transient guests who visit the island for a few days to a week or two. The White Elephant Hotel, with a favorable waterfront location near the Yacht Club, was torn down in the 1960s and replaced with a modern structure of the same name that includes auxiliary cottages and a swimming pool. The White Elephant today promotes the convention business. It is quite likely that the number of hotel rooms available today differs little from the number available nearly a century ago because, starting in the last decade of the century, there was a decided trend toward single-family summer homes. Not only were whole colonies of summer homes built in several places on the island, but the old Nantucket houses were bought and renovated by summer residents. This trend is still operating today. One of the last of the old resort hotels, the Sea Cliff Inn, was taken down a few years ago to make room for single-family dwellings.

Overleaf: **A View of Nantucket at the Start of the Resort Hotel Era, ca. 1885.**
When this picture was made from the South Tower (Unitarian Church), Nantucket was on its way to becoming a major East Coast resort community. The Nantucket, a large summer hotel, had been built on Brant Point (background) near the lighthouse. Passengers arriving on the steamer *Island Home* could dine at the new restaurant on the Steamboat Wharf and, a few steps away, board the Nantucket Railroad (center) for a trip to Surfside and Siasconset. Haydon's Bath Room (left) has been enlarged and provided with facilities for swimmers. However, the partially destroyed "T" on Steamboat Wharf has not been repaired and the tidewater trapped between the railroad embankment and the shore has become a cesspool. The summer home movement has hardly begun; there are but four homes on Brant Point.

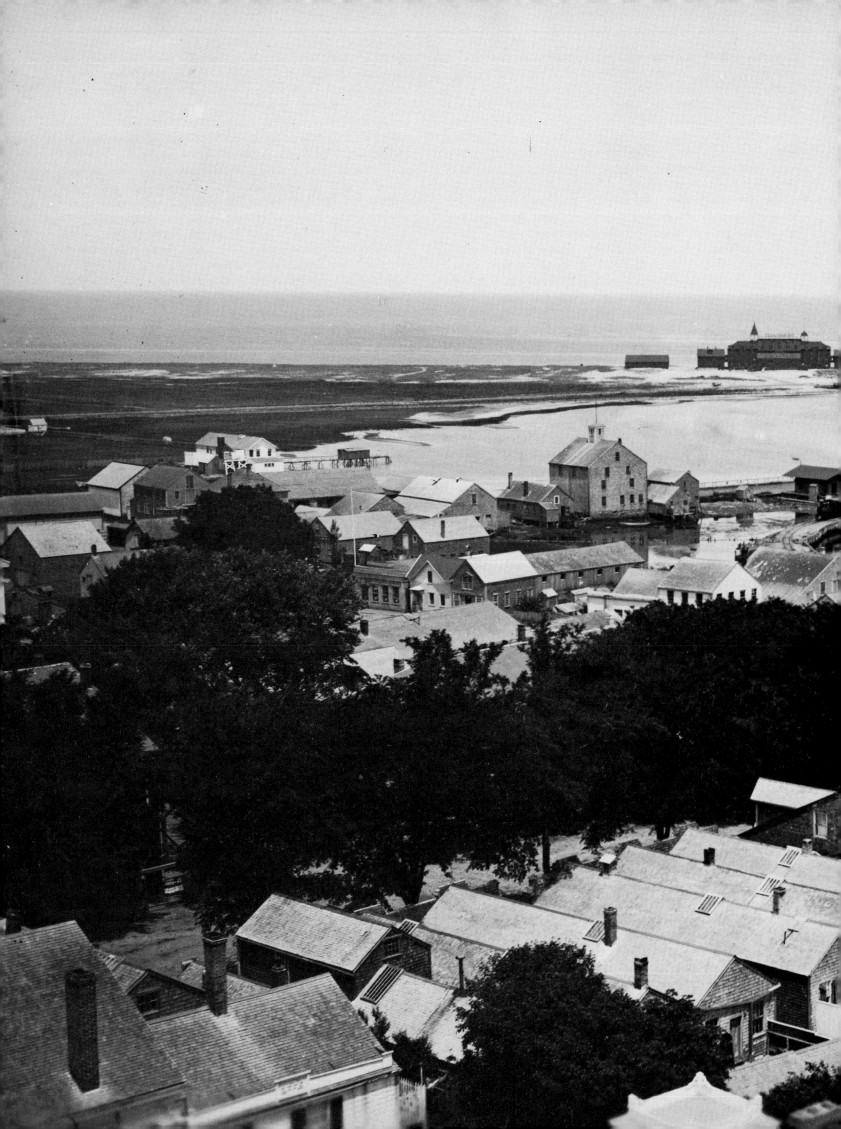

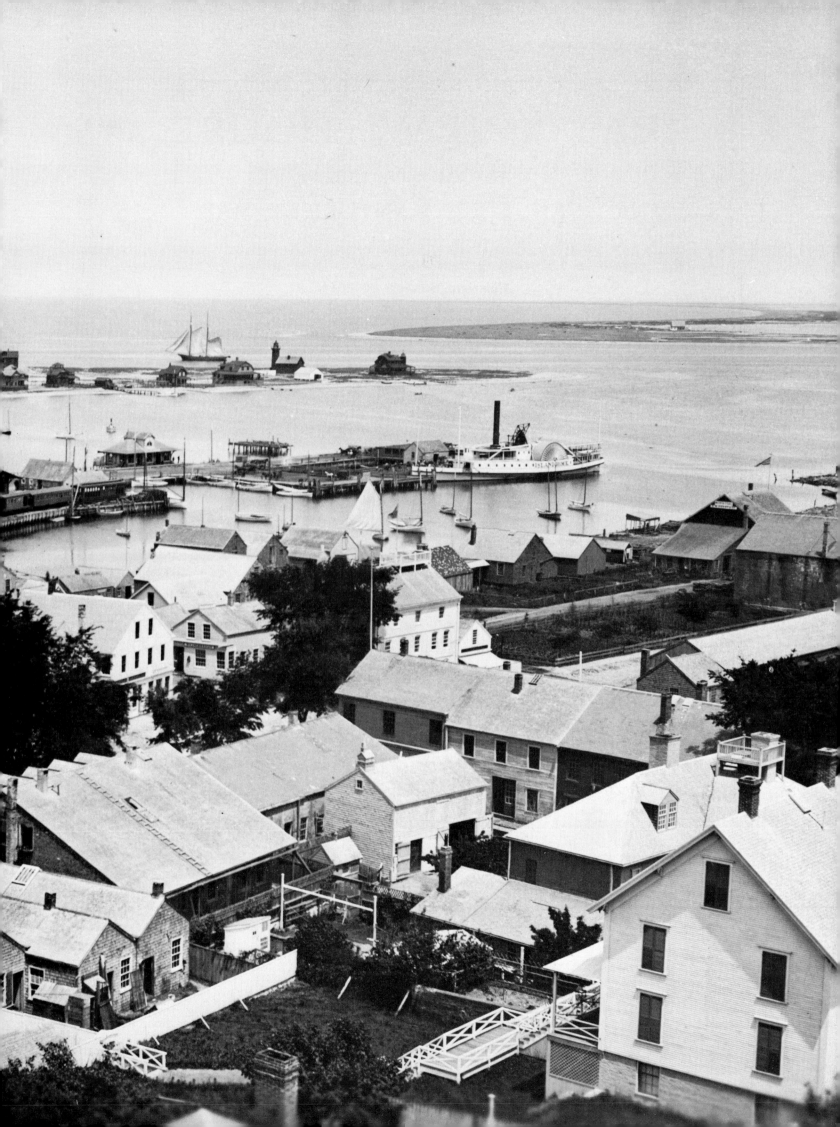

BAY VIEW HOUSE.

F. E. ADAMS, PROPRIETOR.

74 ORANGE ST., NANTUCKET, MASS.

This large and pleasantly located house will be open on the First of May,
For the Season of 1874.

The proprietor will be happy to welcome his old friends and patrons, and the travelling public gener= ally. Large and convenient additions having been made to the house during the past season, he is now able to offer excellent accommodations for his guests. No pains will be spared to secure the comfort of its patrons' and to make the

"Bay View" in every respect a First Class House.

The situation is one of the best on the island, com= manding a fine view of the harbor and ocean beyond; while it is conveniently near the centre of the town.

Those who wish to enjoy all the advantages of a pleasant sojourn at the seaside, with Boat Excursions, Fishing and Sea Bathing, should visit Nantucket the coming summer, where the "Bay View" will be found one of the most desirable of resting places, and every= thing will be done to minister to their comfort and pleasure.

F. E. ADAMS,
Nantucket, Mass., April, 1874.

The Bay View House, Advertisement of 1874.
The Bay View House, 38 Orange Street, is quite typical of the "captain's houses" that were converted to hotels as Nantucket began to recover from the long depression following the demise of the whaling industry. Characteristically, the "bay view" was limited to the cupola and the nearest water was farther than many would care to hike in bathing suits. The next three pairs of views show this characteristic house, front, back and inside.

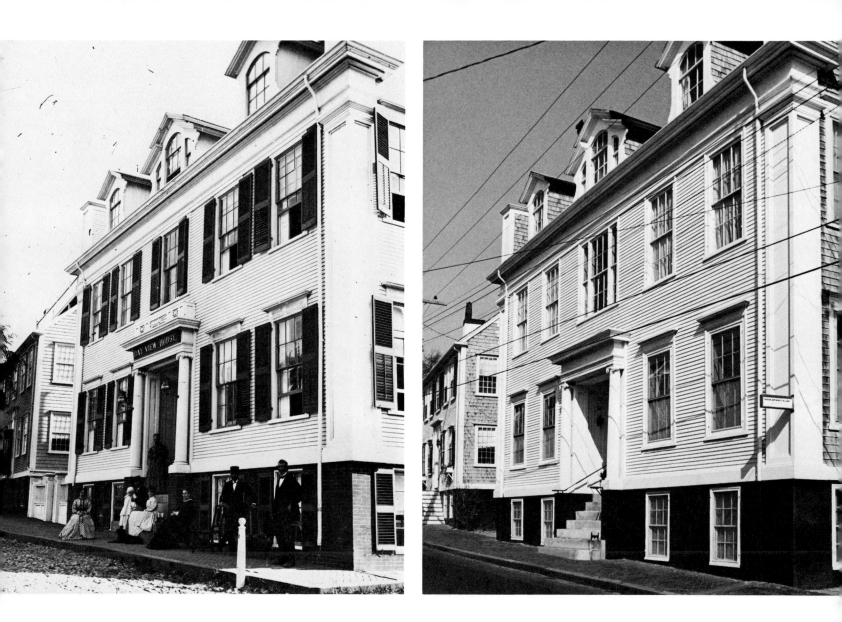

38 Orange Street, ca. 1875 (left) **and 1975** (right).
This Greek Revival house was built in the "captains' row" section of Orange Street in about 1840, at the peak of the island's prosperity. Its history demonstrates the transition that took place on the island over the next century. By the 1870s the building was converted into a hotel, the Bay View House, but it has now been reconverted into a private home. The 1975 view shows the building nearly unchanged except for the ornamentation above the entrance and the sidelights added to the window above the door. On some surfaces, clapboard has been replaced by shingles, which are easier to maintain.

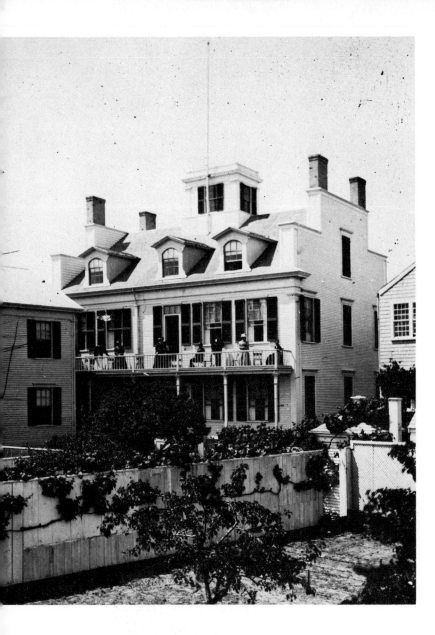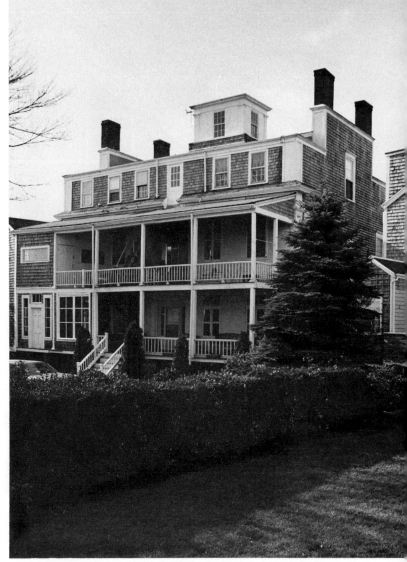

38 Orange Street, Rear View, ca. 1875 (left) **and 1975** (right).
The old view shows the original narrow second-story balcony
and dormers. Over the years the balcony has been enlarged and
covered, and the third story has been expanded, eliminating
the dormers, to accommodate guest rooms.

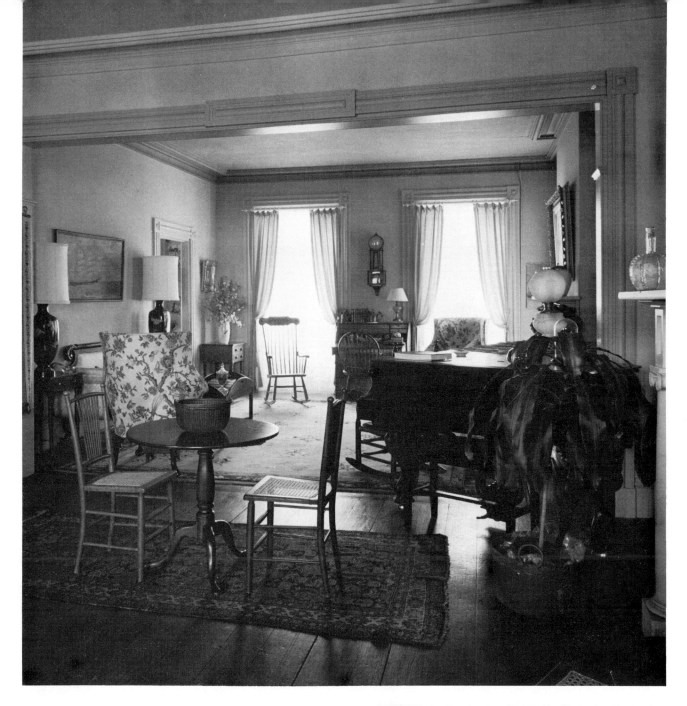

The Parlor, 38 Orange Street, 1875 (right) **and 1975**
(above).
The Bay View House featured gaslights, a marble-
topped card table, a piano, wall-to-wall carpeting, a giant
antimacassar and a potbellied stove venting through a
fireplace. Simpler taste prevails today.

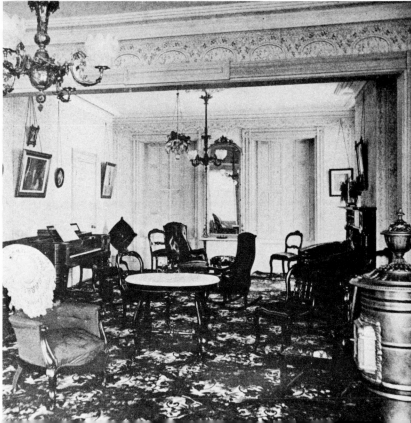

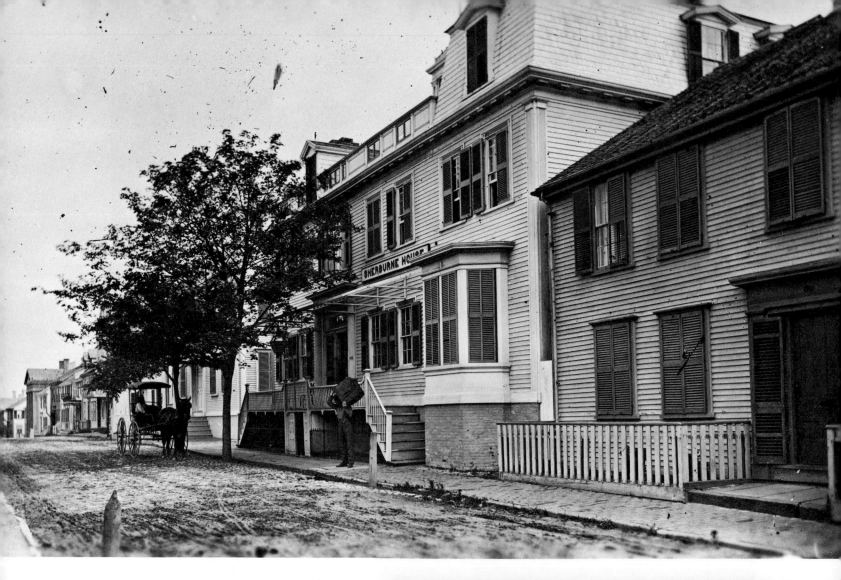

The Sherburne House, Orange Street, ca. 1886 (above) **and 1976** (right).

This is another "captain's house" on Orange Street which was converted into a hotel. To make the building appear modern, a new wing and mansard roof were added. Today the building, reconverted to a private residence, has been moved back on the lot to take advantage of the view over the harbor. The old house to the right has been moved to make room for a garage for the former Sherburne House. The view down Orange Street is today obstructed by trees.

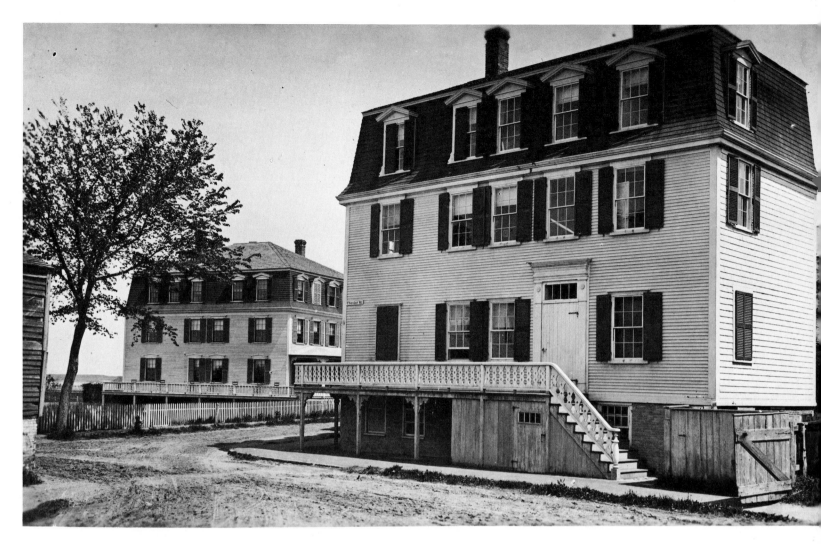

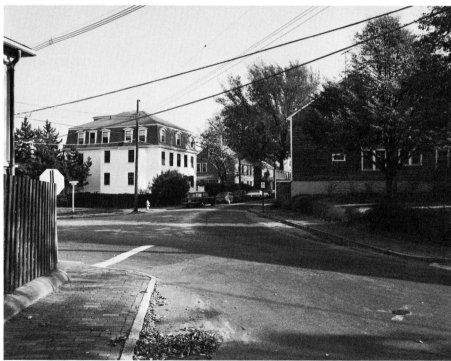

The corner of Easton and North Water Streets, ca. 1885 (above) **and 1975** (left).

The old house in the foreground of the 1875 photograph had been given an extra bay on the left, a wing to the rear and a "General Grant" third story to make it one of the first hotels on the island. Later it and the building in the background to the left were both run as part of the Springfield House (see page 21). The hotel in the foreground was taken down in 1917 to eliminate a jog in the street. The other building now operates as part of the Harbor House.

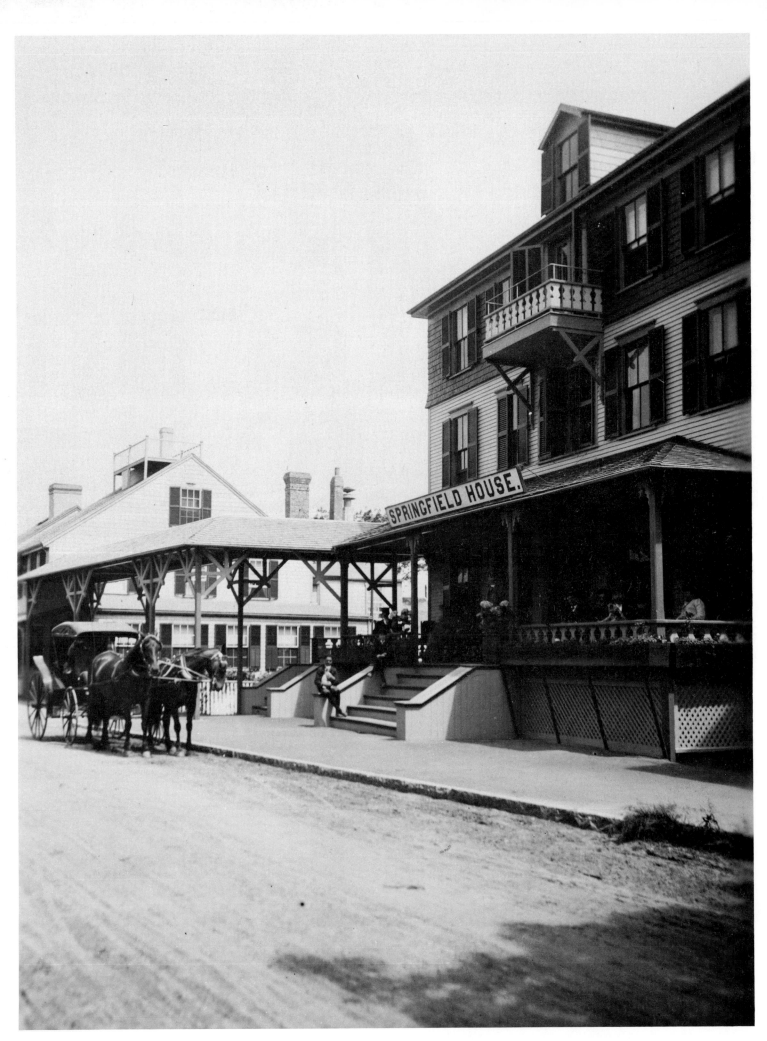

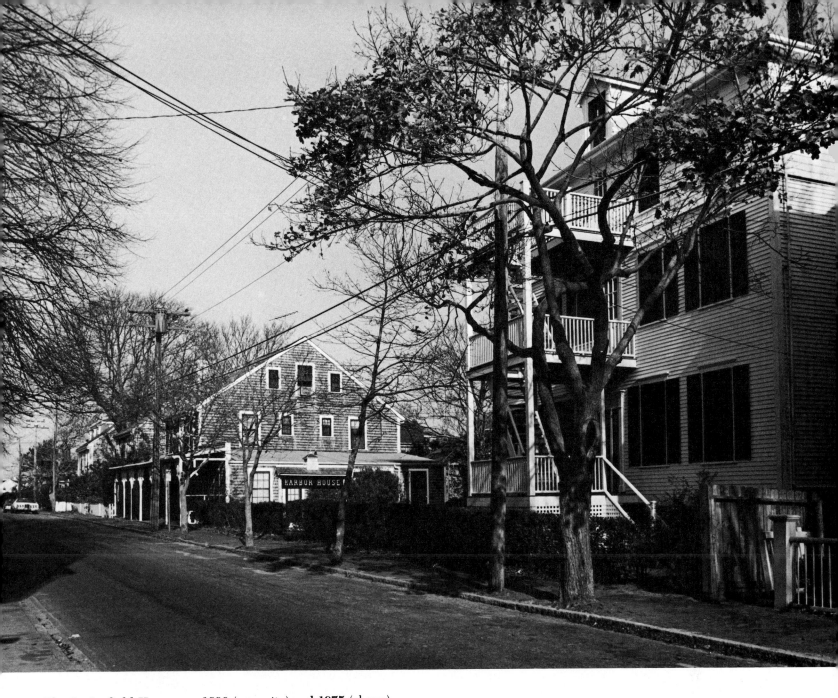

The Springfield House, ca. 1890 (opposite) **and 1975** (above).
This was probably the first structure on Nantucket erected ex-
pressly as a hotel. Built in 1883, the top story was done in a
dark color to create a visual conformity with the two annexes,
seen on page 19. A roofed walkway leads to the house down
the street, where meals were served. Today the posts are in-
corporated into the supports of the awning in front of the old
dining room. The porch of the main building is gone, replaced
by a fire escape.

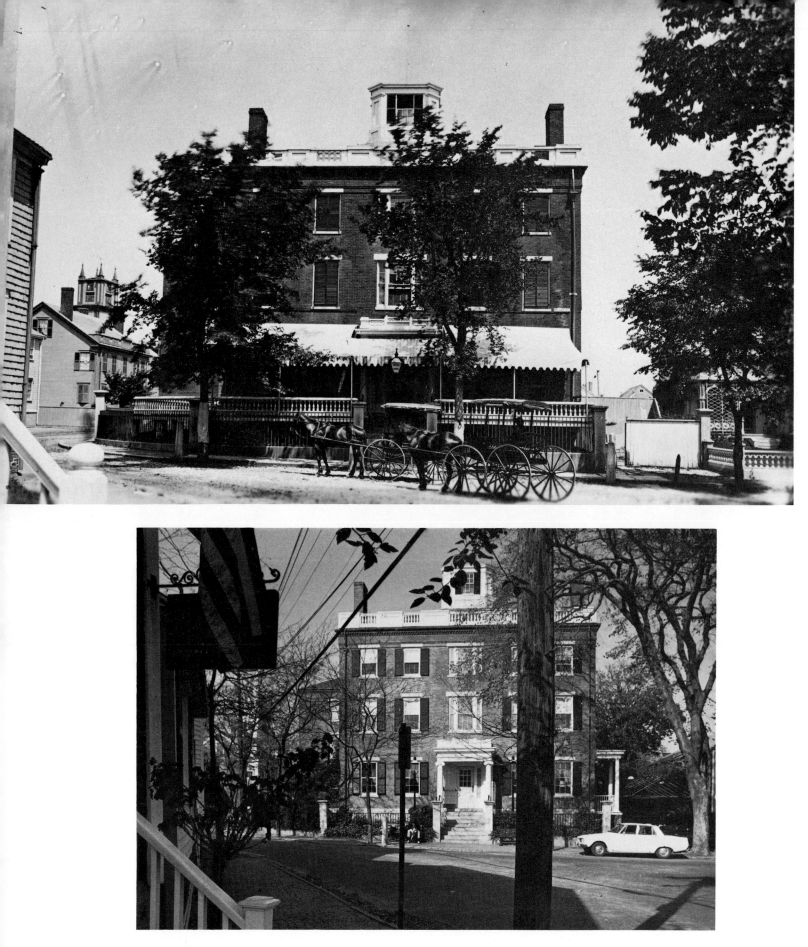

29 Broad Street, ca. 1880 (top) **and 1975** (bottom).
In about 1830 Jared Coffin built a large brick house at what was then the edge of town. His wife did not like living so far from the center of things, so 15 years later he built another, even larger, brick house on Broad Street. The Coffins lived in the mansion only one year and then departed for the more sophisticated life of Boston. The house was sold to the Nantucket Steamboat Co. in 1847 to become the Ocean House, Nantucket's first substantial hotel. A large porch was added across the front of the house as an amenity for the guests.

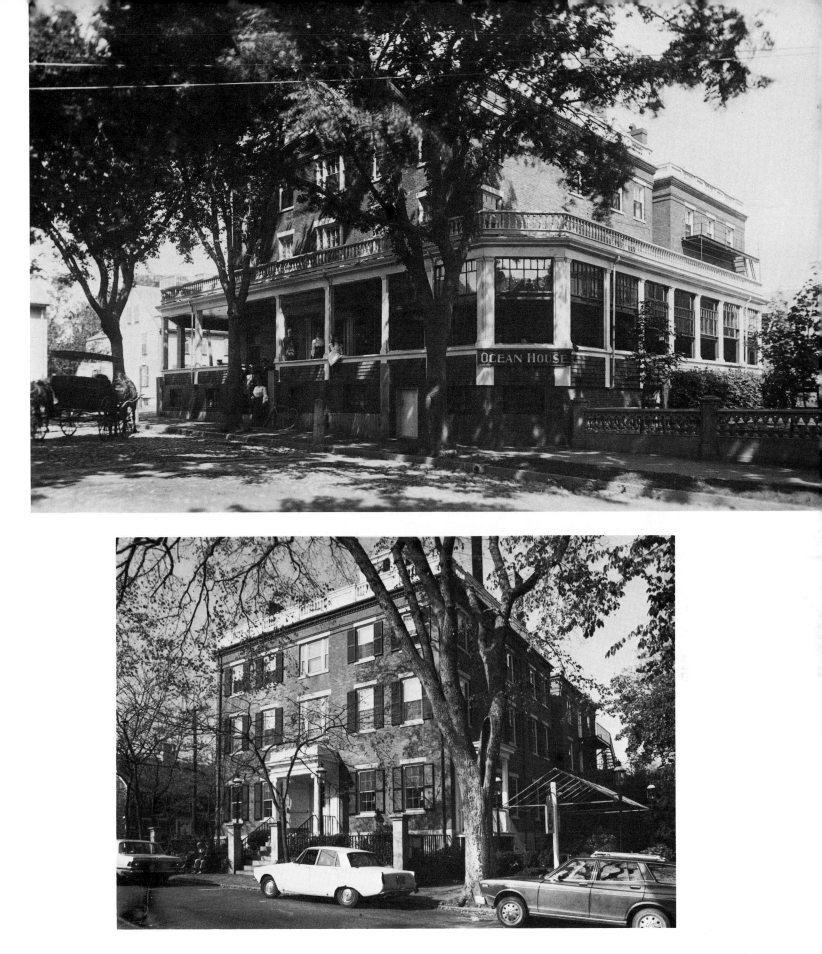

29 Broad Street, ca. 1910 (top) **and 1975** (bottom).

As Nantucket began to attract a larger summer vacation business in the 1880s, the Ocean House added an annex to the rear and a large porch on two sides which attracted guests whose principal recreation consisted of exercising in rocking chairs. The building was acquired by The Nantucket Historical Trust in 1961 and was restored with period antiques and Nantucket-crafted furnishings. The porch has been removed, allowing the splendid Greek Revival facade to be seen in its full glory. Now named the Jared Coffin House, the establishment is one of the country's outstanding small hotels.

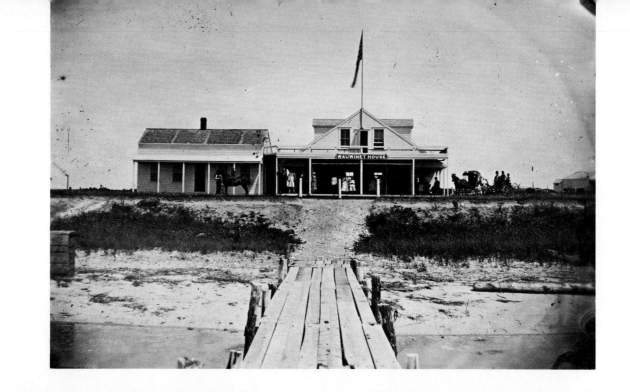

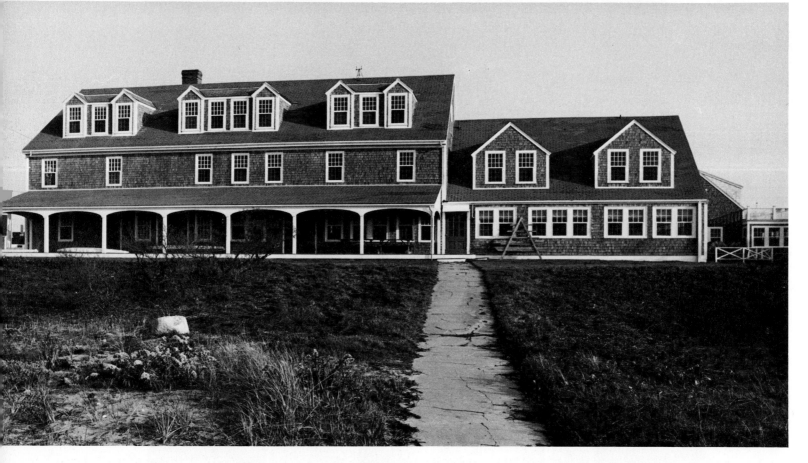

Above: **The Wauwinet House, 1876** (top) **and 1975** (bottom). The Wauwinet House, the first hotel outside of town, was opened in 1876. The inn had an ideal location on a strip of land between Coatue and Great Point, with Head of the Harbor on one side and the ocean on the other. It was at first little more than a picnic facility. However, it was a popular excursion to sail by catboat "up harbor" for lunch at the Wauwinet House. Just as a century ago, anyone who wants "to get away from it all" will find his escape here, although nothing of the old structure is recognizable today in the much-enlarged summer hotel that stands on the same site. The shore has filled in in front of the inn for a distance of about 100 meters.

Opposite: **The Nantucket Hotel, ca. 1885** (top) **and 1975** (bottom).
The era of the resort hotel began to boom with the building of the Nantucket Hotel near the lighthouse on Brant Point. The structure incorporated the Friends meetinghouse that had stood on Main Street, a summer house, a building moved from Orange Street, plus bits of carpentry work pulling all these disparate pieces together. The first hotel to be built right on the beach, it offered amenities that were unavailable in hotels made from converted homes. By the end of the century, however, summer homes were rapidly displacing hotels, and the area is now solidly built up with private summer homes.

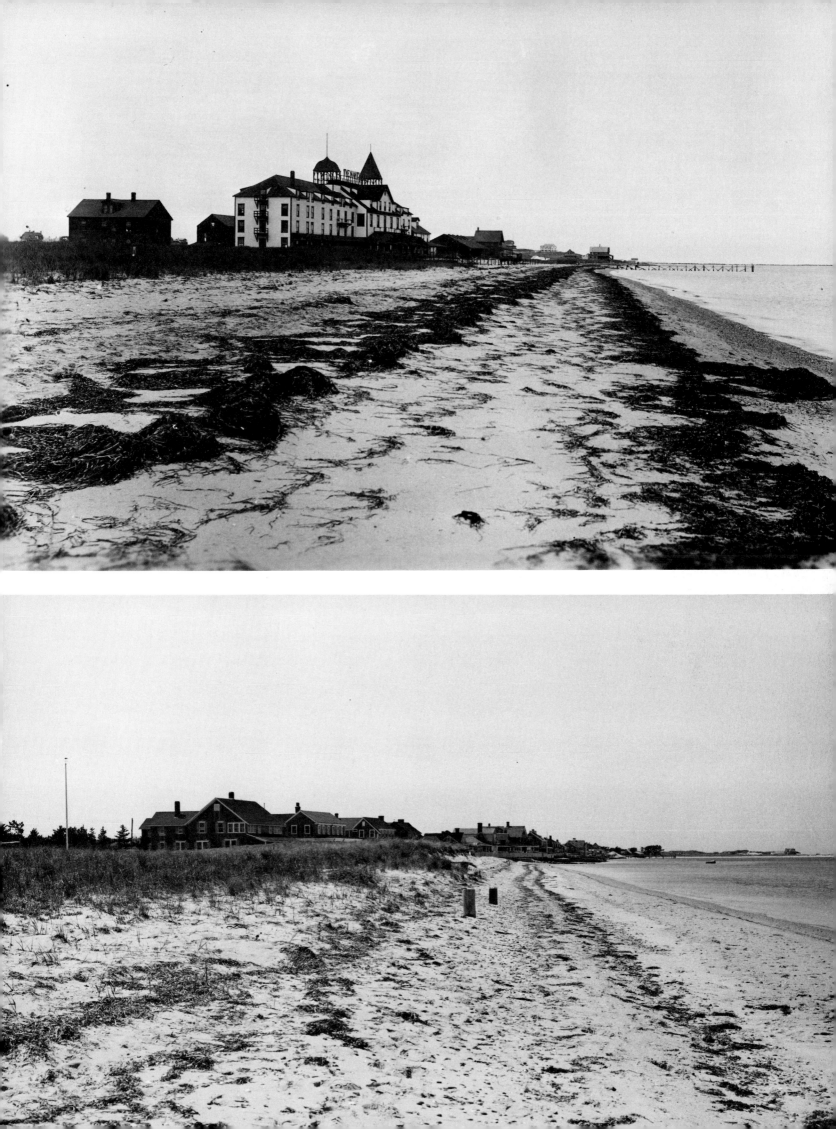

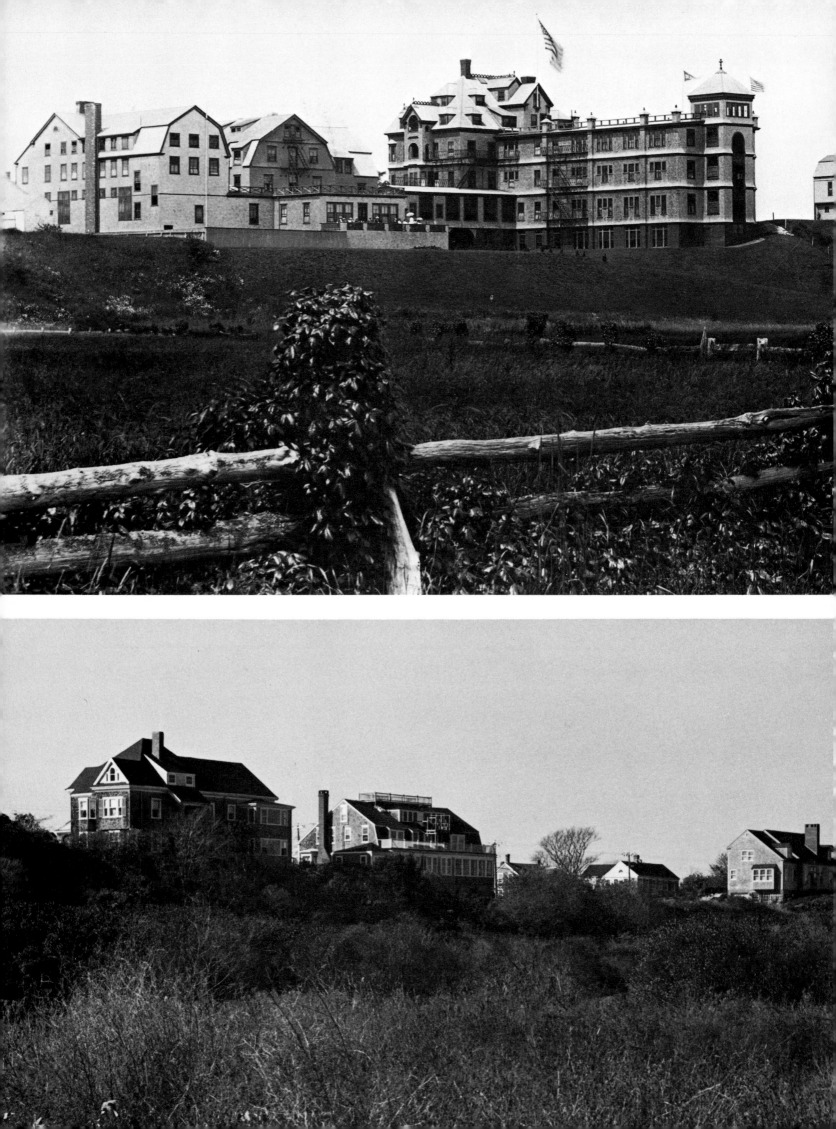

The Sea Cliff Inn, ca. 1890 (top) **and 1975** (bottom).
All but two of Nantucket's old summer hotels have gone; the Sea Cliff was one of the last to disappear. It stood high on the cliff overlooking Nantucket Sound. In its early days it provided a boardwalk half a kilometer long to afford guests easy passage to the water. The hotel closed in 1971 and was taken down two years later. Now the cliff area is given over entirely to large summer homes.

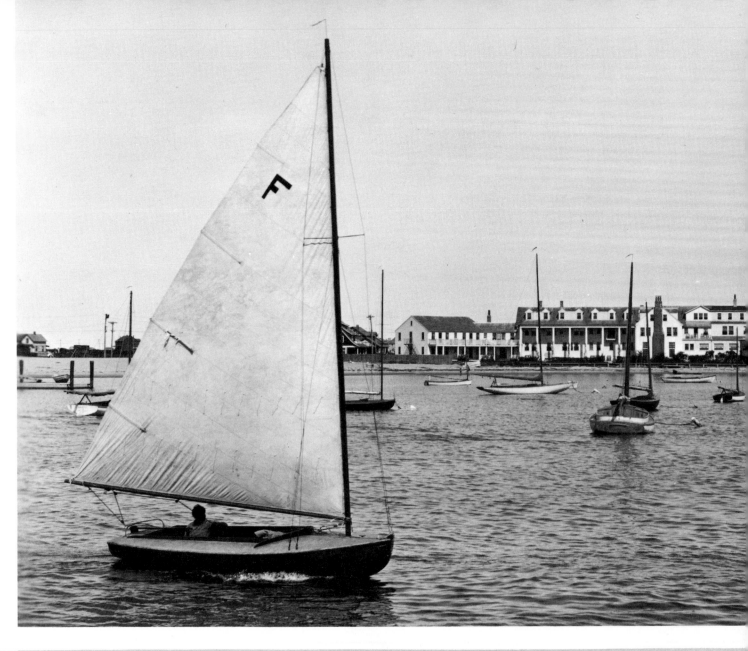

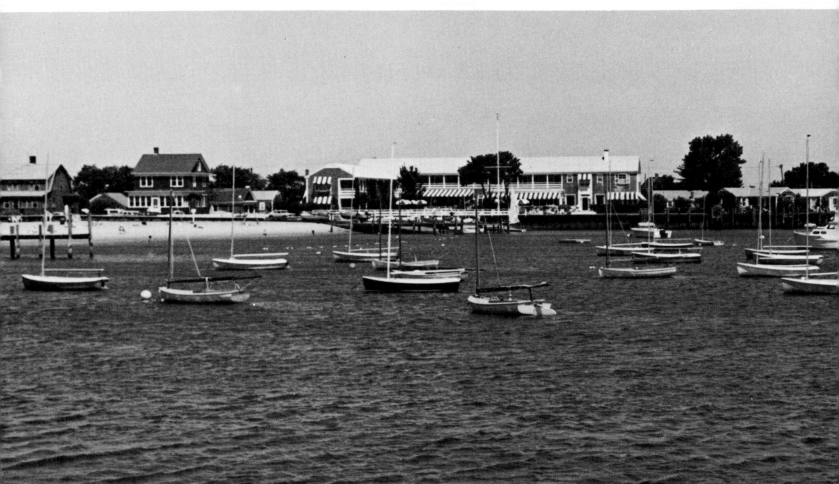

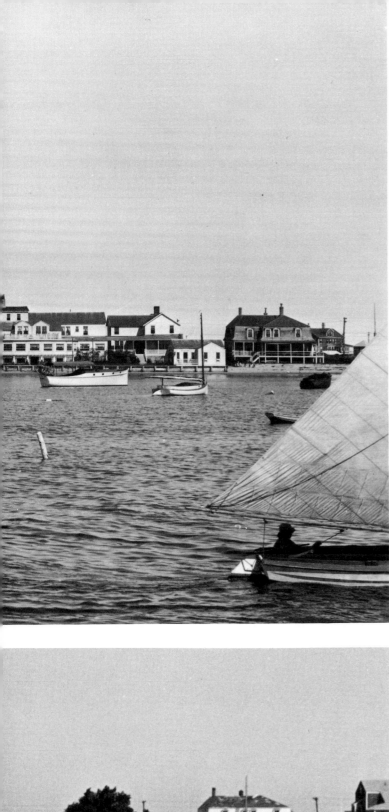

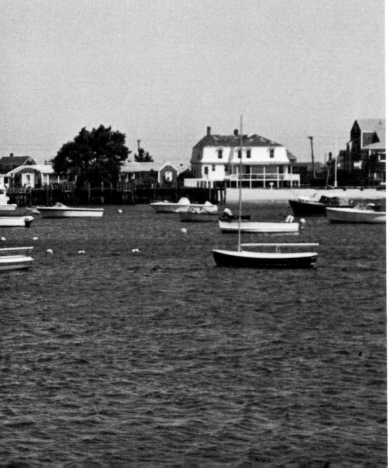

The White Elephant Hotel, ca. 1925 (top) **and 1975** (bottom). With the success of the Nantucket Hotel, the White Elephant, incorporating various old houses and buildings, was put together near the Children's Beach and the new Nantucket Yacht Club. The old hotel was taken down in the 1960s and replaced with a modern hotel with guest cottages and swimming pool. Again it is clear that the scale of buildings on Nantucket has not changed over the years, keeping intact the harmony that existed in the past.

THE HOTEL ERA 29

Chapter III

SUMMER HOMES

A new trend in Nantucket's resort business began in the last decade of the nineteenth century with the movement toward individual family summer homes, a movement that eventually led to the preservation of Nantucket's heritage. Basically, the summer-home trend took two forms: the construction of new houses reflecting contemporary architectural styles, and the renovation and preservation of old Nantucket houses. The summer-home movement on Nantucket was not stimulated or executed by land developers selling lots in subdivisions. On the contrary, it was a slow, gradual movement on the part of individuals, many of whom had vacationed on the island for years before buying property. This movement continues today and is being augmented by new year-round residents who find Nantucket winters more acceptable than the conditions in many of our Eastern cities.

The first summer homes were built along Cliff Road on the high bluff overlooking Nantucket Sound where they had an excellent view and were within walking distance of the center of town and the beach on the north shore. These first summer homes had uninterrupted access to the beach because the Brant Point–Hulbert Avenue area was completely undeveloped. The first homes were quite modest cottages, and many were built in the then-popular gingerbread Victorian-Gothic style. While most of these homes exist today, they have lost many of their Victorian frills, and nearly all have been enlarged with substantial changes. Unlike today, the old photographs show a public way running along the cliff in front of the houses as well as between many of them, creating an open plan with easy access throughout the area. The surroundings consisted of sand and beach grass.

Around the turn of the century the more affluent also began to build summer homes on the cliff—for the most part large, ostentatious structures designed to be operated by servants. Styles were imported from the mainland without regard to area harmony. The architecture ran the gamut from Gothic Revival through Victorian, Queen Anne, Stick Style and on to Shingle Style. One builder, apparently at a loss for a single motif, combined all possible Nantucket architectural features into one house, including a crenulated chimney and two gambrel roofs. Reflecting the conventional taste of the new American bourgeoisie, these homes were surrounded with trees and shrubs and set off by landscaped lawns and flower gardens. The public way at the edge of the cliff disappeared and several of the public ways between houses were usurped by abutters. The tone of the neighborhood changed from one of open summer cottages to a closed area of carefully maintained private estates.

Shortly after the summer-home development along the cliff, other areas of the island were also built up with similar homes. The bluff at Siasconset, from the old village north to the lighthouse, followed much the same architectural patterns as the Cliff development. There, however, the old public way along the Bluff in front of the homes was preserved, and today it provides a scenic (but nearly hidden) path overlooking the Atlantic. The beach area between Brant Point light to the west jetty, running along Hulbert Avenue, underwent another such summer home development, populated by those more inclined to water sports.

These three areas, Cliff Road, the Siasconset Bluff and what came to be known as "Beachside," were the principal groupings of summer homes on the island. The architecture of all three represent the differing tastes of jaded businessmen uncommitted to the rehabilitation and preservation of historical structures. Only a few exceptions exist, where old Nantucket houses were moved into these summer-home compounds. Summer homes were also scattered in a few other parts of the island, but not in concentrated groups. The taxes derived from the homes and the incomes generated from their maintenance and service provided a substantial share of the island's tax receipts and personal income. Unlike income from tourists, the revenues from summer-home owners

was dependable and the properties tended to remain within families.

Although there was considerable overlapping, the three principal groups of summer residents had different recreational interests. The Cliff Road group, social and golf-oriented, contributed to the development of the island's several golf clubs. The Siasconset Bluff group, tennis-minded, established the 'Sconset Casino, the island's principal tennis club (which doubles as a cinema after dark). The Hulbert Avenue–Beachside group, sailing enthusiasts, converted the Nantucket Athletic Club into a yacht club. With its central location on the harbor adjacent to Steamboat Wharf, the Nantucket Yacht Club has over the years been the social center of the island's summer residents. In addition to its intensive sailing program, tennis has become very popular and the "knife-and-fork set" is kept happy with daily luncheons, buffet suppers and weekly dinner dances, to say nothing of numerous special events.

A considerable number of "natives" also had modest summer homes, most of them scattered about the fringes of the island where the principal recreation was fishing and hunting. Enclaves of small cottages emerged at Madaket, Surfside, Quidnet and on Nantucket's satellite island of Tuckernuck.

Nantucket benefited most from still another, and larger, group of summer and year-round residents: those who revered Nantucket's old, historic homes. This group contained many professionals, artists and men of letters. It also included a substantial number of retired people who chose the quiet, graceful life of the island in preference to the confusion and ugliness of the industrial centers from which they came. While a few Nantucket natives still occupy old houses, most of the historic houses have come into the hands of these "off-islanders."

During Nantucket's depressed years not a few old houses were lost. Some burned, some were shipped to the mainland, but most were victims of neglect. It is a pity that many of those lost were among the oldest. The old photographs show some of the seventeenth and early eighteenth-century homes that have disappeared. There simply was no market for them as the population declined during the latter half of the nineteenth century. Some houses were turned into barns or used for other ignoble purposes; others were taken apart for their materials and became additions to newer houses. There is simply no record of the fate of others. But in about 1900 the situation began to change; many people looking for summer homes discovered the virtues of the old homes and the renovation movement was initiated.

The ancient fish shacks at Siasconset attracted a theatrical crowd which not only restored the shacks, but developed them into a whole colony of summer homes. They even named the principal (and very narrow) street "Broadway." Those who renovated the fish shacks and the more imposing homes in Nantucket town found the old houses comfortable, charming, quite functional and a respite from their productive life in the cities of the mainland. The lucky ones bought old houses in the first half of the twentieth century when prices remained low and the supply adequate. Today, Nantucket's old homes are priced and cherished as antiques, and occupancy is nearly 100 percent. Now there is no doubt but that Nantucket's old homes will be preserved regardless of what may happen to the rest of the island.

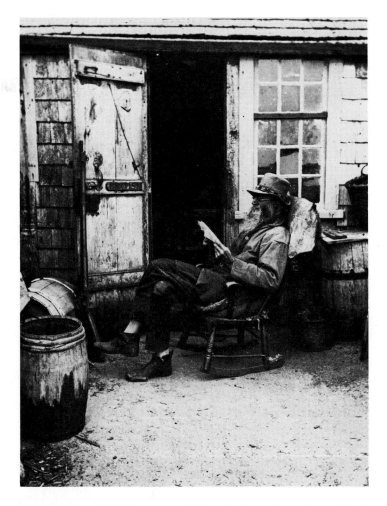

Fred Parker, the Hermit of Quidnet, Gets Away from It All, ca. 1870.
The attraction of summer on Nantucket was, and still is, something more than being close to water sports and in a cooler climate than the hot and humid mainland. The charm is to drop out of the mainstream of the American industrial-commercial environment, to step back into the past when life was simpler, the distances were smaller, time was longer and the open spaces were there for everyone to enjoy. This Elysian potential is today threatened by the automobile; its rigorous control is imperative.

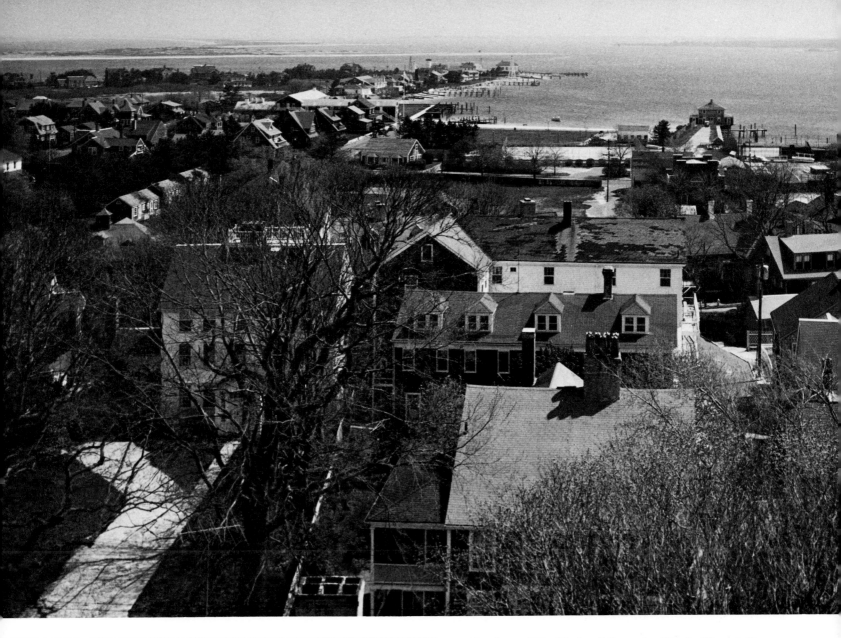

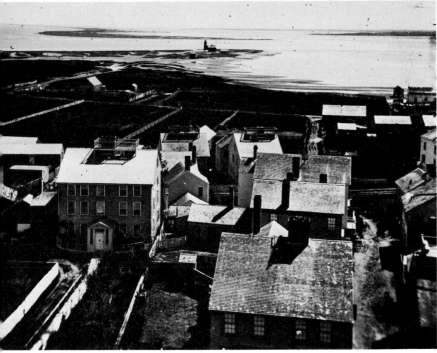

Northeast "Up Harbor" from the North Church Tower, ca. 1875 (left) and 1975 (above).

A century ago there was no evidence of summer homes, hotels or recreation facilities. Hulbert Avenue (to the left of the lighthouse) was a sandy slough that flooded at high tide. All of Brant Point up to Haydon's Bath Room (waterfront, extreme right) was fenced-off farmland, and the town ended at North Water Street (running left to right, center). Today this same area is built up with summer homes and tourist facilities. Recreation is evidenced by the Children's Beach (center waterfront) and the Nantucket Yacht Club property abutting to the right. A portion of Haydon's Bath Room still serves the yacht club as a service building and dormitory for summer employees.

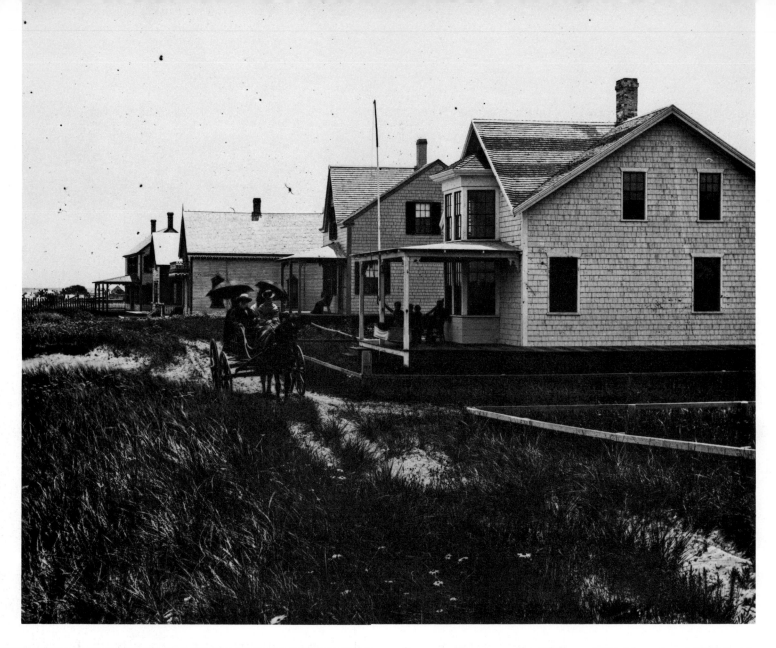

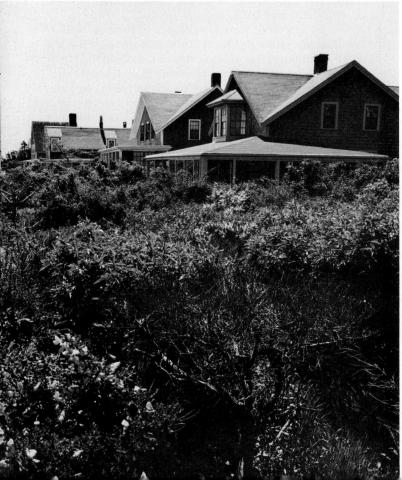

Summer Homes on the Cliff, ca. 1880 (above) **and 1976** (left).
The first summer homes on Nantucket were on the Cliff, over-
looking Nantucket Sound. The house on the right, 9 Grant Av-
enue, had been moved to its present location in 1874. The sur-
rounding area was then open and dominated by sand and beach
grass. A public way, now gone, ran along the Cliff in front of
the houses.

Opposite: **Summer Homes on the Cliff, ca. 1890** (top) **and 1976**
(bottom).
Although most of the homes on the Cliff were built there as
summer residences, some, including the old Nantucket house
at the center of the 1890 view, were moved from other parts of
the town. Today the area has changed considerably; landscap-
ing, fencing and remodeling have created small estates.

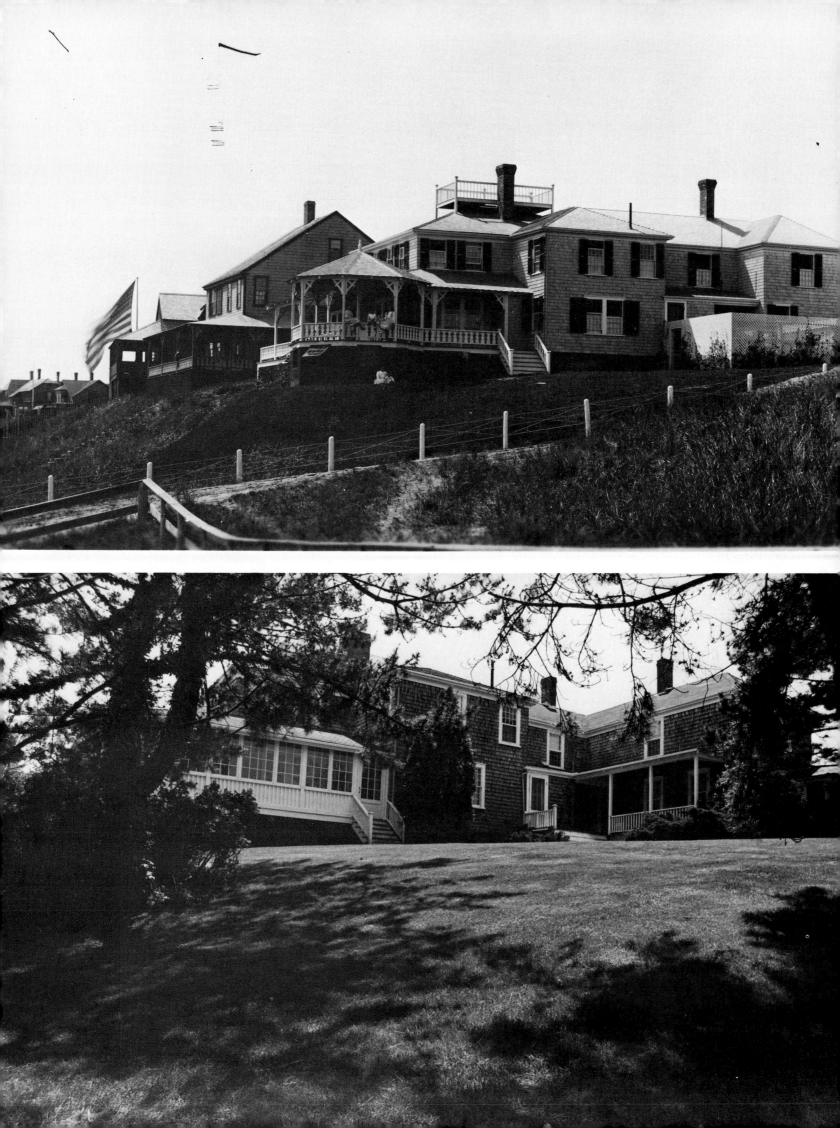

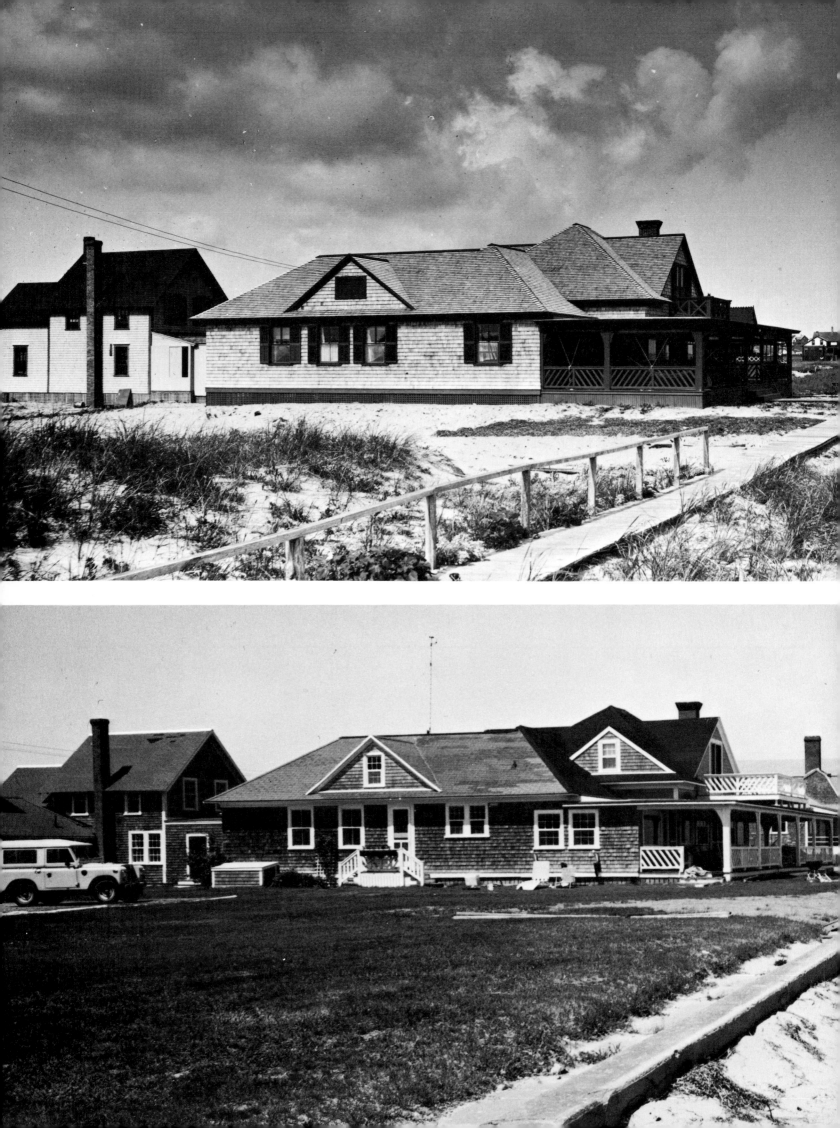

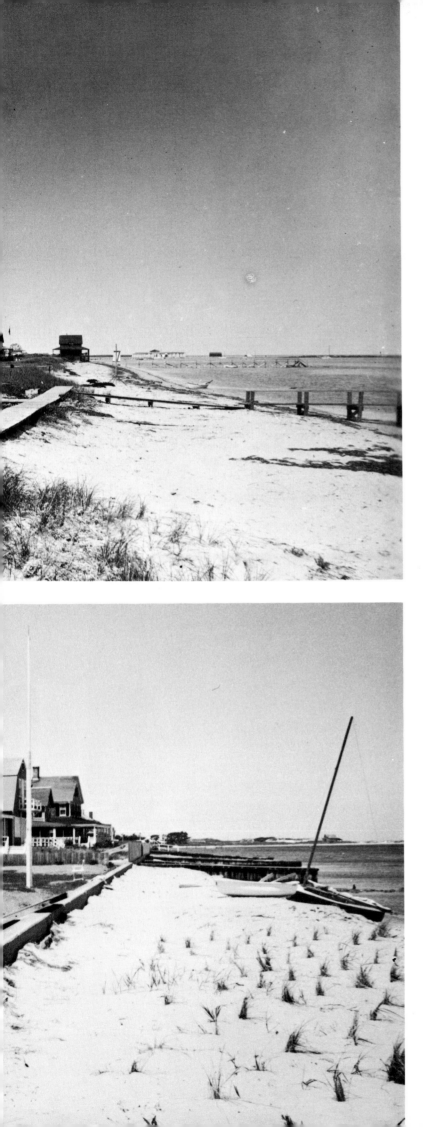

The Atkins Cottage, Beachside, ca. 1910 (top) **and 1975** (bottom).

Starting with the construction of the Nantucket Hotel in 1883–84, the area along Beachside was filled in, making it possible to build on land now secure from flooding. The whole beach is now lined with summer homes, but, unlike the Cliff, there has been only a minimum of landscaping and planting. Beachside has retained a more open configuration reminiscent of earlier times.

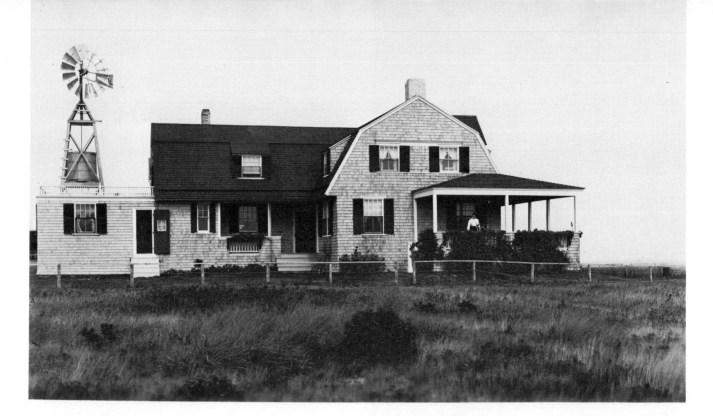

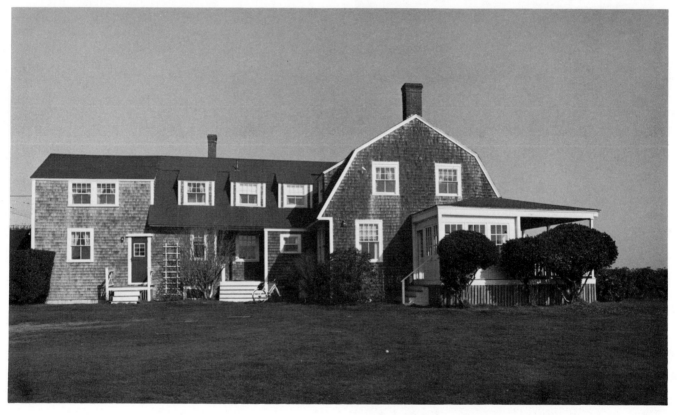

Summer Home on the 'Sconset Bluff, ca. 1915 (top) **and 1975** (bottom).

A large compound of quite substantial summer homes was built along the bluff between the old village and Sankaty Lighthouse. Most of them have been little changed over the years except for minor additions. A public way in front of the summer homes along the bluff overlooking the Atlantic Ocean has survived here.

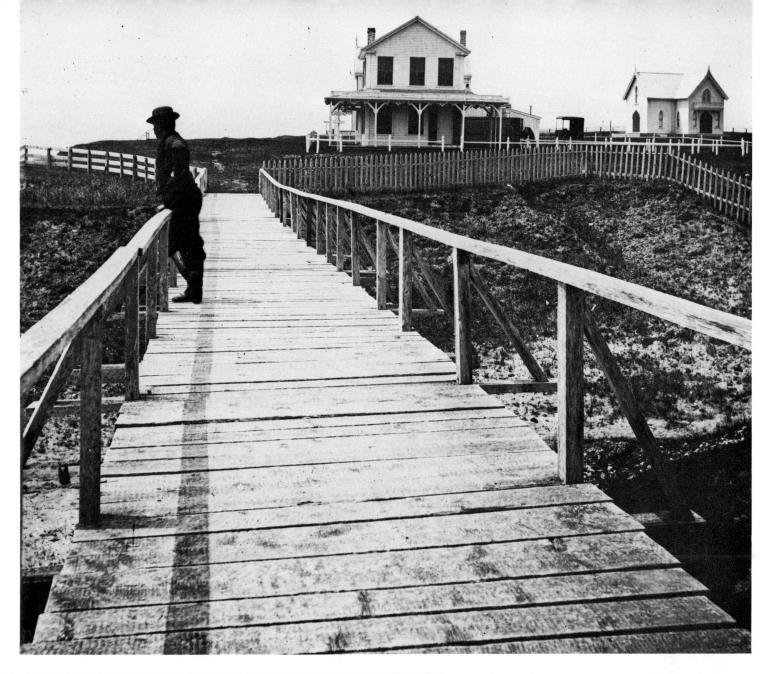

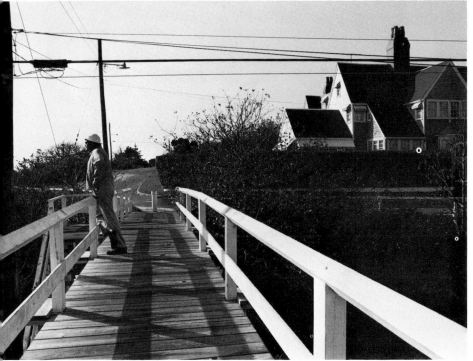

The Bridge at Siasconset and the Charles H. Robinson Cottage, 1873 (top) **and 1975** (left).
The bridge over the "gulch" at Siasconset has been reconstructed several times since it was built to help promote a real-estate development to the south of the village (background). Although the bridge remains much the same, the development had to await the coming of the automobile. Then the more affluent summer residents built pretentious homes that copied the "Newport Cottage" style popular on the mainland.

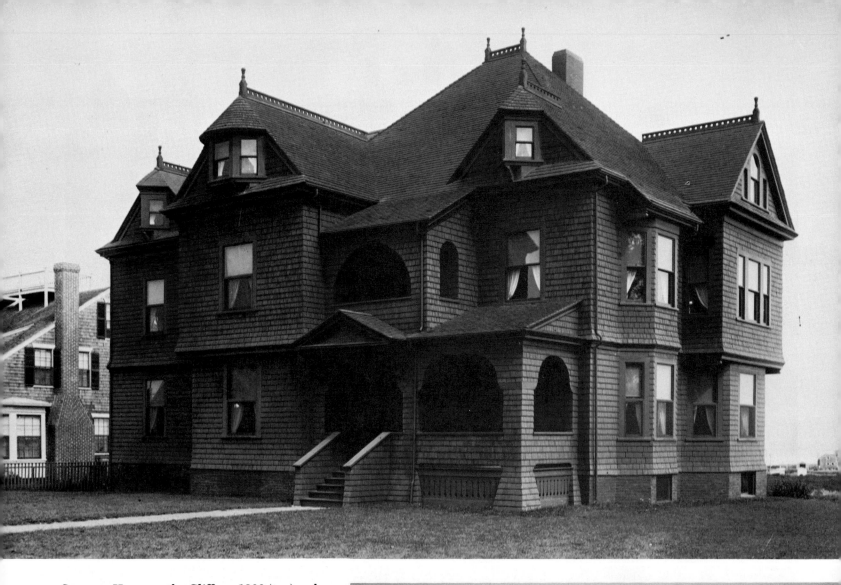

Summer Home on the Cliff, ca. 1900 (top) **and 1975** (bottom).

By the turn of the century larger and much grander homes were going up on the Cliff. Their grounds were landscaped and planted; the sand and beach grass disappeared. Over the years most of these homes have been little changed except for the loss of some frills (in this case roof trim and bay windows on the third floor). The style is one that was popular for residences in many Eastern cities in the 1870s and 1880s.

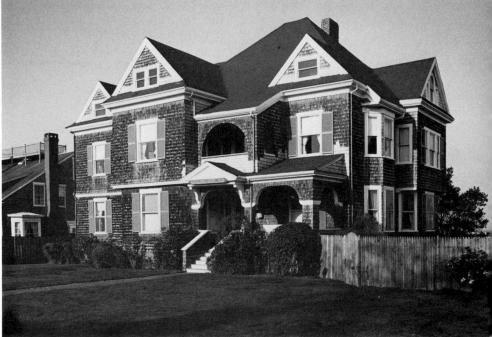

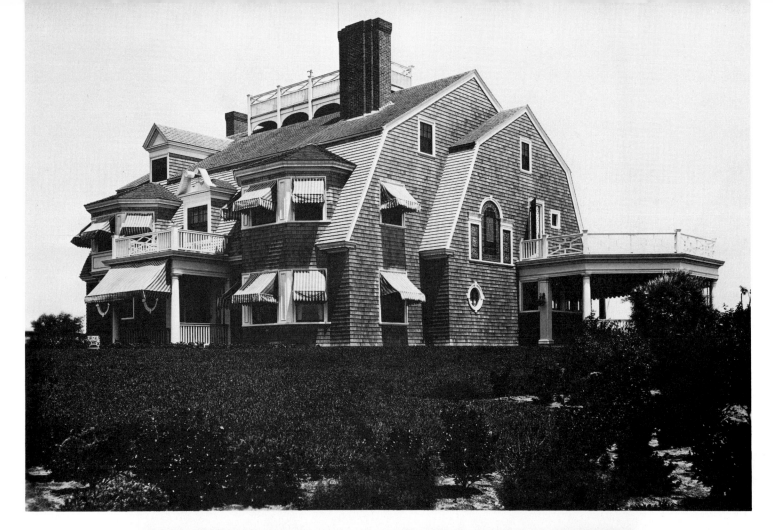

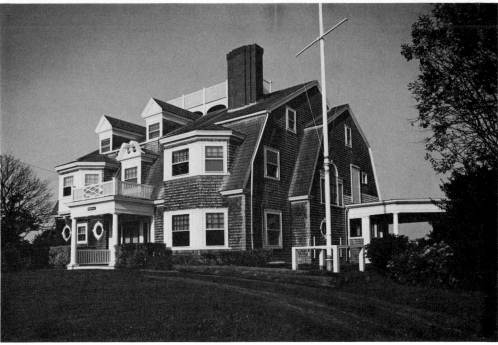

Summer Home on the Cliff, ca. 1910 (top) **and 1975** (bottom).
A simply incredible mixture of styles was incorporated here,
as if each feature had been plucked from a different carpenter's
dream. A fancy roof walk perches behind an articulated chim-
ney which is "balanced" by a single dormer. Two gambrel roofs
are sported; the porch columns are Greek. The fenestration in-
cludes oculi, square windows, double-hung sash windows with
panes ranging from 4 over 1 to 15 over 1 and a Palladian window
with stained-glass lights. Three styles of railings grace the
porches and the roof walk, and striped canvas awnings partially
obscure the larger windows. The front of the house addresses
the street in the conventional city manner even though the view
is to the rear.

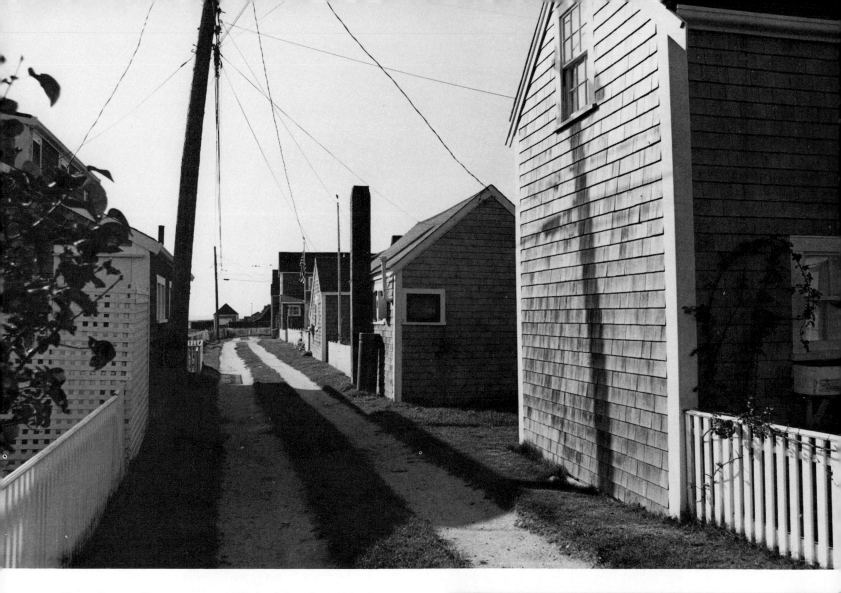

Front Street, Siasconset, ca. 1870 (right) **and 1975** (top).
It may come as a surprise to some, but much more of Siasconset
has been changed than Nantucket. Most communities have a
history of old residential areas giving way to commerce and
industry; in 'Sconset quite the reverse has been the case. The
village began in the seventeenth century as a group of fish
shacks, which they remained for two centuries. Now the village
is entirely residential. What has not changed is the scale of the
buildings; nearly all of the summer cottages are small. The boat
in the foreground of the 1870 picture is of most unusual design,
and that doll carriage would bring a good price today as an
antique.

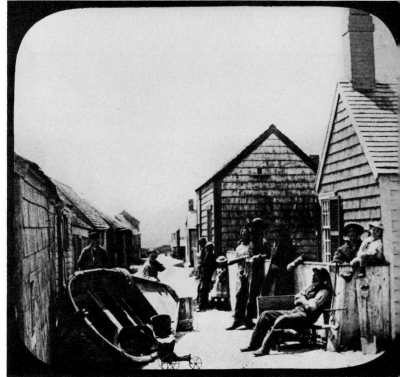

Chapter IV

PUBLIC BUILDINGS

The preservation of Nantucket's past is seen not only in the hundreds of homes that have been saved but also in the public buildings that continue to function today just as they did a century or more ago. Churches have the best survival record with government buildings running a poor second.

In the earliest times Nantucket had no established religion and, hence, no churches. Since the Quakers built meetinghouses, the construction of churches had to wait until the nineteenth century when the Society of Friends broke into dissenting groups and the larger Protestant sects took over. In most New England towns the churches face a large open town square since they laid claim to this prime property when the towns were established. On Nantucket, however, all the churches were built long after the town was well established, so they had to squeeze in wherever a lot might be available. Thus Nantucket's churches are scattered about the town and are wedged in between homes and other buildings with little or no room for lawns, cemeteries and the other appurtenances usually found with New England religious establishments.

All but three of Nantucket's churches have been preserved, for the most part, with little change. Even three Quaker meetinghouses have been saved, but only one—now the Historical Association's Fair Street museum—in anything like its original condition. Another meetinghouse now serves as the dining room annex to the Roberts House. A third originally stood on Main Street. In succession it became a social hall, a straw factory, a part of the old Nantucket Hotel and finally was moved to South Water Street to serve first as a lodge hall and now as the "Dreamland Theater," the most appropriately named cinema in the United States.

Nantucket lost the Trinity Church and the Universalist Church (Atheneum) in the great fire of 1846. St. Paul's Episcopal Church was torn down and replaced in about 1900 by the present structure which, unfortunately, re-flected the conventional taste of the new, affluent summer residents rather than Nantucket's tradition. The Old North Vestry was built in about 1725 as a Presbyterian church among the original homesites outside of town. It was moved into town and became part of the First Congregational Church; the latter was built in 1834. Nantucket's centerpiece is, of course, the gold-domed clock tower of the South (Unitarian) Church (1809–15) which today continues to toll the hours. The architecture of Nantucket's churches ranges all the way from the simple meetinghouse style of the Old North Vestry through the neo-Gothic of the Congregational Church, the Greek Revival of the Methodist's place of worship, to the Romanesque style of the Episcopal Church. Until late in the nineteenth century, Nantucket's Catholic population was small; the last church to be built was the Roman Catholic Church which was jammed into a small lot next to the post office. The African (black Baptist) Church, dating from 1823, still stands on the corner of Pleasant and West York Streets. It deserves restoration, if for no other reason than to remind everyone that, in the past, Nantucket, too, practiced segregation.

Government buildings, with one exception, fared less well than the churches. The Atheneum was one of the first buildings to be rebuilt after the destruction of the fire of 1846. The job was well done in the then-current Greek Revival style. The handsome building, originally used as a lecture hall and museum, has been the town's public library since 1900. On the other hand, other actions of the town fathers and the Federal Government have not made much of a contribution to the preservation of public buildings. The town fathers, heavily committed to a philosophy of laissez-faire, managed to limp along until 1968 without a proper town building. An old Town Building stood on the southwest corner of Main and Milk Streets until about 1830. It was not kept in good repair and was taken down. In 1836 the town bought half of a two-story brick commercial building fronting on both

Washington and Union Streets and installed the town offices there. Apparently these rather small quarters were deemed adequate for about half a century. Then, in 1884, the town bought the other half of the building and included the police station and two jail cells in the enlarged quarters. The Old Gaol and the House of Correction on Vestal Street were maintained as auxiliary lockups. Since over most of this period the population of the town declined, apparently these minimal accommodations were no serious handicap.

In the 1960s, however, the town functions (if not the population) had grown considerably, and the old double store could no longer house all the town offices. For a period, several town functions had to be installed in converted residences and commercial buildings in various parts of the town. Finally, in the mid-1960s the town razed an old historic home and built a large, Georgian-style brick Town Building with about six times the area of the old building on Washington Street. Whether this says more regarding the requirements of local government in the latter half of the twentieth century or about the fact that the principal employment of Nantucketers is in the building trades is hard to determine. Subsequently, the Old Town Building on Washington Street was restored under a grant from the Nantucket Historical Trust. It now serves as the headquarters for the Nantucket Historical Association.

Among the interesting historic buildings preserved on Nantucket are lodge halls. Derived from medieval guilds, lodges proliferated in America in the second half of the nineteenth century, especially among wage earners and the petite bourgeoisie. Although most of the lodges were no longer associated with the protection of specific crafts or businesses, they served to provide fellowship, ritualistic honors and, for Protestants, substitute vestments and pageantry for those lost in the Reformation. But they had a more practical function: they provided a form of social security. Insurance and consumer credit, which we tend to take for granted today, were not available to wage earners and others in low-income brackets until well into the twentieth century. Although national social-security systems were introduced in other countries as early as the 1870s, the United States had no such program until the administration of Franklin Roosevelt. To obtain at least a minimum of insurance and some measure of social security, many found the mutual assistance arrangements of the various lodges their only answer.

Most lodges built meeting halls, usually among the more prominent buildings, especially in smaller communities. In 1802, the Freemasons built one of the earliest and handsomest Nantucket lodge halls on Main Street adjacent to the Pacific Bank.

It is hard to decide whether the cause of preservation and conservation is hampered more by myopic commercial interests or the mindless bureaucracy of government. While we find commercial interests willing to tear down historic buildings for parking lots, we also find the government involved in similar desecrations. The Federal government was so enthralled with efficiency and so unaware of community traditions that it recently removed without warning the lamp house from Sankaty Light, a historic guide to mariners constructed in 1849–50. On the truncated tower an aircraft-type beacon was installed, changing the whole character of the old light. Only a catholic and vociferous appeal to the highest levels of Washington bureaucracy succeeded in having this monument restored. And yet there are always exceptions. When the government built a new post office for Nantucket during the Great Depression, the town received a handsome, well-proportioned and aesthetically pleasing structure that continues a half century later to complement the center of town.

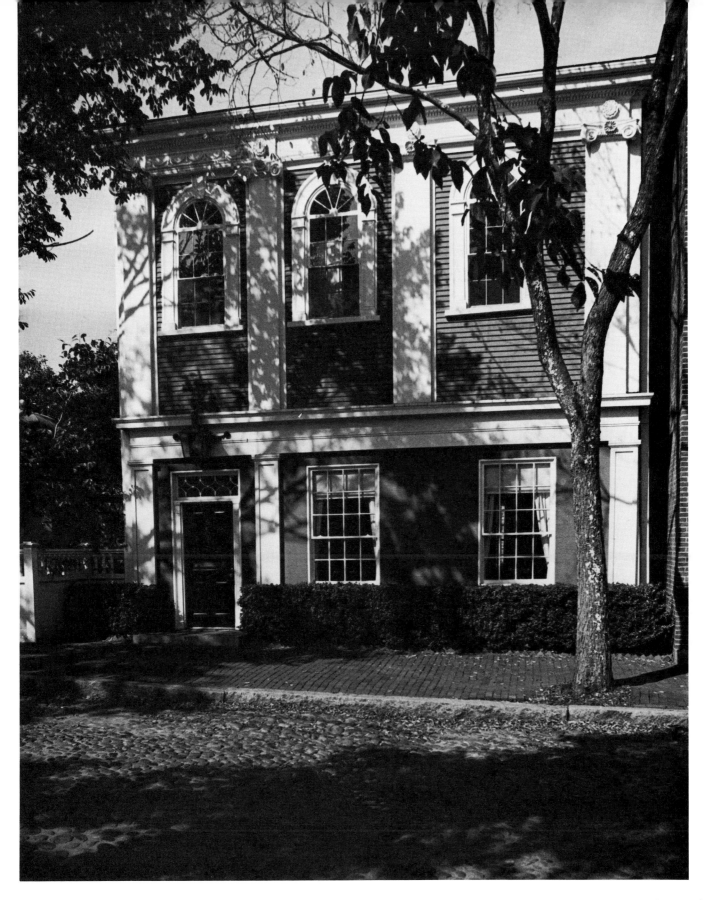

The Masonic Hall, Main Street, 1975.
Public buildings have a better survival record than commercial structures, but the fight for survival is always sanguinary and sometimes lost. This lodge hall was built by the Freemasons in 1802 abutting the Pacific Bank. Originally it had five bays, but it lost two of them in 1872 when a house (since razed) was built on a lot to the left. The lodge was sold into trade by the Masons and for many years housed one business after another, including the Western Union telegraph office. Abandoned in the 1960s, it was saved from becoming a parking lot by the Historic Districts Commission. Now the lodge hall has been beautifully restored by the Pacific National Bank to house the bank's trust department.

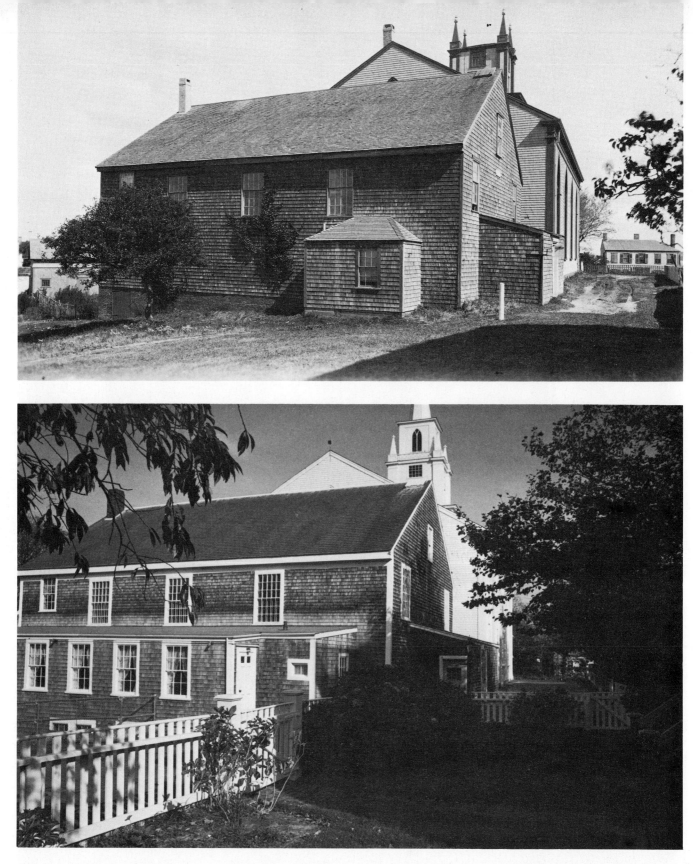

Above: **The North Shore Meetinghouse, ca. 1900** (top) **and 1975** (bottom).

The building in the foreground is Nantucket's oldest church, having served as a place of worship for over 250 years. Built in about 1725 for the Presbyterians in the area of the original settlement west of the present town, it was moved to the new town area in 1765 as Nantucket began to prosper from the whaling industry. The building was moved again to the rear of the new church when the latter was built in 1834. Although additions have been made to all sides of the building, the central hall remains largely unchanged. It serves as winter quarters for the present congregation, and it is a popular place for weddings.

The North Church (Congregational) stands in the background.

Opposite: **First Baptist Church, ca. 1900** (top) **and 1975** (bottom).

The frame for the church was shipped to Nantucket from Maine and the building was erected in 1840. When it became necessary to replace the steeple in 1962, the original design was copied. The typical Nantucket house to the left of church was built in about 1790. The exterior today shows no change except for the removal of shutters. In this century a number of barns and other outbuildings, such as the barn to the right in the 1900 photograph, have been converted into homes.

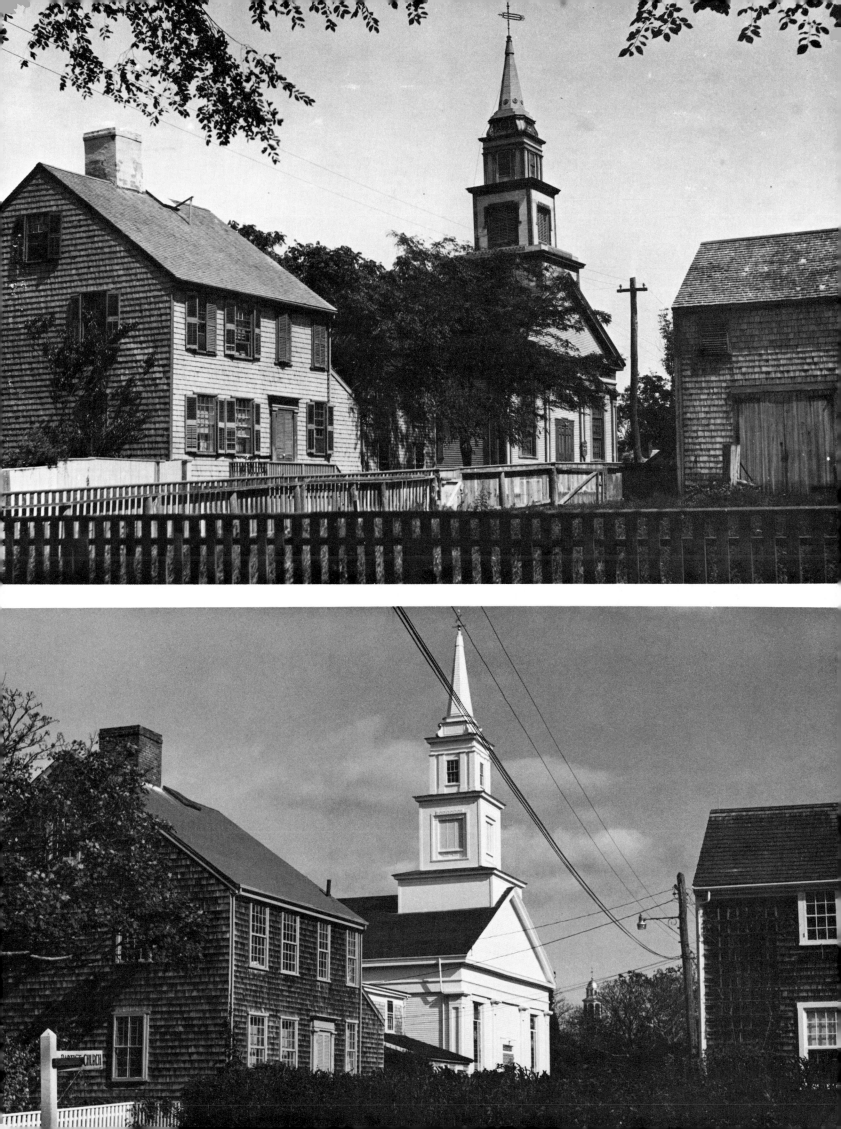

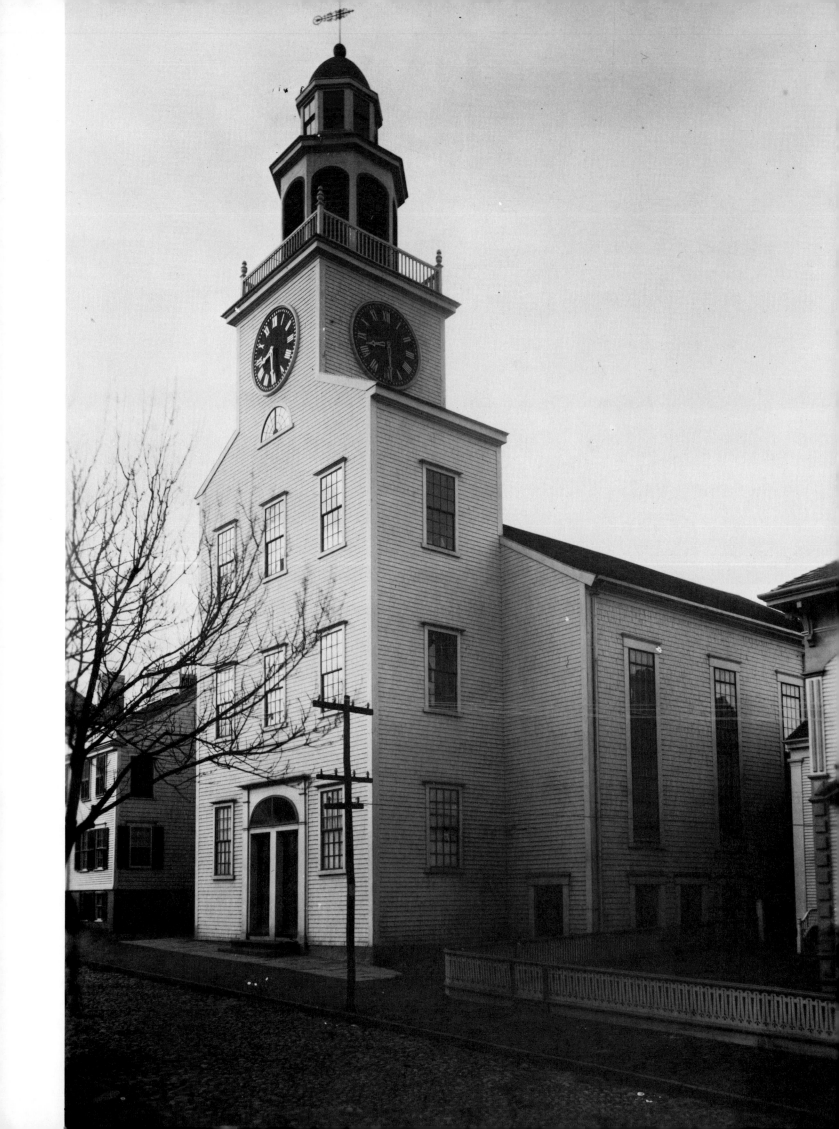

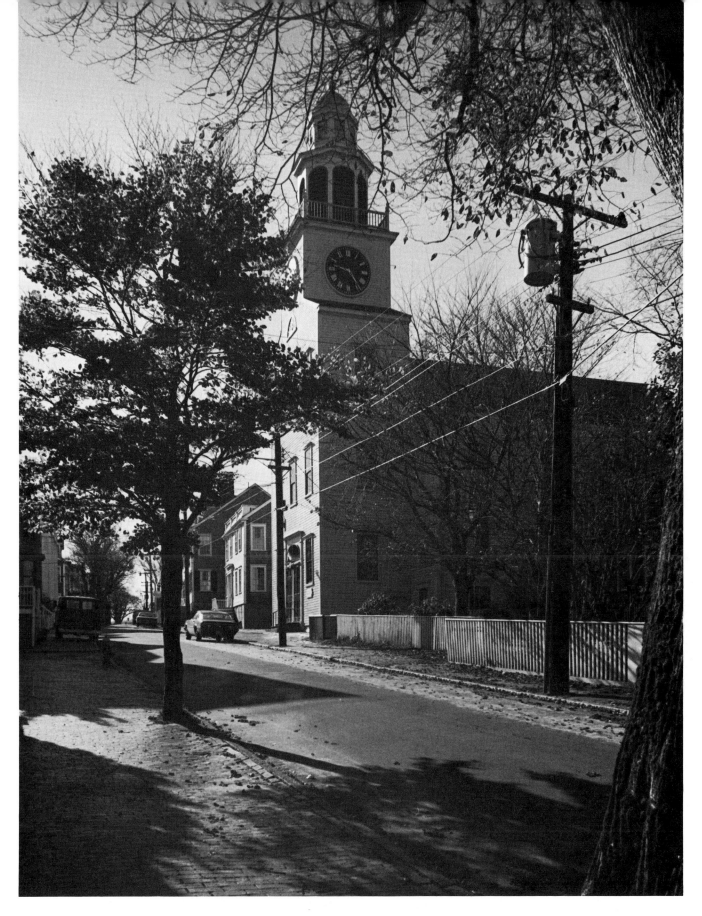

**The South Tower (Second Congregational Church), ca.
1890 (opposite) and 1975 (above).**
This church, built in 1809, remains the most prominent
feature of Nantucket's skyline. The church's bell was cast
in Lisbon, Portugal, in 1810. The clock, installed 13 years
later, has become the "town clock." The tower for many
years accommodated the town's fire watch. The audito-
rium has excellent acoustics and is used in summer for
concerts of classical music. The church now belongs to
the Unitarians, who hold services here both summer and
winter.

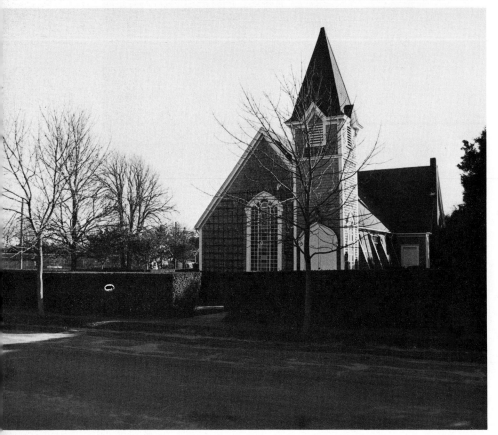

Left: **The Siasconset Chapel, ca. 1890** (top) **and 1975** (bottom).
The small population of 'Sconset never rated its own churches; in the summer services are held in this pan-denominational chapel. Over the years the ornaments have been removed and a door replaced the window in the tower. An ell was added to the rear and, most unusual, butresses were added to shore up the west wall. The area around the chapel was clearly agricultural in the early photograph.

Opposite: **Sankaty Lighthouse, ca. 1870** (top) **and 1975** (bottom).
Sankaty light has guarded Nantucket's east coast since 1850. It is unfortunate that the government did not see fit to preserve the old brick keeper's cottage; certainly the present nondescript buildings are anachronistic. Only in the last few years have the government and some businesses given attention to the preservation of our heritage.

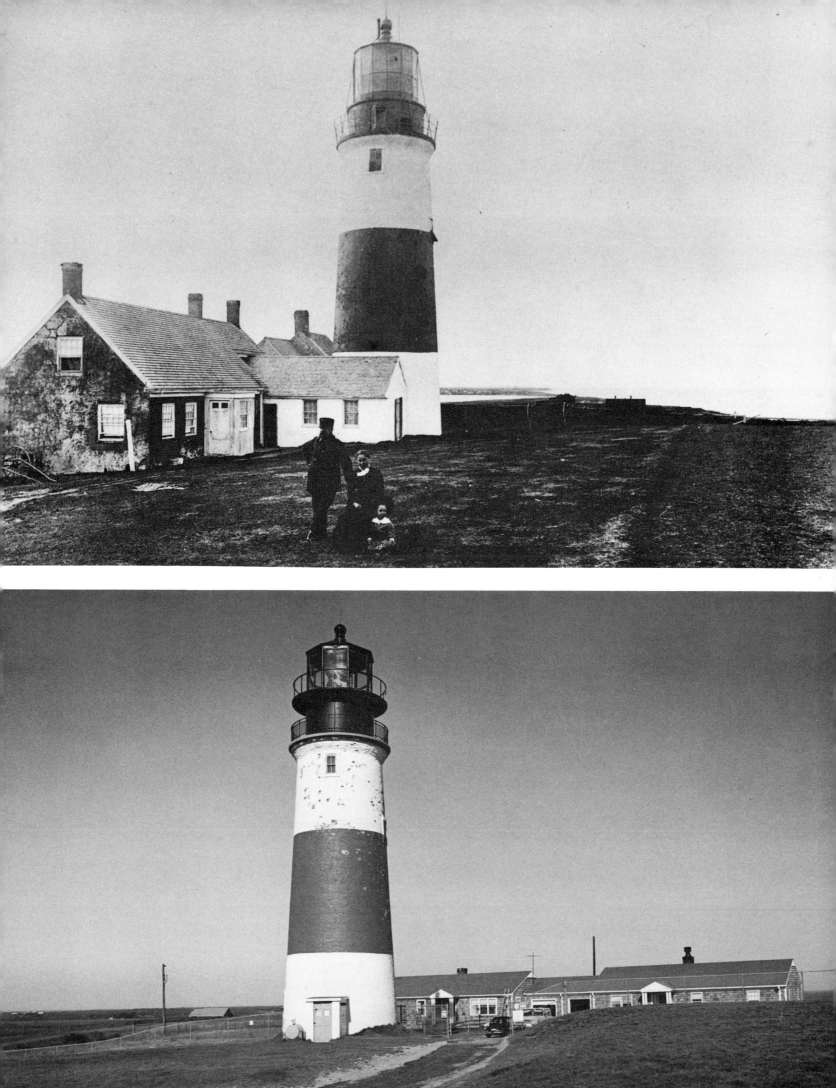

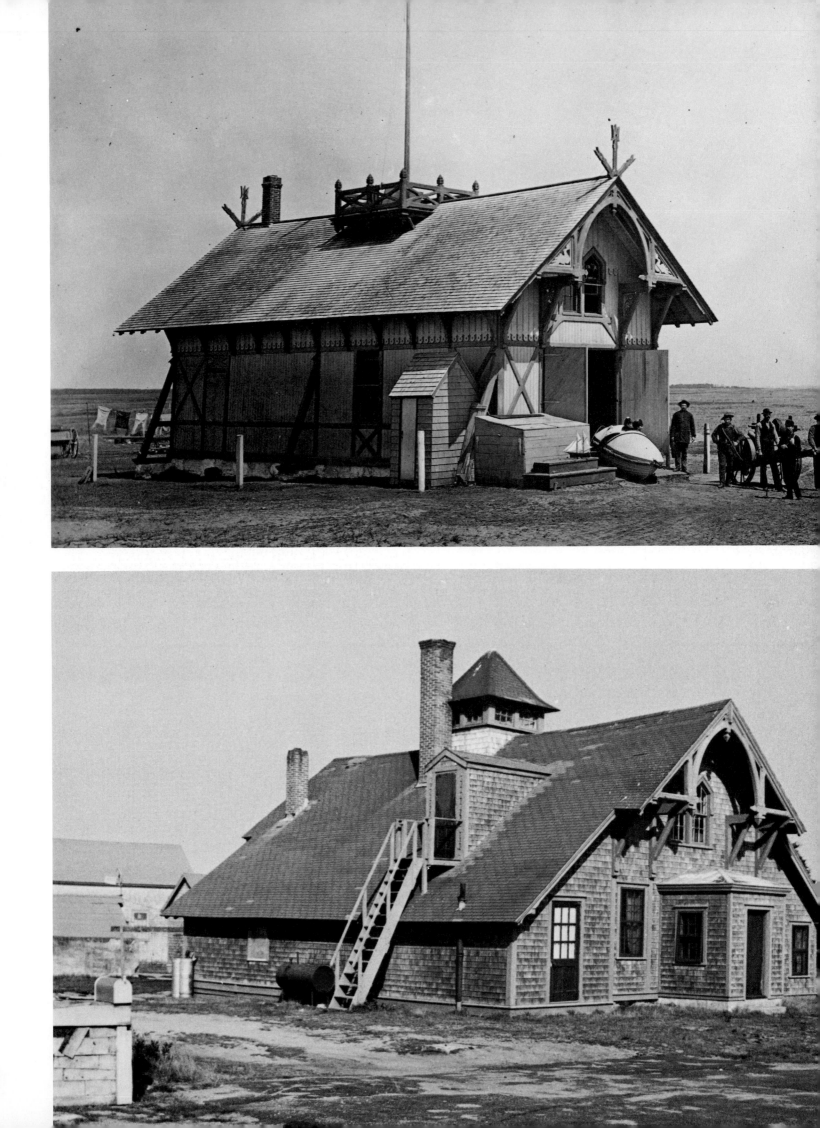

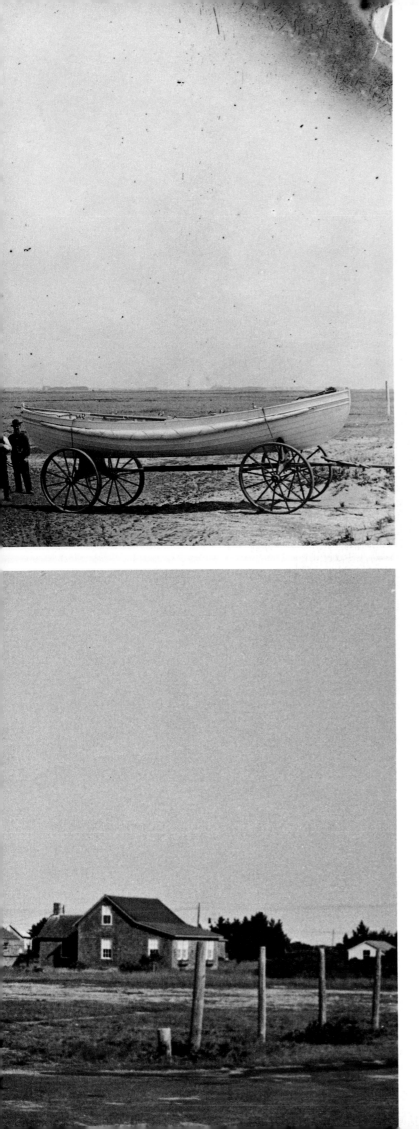

The Lifesaving Station at Surfside, ca. 1875 (top) **and 1975** (bottom).

By the second half of the nineteenth century sailing ships had become second-rate vessels, often sailing with inferior aids to navigation and shorthanded crews. Consequently, wrecks, strandings and sinkings were frequent, with the loss of life heavy. The federal government established the Lifesaving Service in an attempt to reduce fatalities and salvage cargoes. Combination boathouse–dormitories were built at intervals along exposed coasts. Several guarded Nantucket where the surrounding shoals claimed many ships. The Surfside station, enlarged and shorn of some decoration, now serves as a youth hostel, but a copy of the station has been built off the Polpis Road where it houses a museum of the Lifesaving Service (page 147).

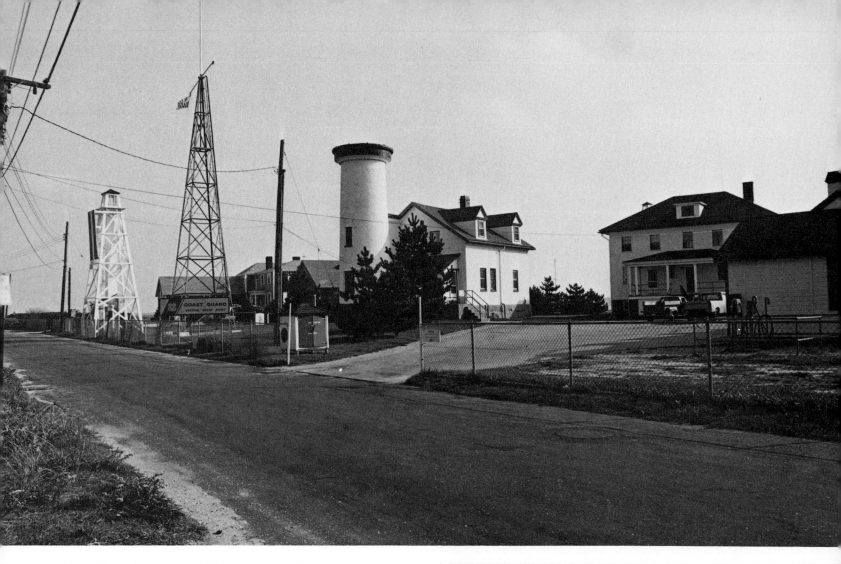

Brant Point Light, ca. 1870 (right) **and 1975** (above).
There has been a light at the entrance to Nantucket Harbor for
over 230 years. The lighthouse, the second-oldest in the United
States, has been rebuilt several times, and the present light is
low and out of sight to the left. When the old picture was taken,
the light was reached over marshy bottoms that flooded at high
tide into what is now Hulbert Avenue. The hipped-roof build-
ing to the right in the 1975 photograph was once part of the
Lifesaving Station at Coscata; it was floated on a barge to its
present location by the Coast Guard.

Opposite: **The Atheneum, ca. 1875** (top) **and 1976** (bottom).
The Atheneum was originally the Universalist Church which
came to be used as a "library society" in the first half of the
nineteenth century. The building was lost in the fire of 1846.
The new Atheneum was one of the first buildings to be rebuilt
after the fire. It served the town first as a private library and
museum and since 1900 as a public library. The only changes
shown in these two pictures are the loss of the light over the
entrance and two balusters in the fences. Note the condition
of the street and the type of drains employed a century ago.

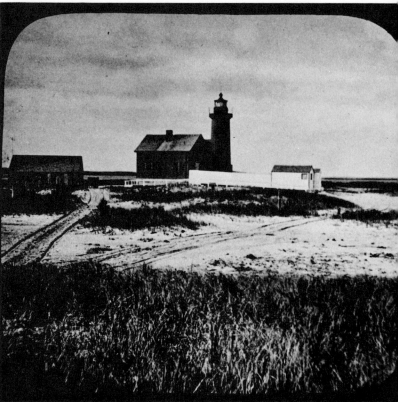

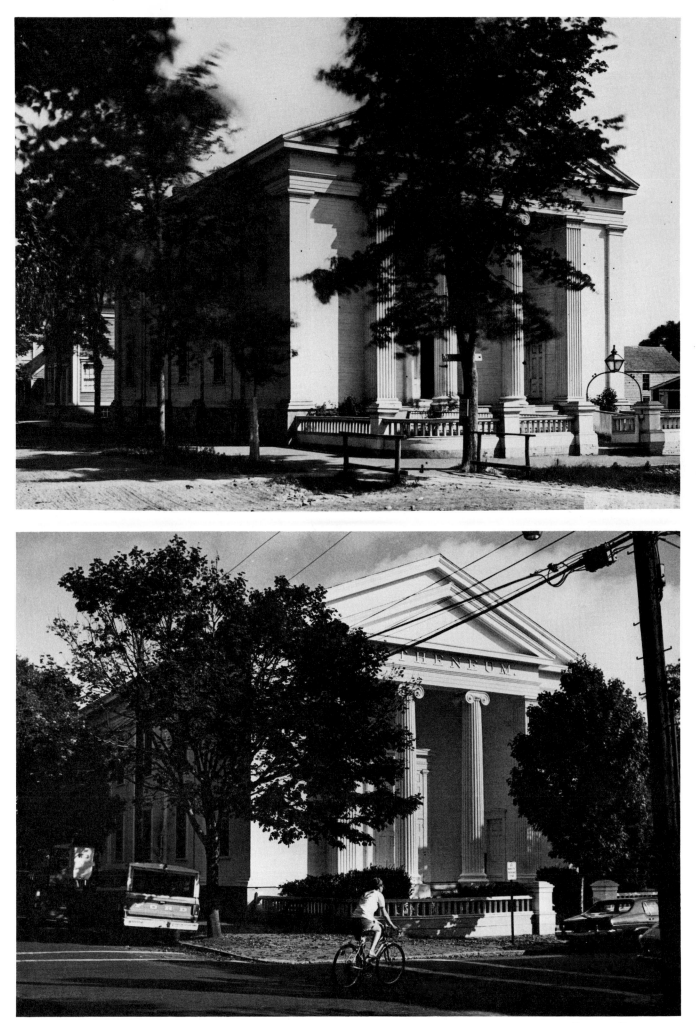

Old Gaol and House of Correction, ca. 1910 (bottom) **and 1975** (top).

Nantucket's oldest public building is the old gaol on Vestal Street. It has stood on this site since 1805, and it was used as a lockup as late as the 1930s. To the right stood the House of Correction, the women's jail, which was built in Quaise in 1805 and demolished in 1954. The old jail was given by the town to the Historical Association in 1946, and it was opened to the public the following year. Nantucket is probably the only growing community in the United States where the number of prison cells has decreased in the last century.

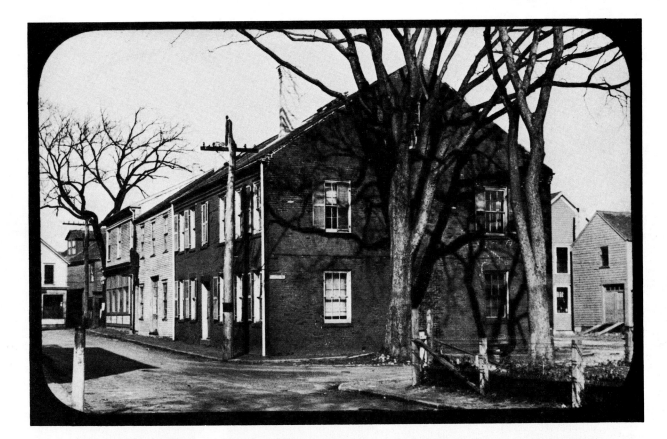

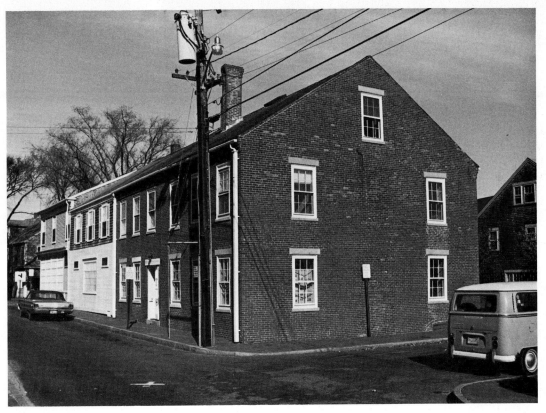

The Old Town Building, ca. 1890 (top) **and 1975** (bottom). The brick structure was built in about 1830 as a commercial building. In 1836 the town bought the south section (nearest the camera). This half-building served the town for half a century. In 1889 the town bought the remainder and installed the police and two cells in the enlarged quarters, which served the town until 1968 when the building became the property and headquarters of the Nantucket Historical Association. The interior, rebuilt after the fire of 1846, was restored by the Nantucket Historical Trust in 1969–70, with the rest of the building. It has been designated a historic landmark by the Department of the Interior.

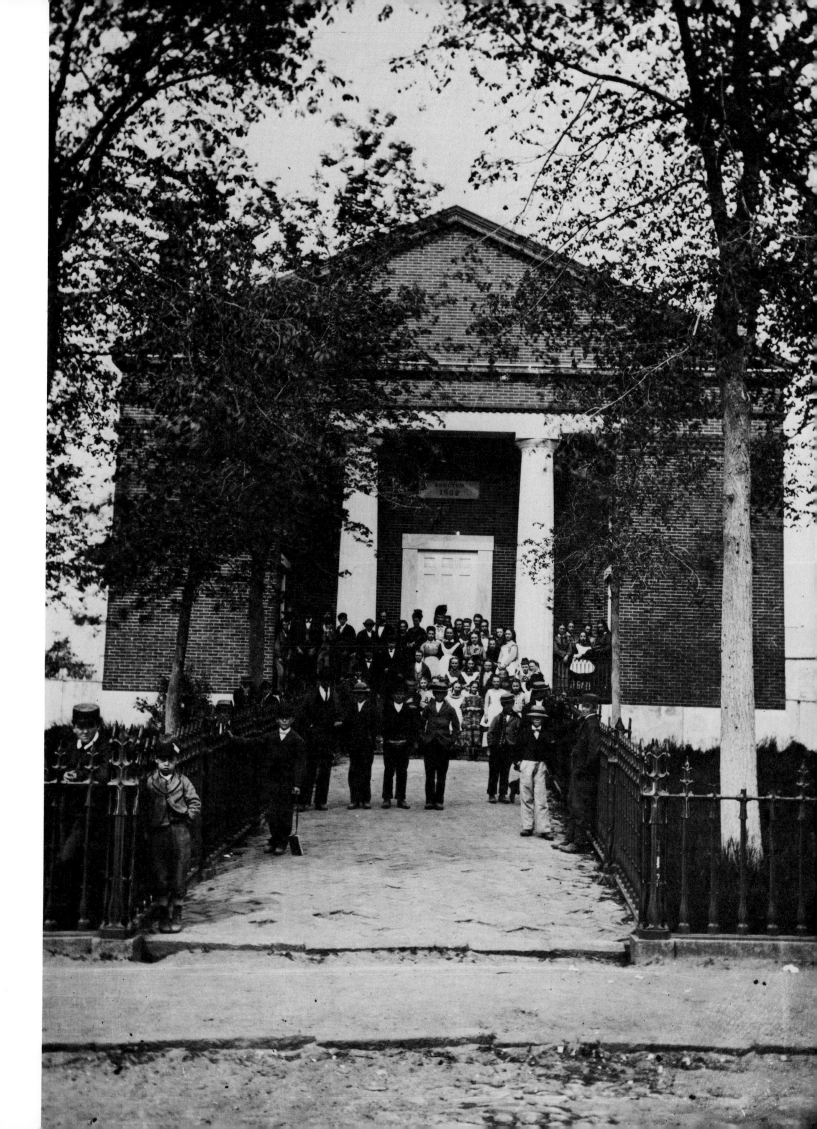

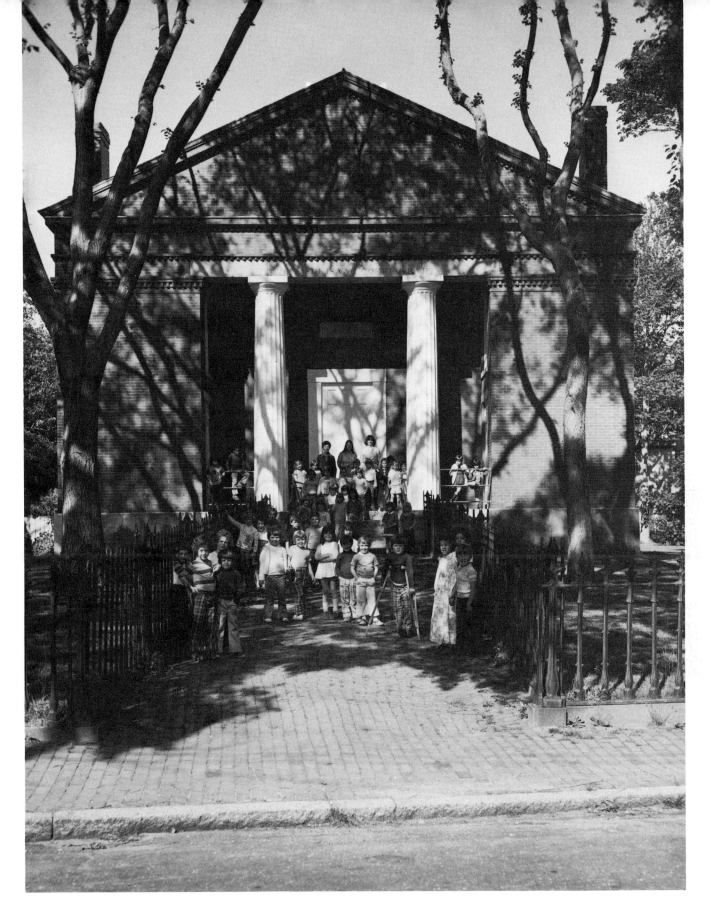

The Coffin School, ca. 1876 (opposite) **and 1976** (above).
Since Nantucket had no public schools, such education as existed had to be provided privately. In 1826 Admiral Sir Isaac Coffin visited Nantucket and gave monies to establish a school for his descendants. The Coffin school opened the following year and, fortunately for Nantucket, the Admiral had many kin on the island. The construction of a new brick schoolhouse was begun in 1852 and completed two years later. Today the school remains in the hands of Coffin's trustees; only limited use of the building by the public school system is permitted.

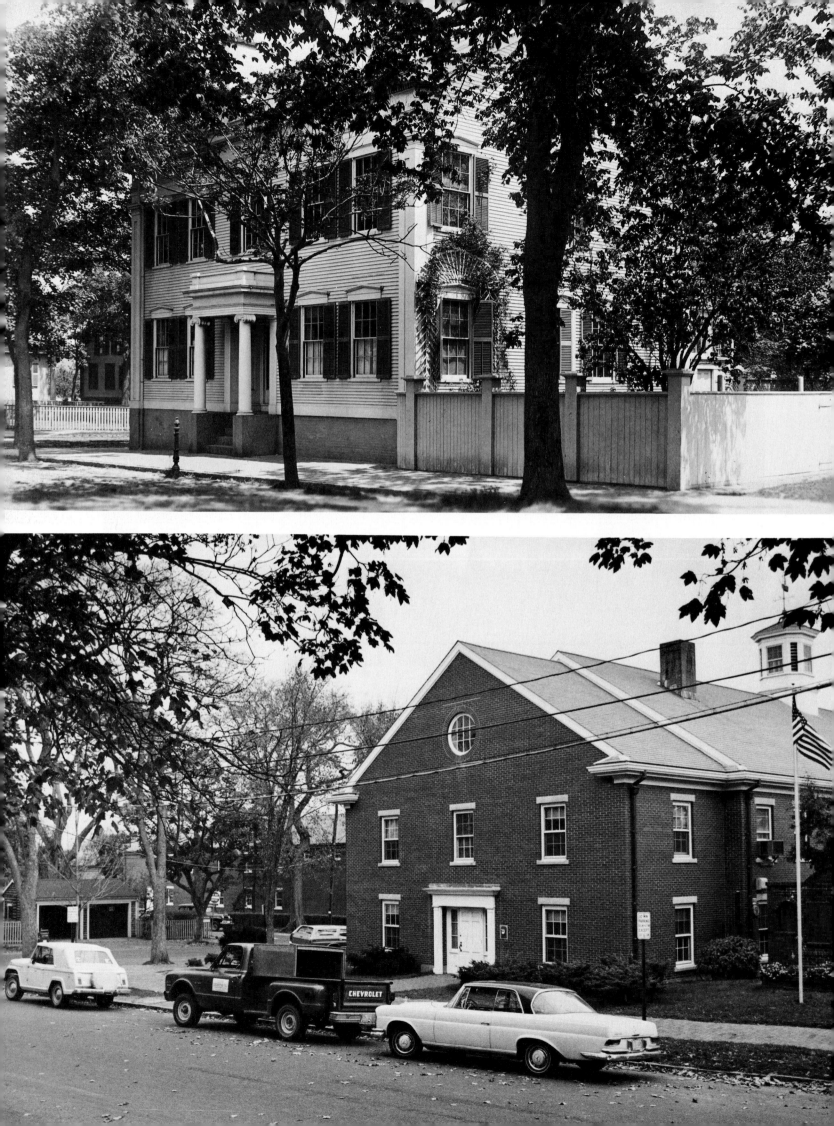

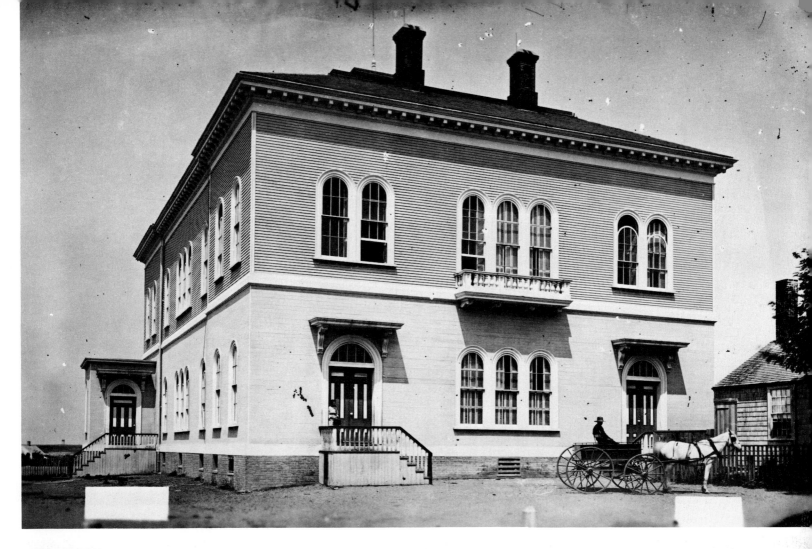

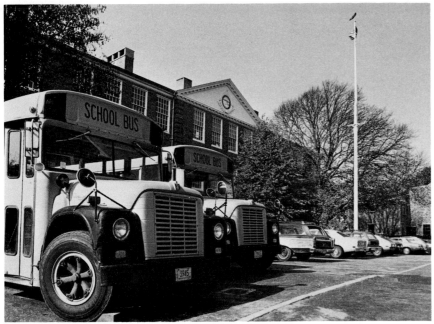

Opposite: **Sanford House, Corner of Federal and Broad Streets, 1890** (top) **and the New Town Building, 1975** (bottom).

The battle to save historic antiquities is a continuous one; sometimes a skirmish is lost. The town of Nantucket itself took down the Sanford House to make room for a large new Town Building in an action approved by the Historic Districts Commission. However, many thought the Sanford House should have been restored and similar, interconnecting buildings built to serve the town with an open plan including public park areas.

Academy Hill, ca. 1870 (above) **and 1975** (left).
In the 1850s, with the fight to desegregate Nantucket's public schools recently won, the town undertook to improve the education system. There was also a need for public spending to combat the depression that began in the same decade. In 1856 the town spent $20,000 to build a new high school, marking the beginning of a modern education system for the islanders. It served the town for nearly three quarters of a century, and was replaced by the present brick structure in 1928. It is obvious that the automotive age has invaded the education system on Nantucket: the students ride the big yellow buses and the teachers park their cars across the whole front of the building.

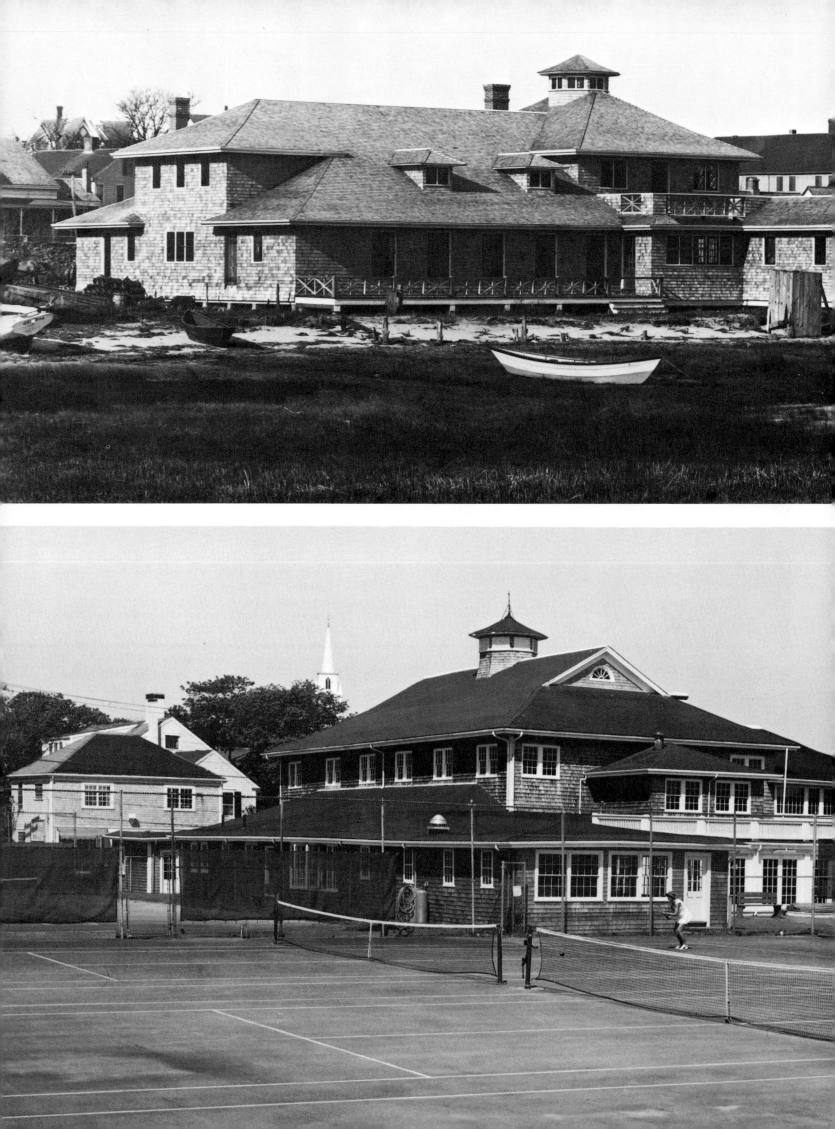

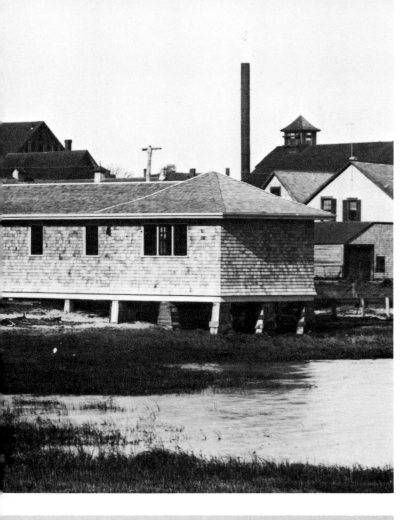

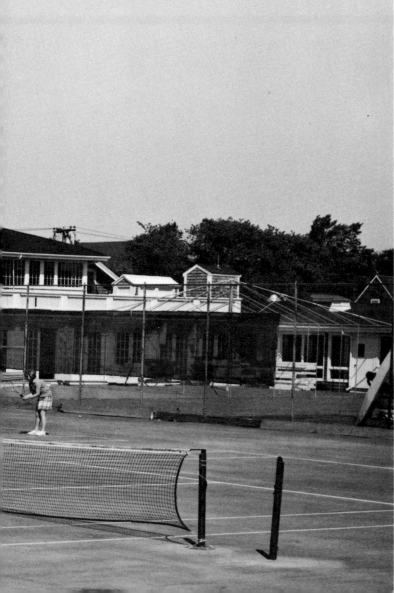

**The Nantucket Athletic Club (now the Nantucket Yacht Club),
1905** (top) **and 1976** (bottom).

The Nantucket Athletic Club was organized in 1890 and soon
afterward bought waterfront property just north of the Steam-
boat Wharf. A large clubhouse, constructed in 1904–05, was
opened for the season of 1905. It contained two bowling alleys,
a billiard room, reception room, card rooms and an amusement
hall. Such were the "athletics" of those times! Only four years
later the clubhouse was greatly altered by the addition of a
gymnasium. The structure was used during World War I by
Naval Reserve units. After the war the property was acquired
by the Nantucket Yacht Club (which had been organized by a
group of Hulbert Avenue summer residents) and it has served
as a yacht club since then. Throughout its existence the club
has been much more than a sailing club. Activities have in-
cluded bowling, tennis, dancing, cinema and many special
events. The club has a popular bar and meals are served to
capacity crowds throughout the season. This summer social
center's most popular activity today is tennis. The club's 12
courts are reserved long in advance during the summer months.

Chapter V

COMMERCIAL AND WATERFRONT

Because of the ephemeral nature of most private enterprises and their lack of any motive for historical preservation, old historic commercial structures are scarce. Moreover, on Nantucket the 1846 fire destroyed nearly all the wooden commercial buildings in the center of town. The wharves, however, abounded in commercial buildings which escaped the fire. From the pictures of the wharves, it is clear that, fires or not, commercial buildings were short-lived. They were altered, enlarged and razed time and again over the years. When the three southmost wharves were completely rebuilt into a modern marina in the 1960s, only one commercial building, a grain elevator, was deemed worthy of preservation. Old North Wharf's old buildings were for the most part fish shacks. All but one have been remodeled into summer homes, studios and other uses. Nevertheless, the North Wharf remains the most typical of the old wharves.

Only two eighteenth-century commercial structures have been saved. Nantucket's windmill, known as the East Mill, was built in 1746, and it is still in operating condition. Owned by the Historical Association, it is a major tourist attraction. The other is the Rotch Market (now Pacific Club), built in 1775. A few early nineteenth-century commercial buildings have been preserved, principally those built of brick. Examples are the Thomas Macy Warehouse of 1846 (now Kenneth Taylor Gallery), Richard Mitchell & Sons Candle Factory of 1847 (now the Whaling Museum) and the Pacific Bank of 1818 (now Pacific National Bank) at the west end of the Main Street square. A few old wooden commercial buildings such as the Cooperage on Vestal Street, remain little changed, but most have been greatly altered, converted into residences or moved and combined with other structures. (Wooden buildings, unlike brick, were easily moved as demands changed, and they could be readily grafted onto other existing buildings. For example, the Atlantic Silk Company mill on Gay Street, built in 1835, was remodeled into a duplex residence after that subsidized venture failed.)

The early photographs show that Nantucket's waterfront consisted of five wharves. The steamers used the northernmost; the others were given to various commercial operations. On the wharves were storage sheds and warehouses for coal, lumber, ice and other bulk materials. In addition there were many fish shacks, boat houses and shops occupied by craftsmen, most of whom worked the maritime trades. As early as 1870, the waterfront was becoming dilapidated after a quarter century of neglect. There continued a slow decline in wharf conditions despite minor repairs. The only exception was the steamboat wharf, which was renovated from time to time. The number of vessels entering Nantucket harbor continued to decrease as fishing declined and more of the freight was shipped on the regular steamers. Many changes occurred, but none was designed to prevent the gradual deterioration of the area. The gas plant was enlarged and bigger gas holders were built; businesses changed hands and slowly died; and piles of offal and scallop shells rose to an alarming extent.

Perhaps the most noisome aspect of the waterfront was Nantucket's sewage system (or lack of one). Until the last decade of the nineteenth century, the town had no public sewer system—sewage was literally dumped into streets, pits, ponds and the harbor. When the town at last constructed a public system in the 1890s, it was a gravity system with all the outflow going into the harbor. Although this first public system did much to sanitize the residential and commercial areas back from the waterfront, it also made certain the condition of the harbor would be degraded.

Shortly after the Nantucket Railroad was built in 1880–81, an embankment was constructed from Easy Street to the Steamboat Wharf so that trains might pick up passengers directly from the steamers. This trapped a large pool of noxious sewage and offal between the embankment and the high-tide line, creating a condition that did not provide an especially auspicious welcome to the summer residents and tourists disembarking from

the steamer to enjoy the "health-giving breezes" of the island. It was many years before the town filled in this area completely. Because of pollution, bathing along Beachside and Brant Point was safe only on a flood tide. Nothing was done until the late 1920s, when settling beds were constructed between Surfside and Miacomet Pond and town sewage was pumped across the island instead of being dumped into the harbor.

Even today sewage sometimes flows through "emergency" outlets at, of all places, the Children's Beach and Brant Point light, both popular bathing areas. The pollution level is at times so high at the Children's Beach that those waters must be closed to swimming. Nantucket is now beginning to realize that the one thing a resort area does not need is pollution of the environment. Federal and state funds are now being sought to improve the sewage system and eliminate once and for all the dumping of sewage into Nantucket's beautiful harbor.

Because of the deterioration of wharf facilities and pollution, Nantucket's waterfront was unattractive. Pleasure boats were permitted to tie up at the wharves without charge, indicating that the slip areas had no economic value, even in the summertime. The town was once offered all of Straight Wharf for one dollar. The town thought it a poor bargain and refused! Visiting sailboats, practically without exception, chose to anchor away from the waterfront, and powerboats tended to avoid Nantucket altogether because there were no modern facilities. Parts of the wharves were abandoned, such as the "T" on North Wharf.

Today, nothing is so changed in Nantucket as her waterfront. The Sherburne Associates, financed by a Nantucket philanthropist, bought the three southernmost wharves and much of the land behind them. This area of the waterfront was converted into a first-class marina. The wharves were reconstructed with modern facilities for pleasure boats and built up with small commercial buildings (in the old tradition) which provide space for shops, craftsmen, artists, restaurants and marine-service facilities. Behind the marina a whole shopping area was developed, including a supermarket, and substantial space was assigned to automobile parking. This marina-shopping complex tended to prevent the growth of a "rotten core" downtown area such as has afflicted so many American cities and towns.

Along similar lines, Old North Wharf has been renovated as a residential area by private interests. Today this area provides a picturesque waterfront of summer homes and docks. The Steamboat Wharf too has seen considerable renovation in recent years. The new photographs of Nantucket's waterfront illustrate the drastic changes as over a century of neglect finally gave way to facilities that could serve the needs of a resort community in the last quarter of the twentieth century. Fortunately, these changes have been made in a way that complements Nantucket's old homes, streets and buildings. Most visitors to Nantucket would be hard put to separate the old from the new, even on the waterfront where nearly everything has been constructed in the last decade.

Perhaps the best that can be said about Nantucket's commercial center is that it is small—it does not sprawl out into the residential areas of the town. Only a few distinguished buildings have been saved, but all that has been rebuilt is in scale. The fact that few buildings exceed two stories makes the new blend with the old, deceiving the eye so that an appearance of harmony is established with the old homes that grace the nearby streets.

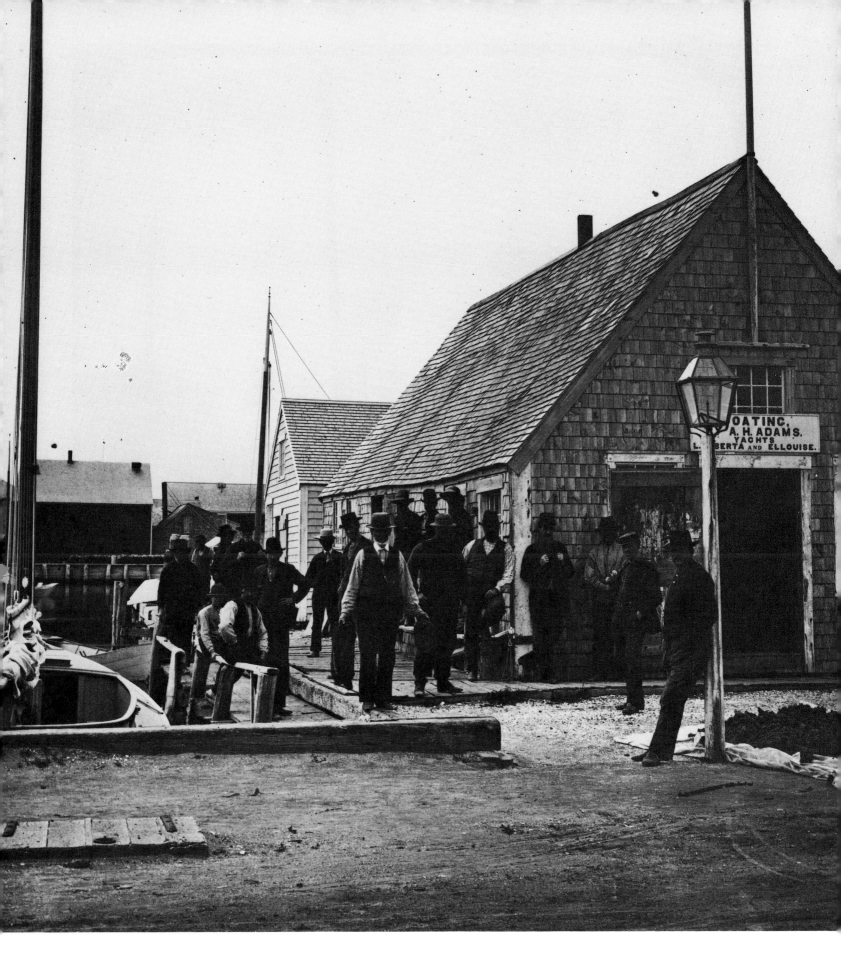

Adam's Boat House, Catboat Basin, Steamboat Wharf ca. 1875.
Before World War I, Nantucket's harbor provided few recreation facilities. Commerce and industry, even though generally depressed, occupied all the wharves; there were no yacht-club facilities and the Children's Beach was a mud flat. Moreover, the harbor was so polluted that fishing for shellfish was frequently prohibited. One could hire a catboat with captain and go sharking or codding. In 1875 there seems to have been a substantial number of unemployed "captains." Today the whole waterfront is devoted to recreation and tourist attractions except for the Steamboat Wharf.

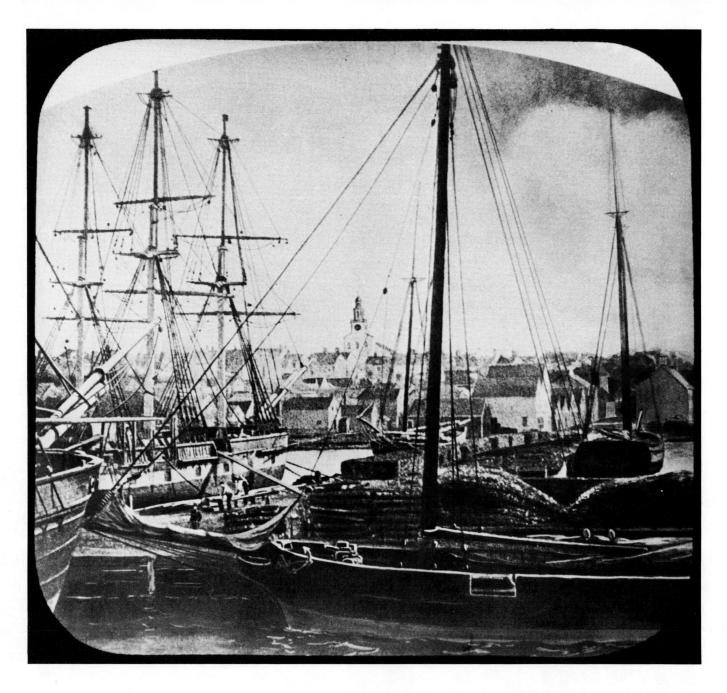

Nantucket's Waterfront, ca. 1865 (above) **and 1975** (opposite, top).

In changing from an industrial community to a resort, the waterfront area of Nantucket has been totally altered. Hardly a building that existed in the 1865 photograph stands today. Yet the scale of the structures remains unchanged, and, therefore, the impression one gains from the overall view is much the same. Despite the increased number of trees and the bulkheads, the skyline is still dominated by the South Church steeple, so no one is likely to mistake it for some other place. Unfortunately, the 1865 photograph (the earliest of the waterfront) has been heavily retouched and is not historically reliable.

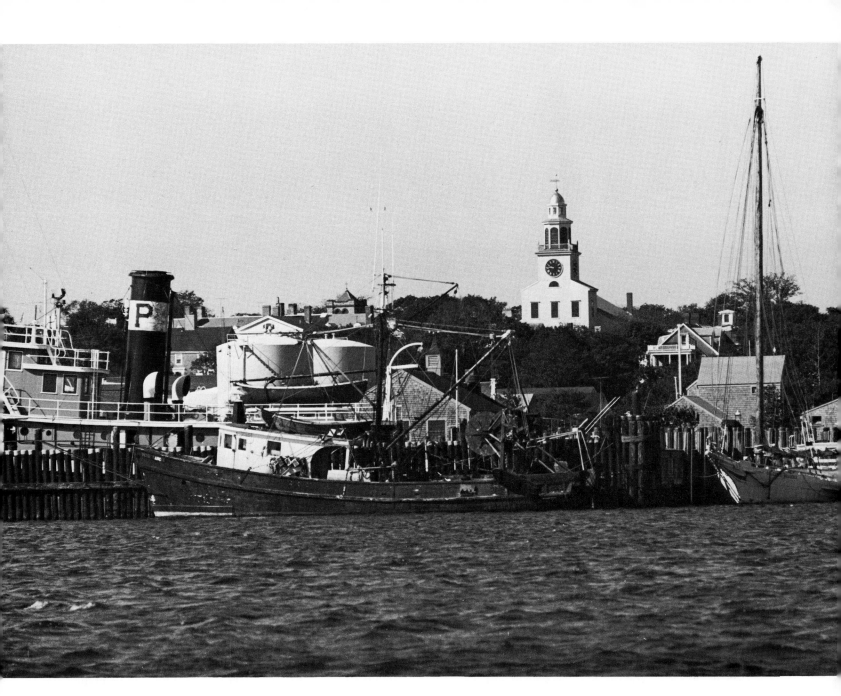

The Round-top Mill, ca. 1868 (right).
Lacking a source of waterpower, Nantucket had to depend on windmills for grinding grain and other industrial activities. On a ridge known as "Popsquachet Hills" behind the town there stood five windmills in the early 1800s, three having been built before the Revolution. The Round-top Mill, also known as "Joe Chase's Mill," was the last built (1802) and the last to be taken down (1873). It stood just north of the millpond on New Lane which is used each winter for ice-skating. This old photograph, printed from the original wet-plate negative, is probably the oldest existing photograph of any industrial operation on the island. One old mill has been preserved (see page 102).

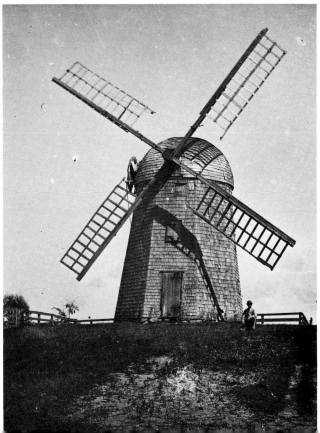

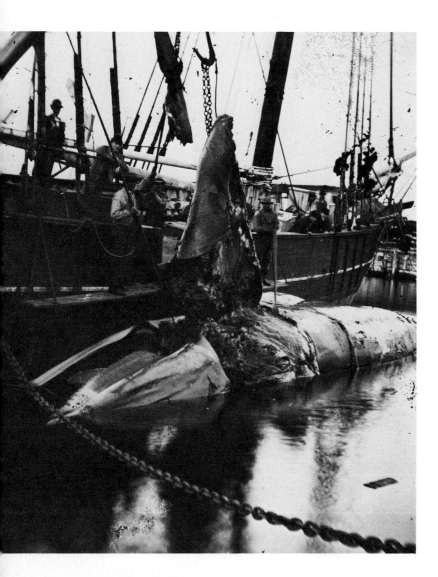

The Last Whale To Be Cut in at Nantucket, 1870 (top left) **and Nantucket Receives a Shipment of Oil, 1976** (top right).
Whaling was *the* oil industry before the discovery of petroleum and the process for refining kerosene in the middle of the nineteenth century. For nearly a century Nantucket was the center of this industry. Today all of Nantucket's energy is imported by tankers in the form of petroleum products, and the amount of oil imported to generate electricity for home heating and to power automobiles far exceeds the amount of whale oil exported when Nantucket was the whaling capital of the world.

Opposite: **Old South Wharf, ca. 1915** (bottom) **and 1975** (top). Although the old wharves have been completely rebuilt into a modern marina, the scale and design of the buildings reflect Nantucket's past. Visitors will have difficulty separating the old from the new.

Pages 72 through 81. A panorama of Nantucket's commercial district and waterfront. One hundred years of change and preservation: 1876–1976. Left-hand page photos are all from 1876, right-hand page photos are from 1976.

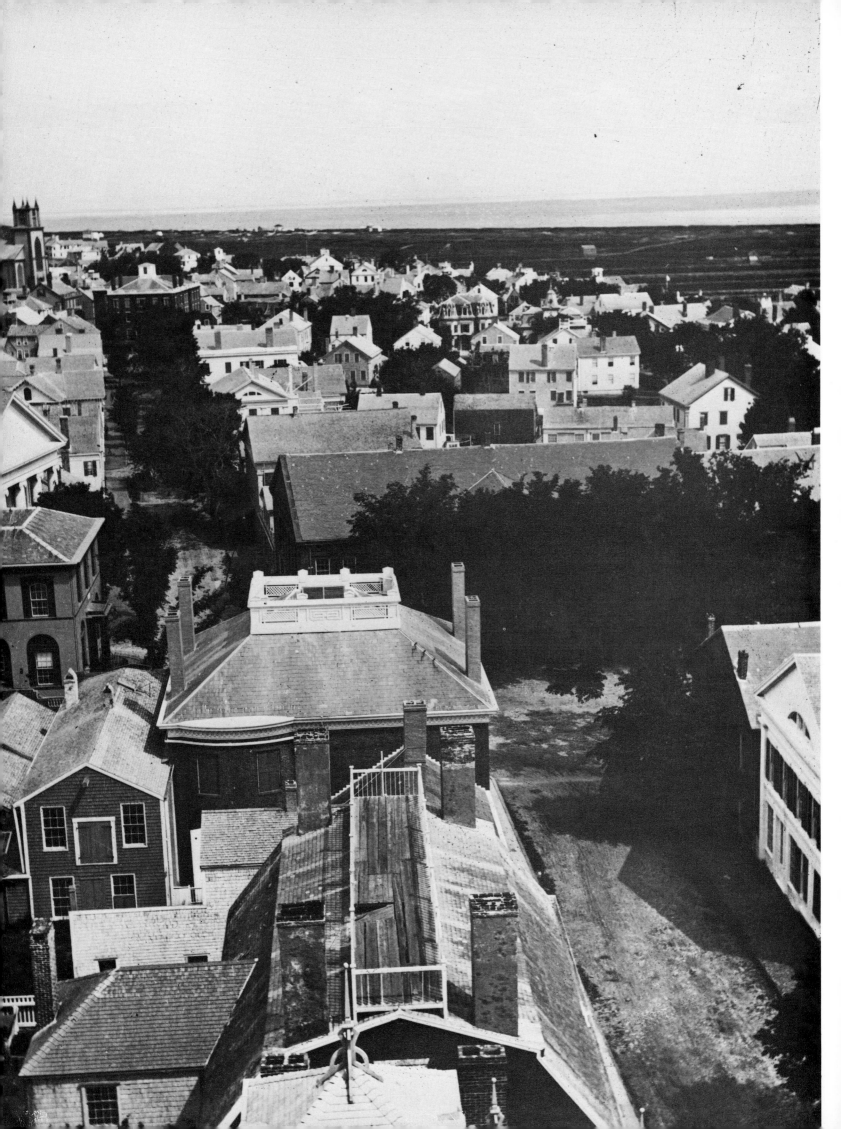

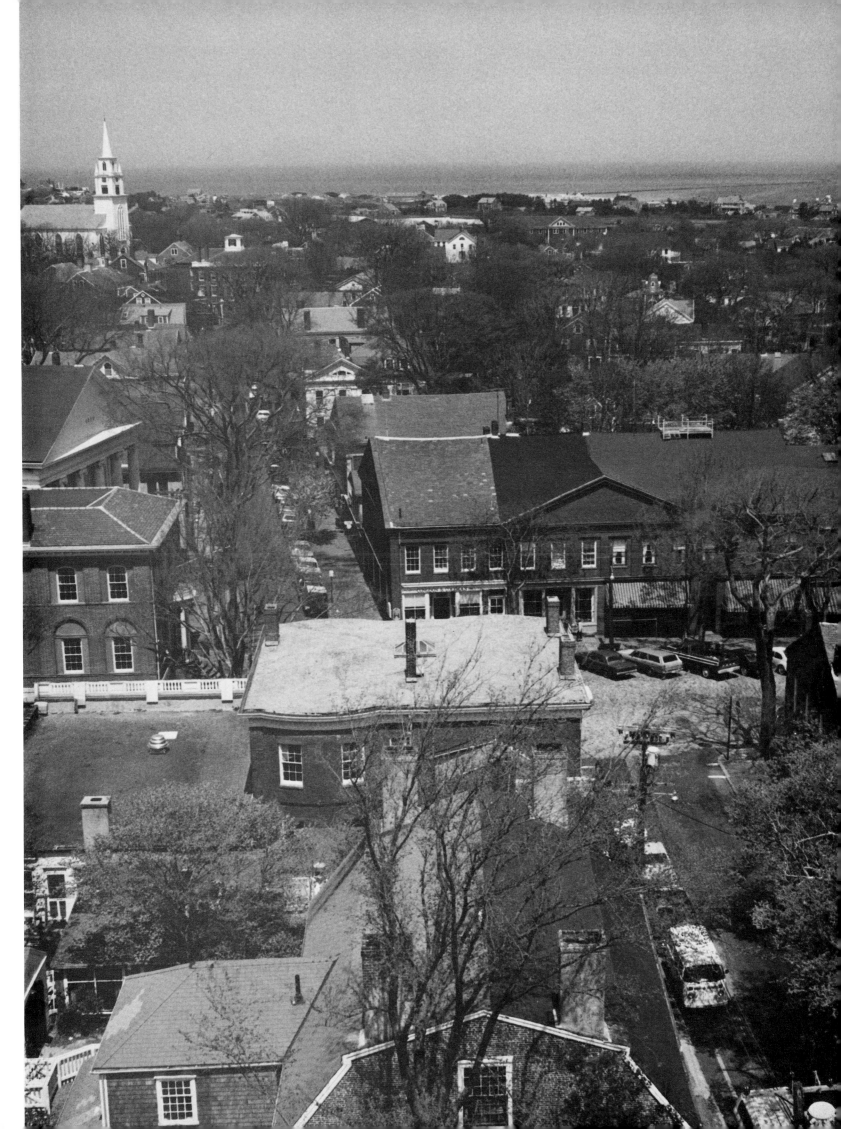

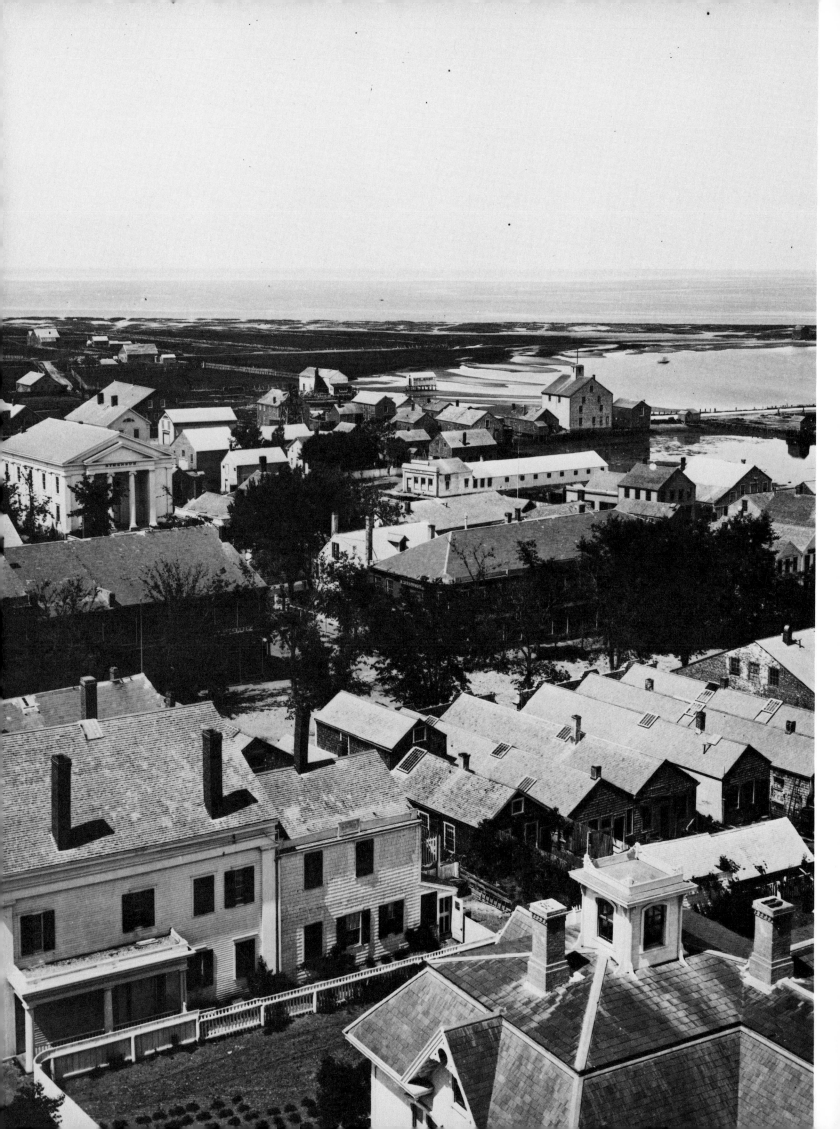

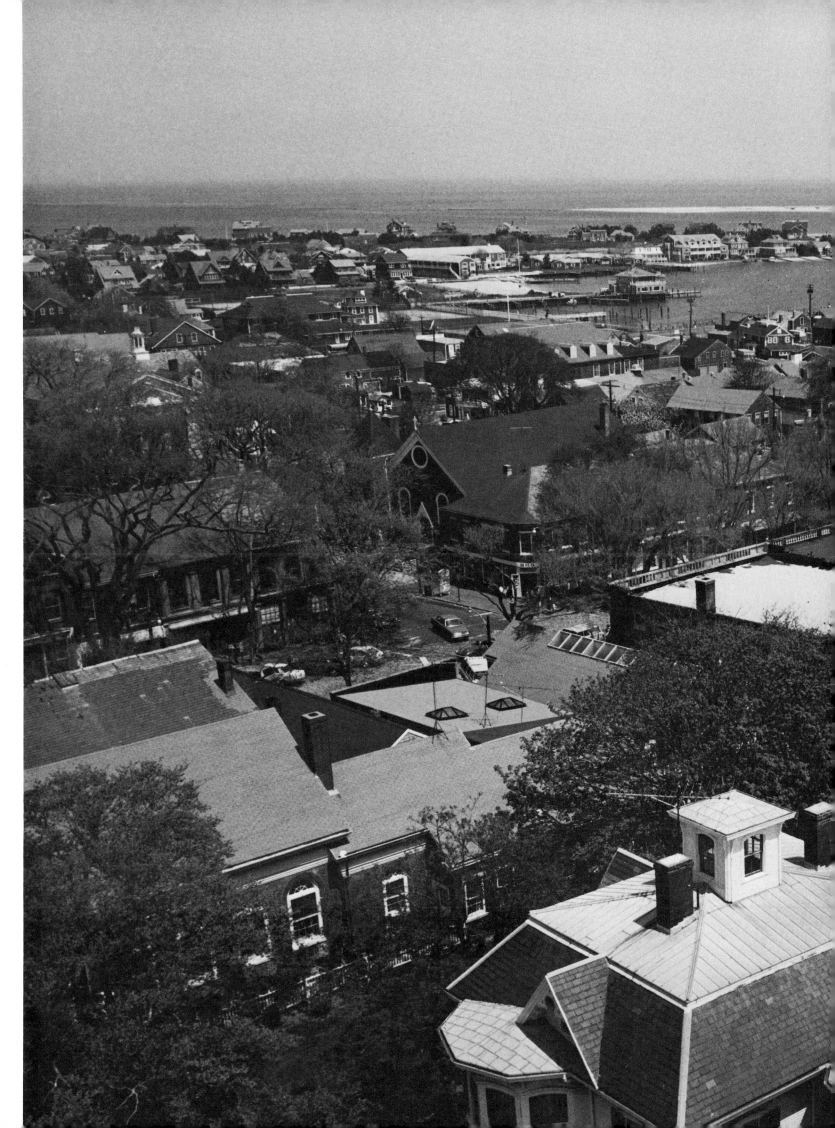

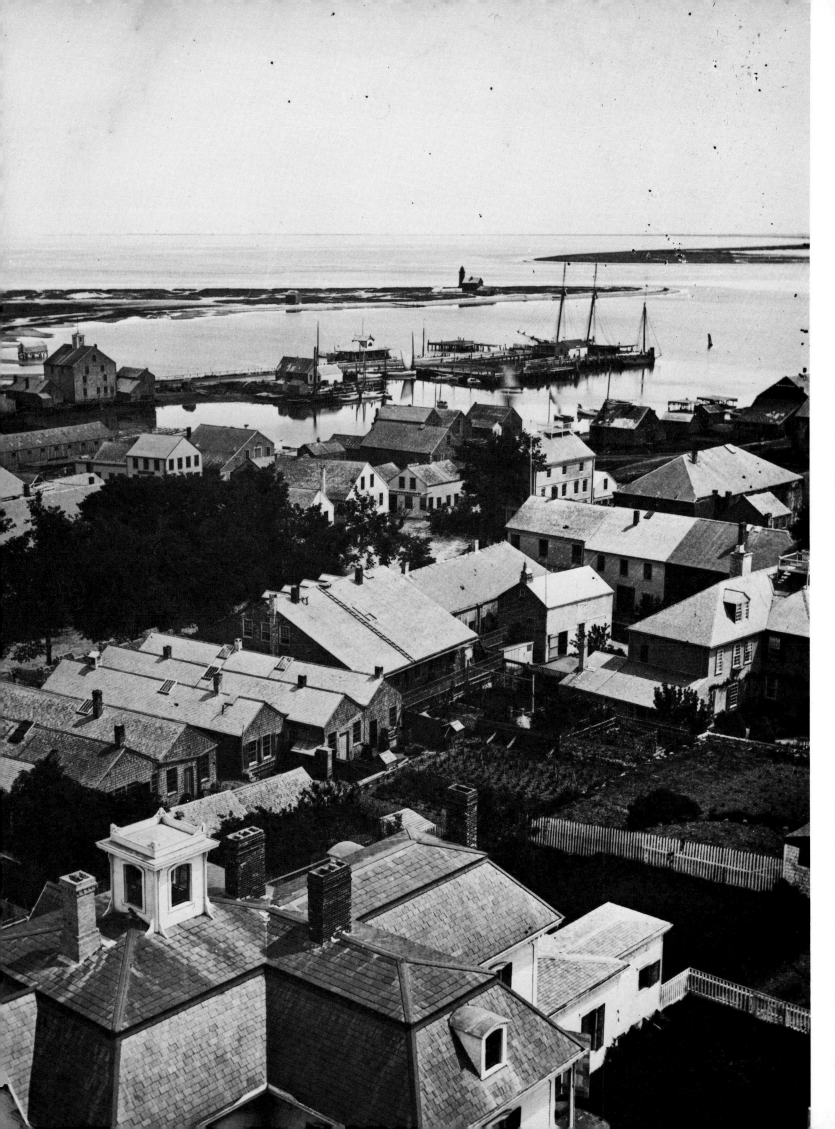

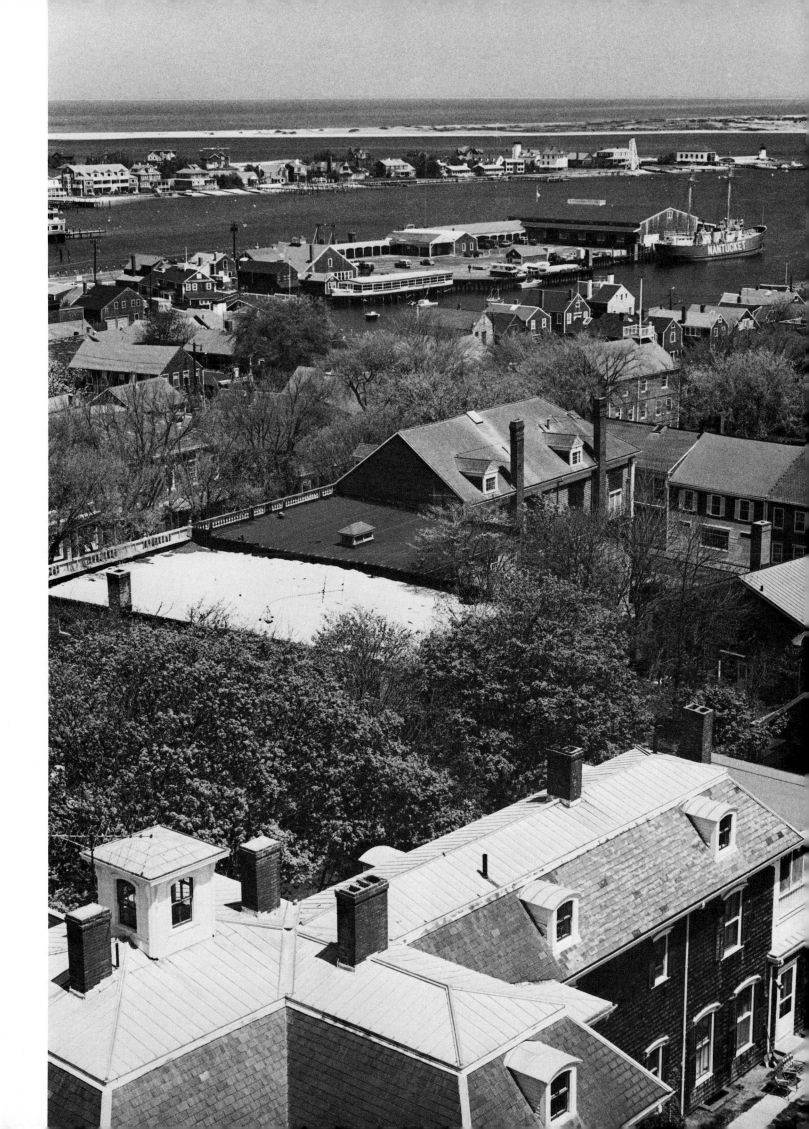

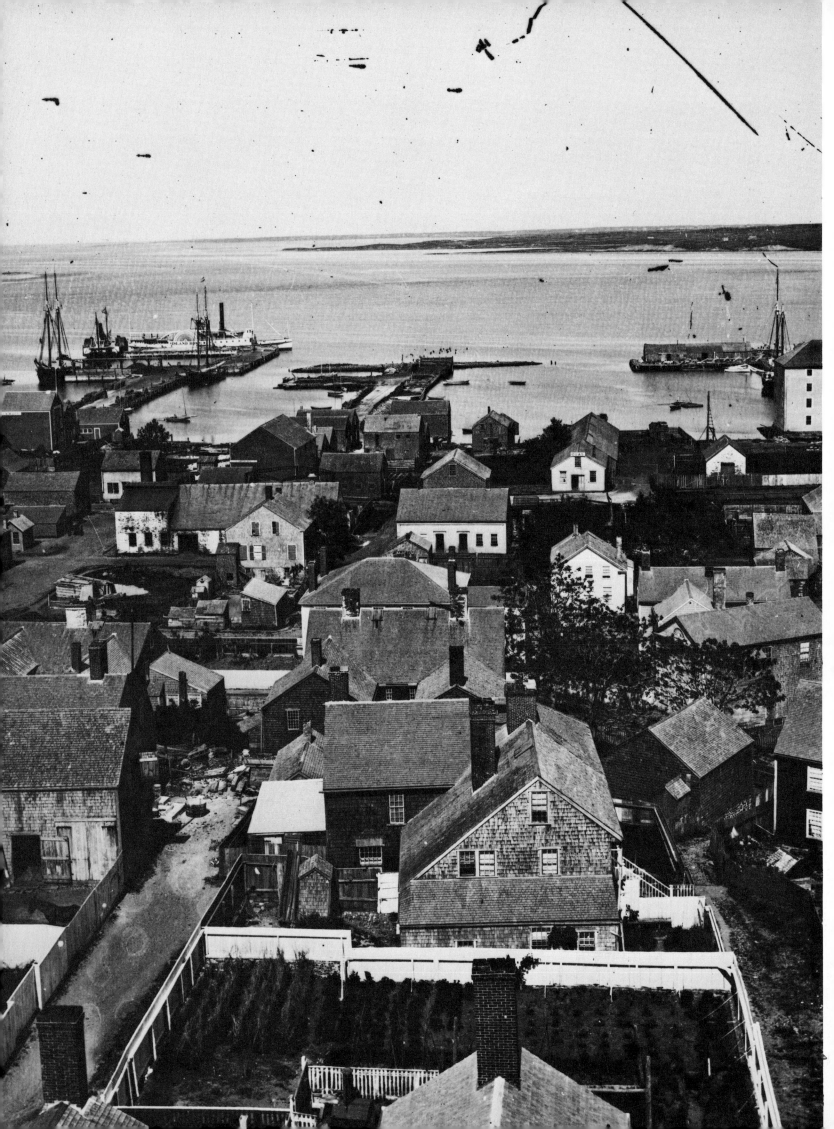

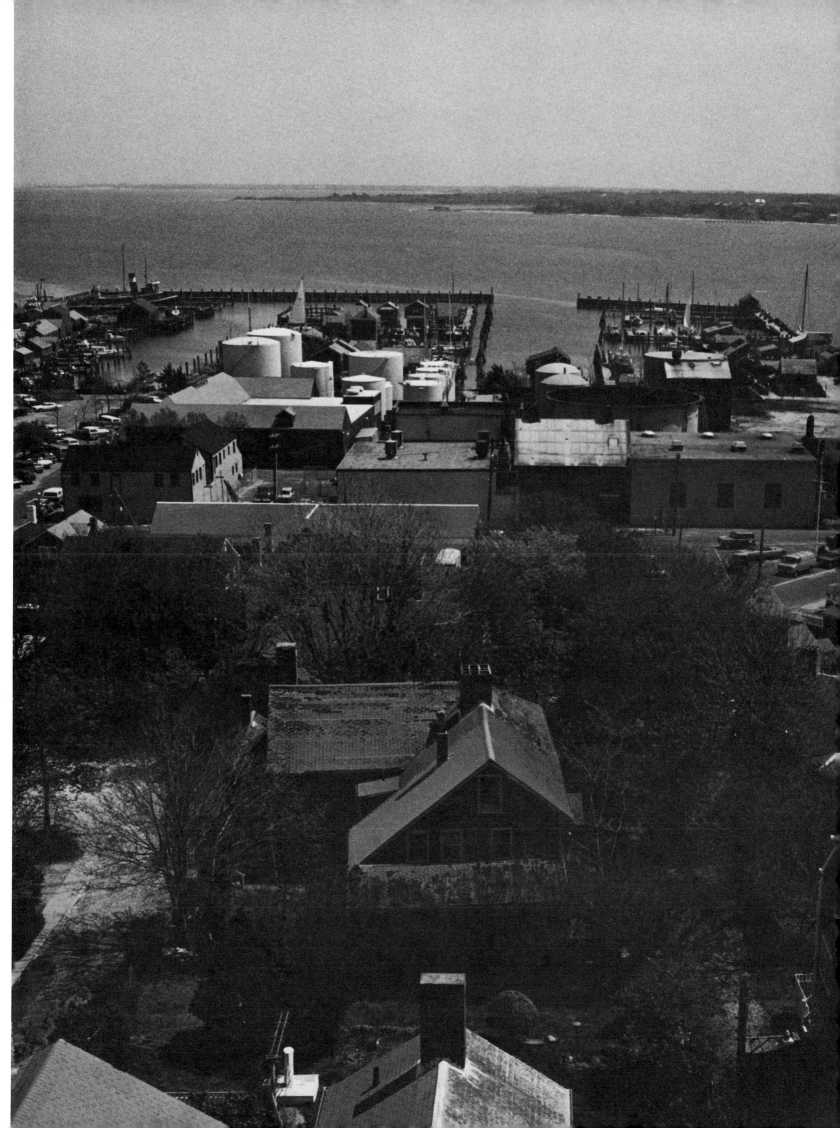

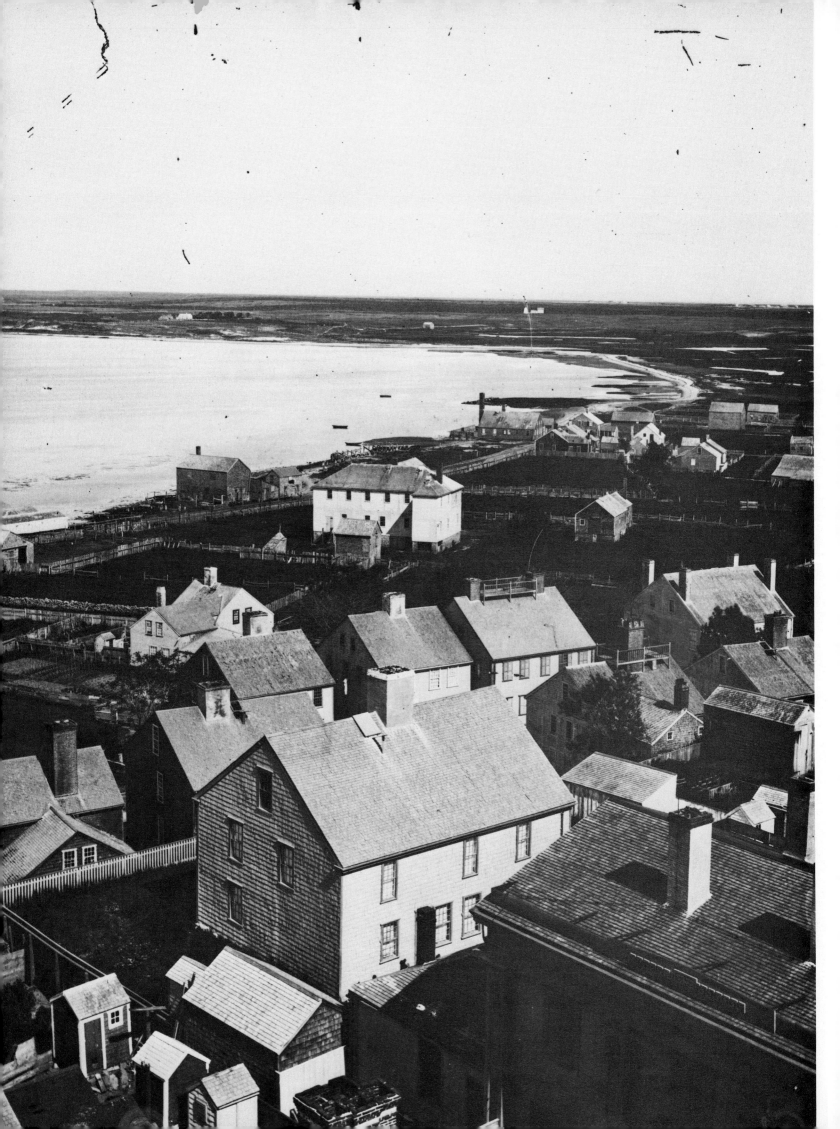

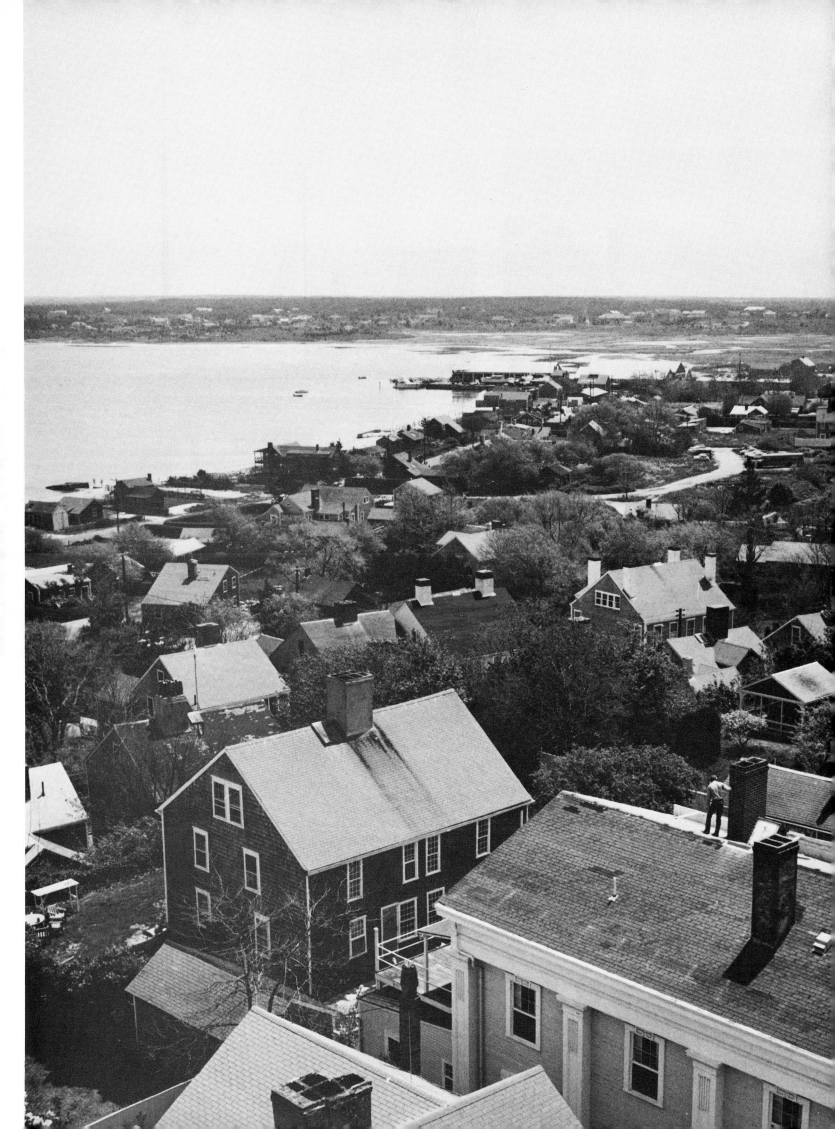

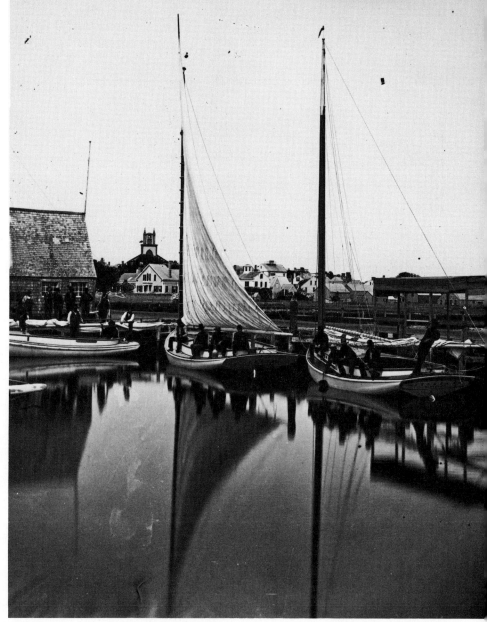

Above: **The Catboat Basin, Steamboat Wharf, ca. 1875** (right) **and 1975** (left).

For many years there was an indention on the south side of Steamboat Wharf in which numerous catboats tied up. Early in this century the basin was filled in to provide more space for automobile parking and commercial buildings. What remains of a once-picturesque waterfront area is now a trash-littered backwater. Not all of Nantucket has been improved over the last century.

Opposite: **Head of Straight Wharf, 1924** (top) **and 1975** (bottom).
Nothing so disfigures a commercial area as outdoor advertising. Nantucket now bans such signs. Many older Nantucket residents and summer visitors will remember Paddock's Paint Store on Main Street. It is now an antique shop. All the other buildings were eliminated in the modernization of Nantucket's waterfront in the 1960s.

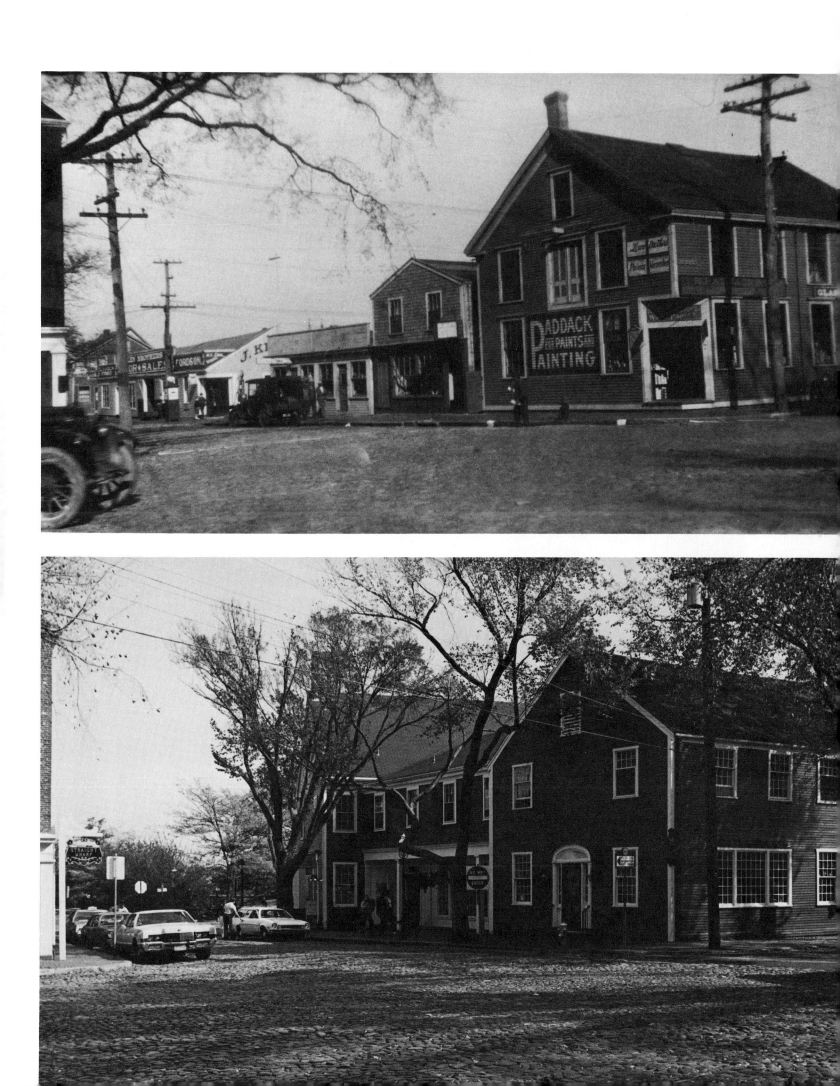

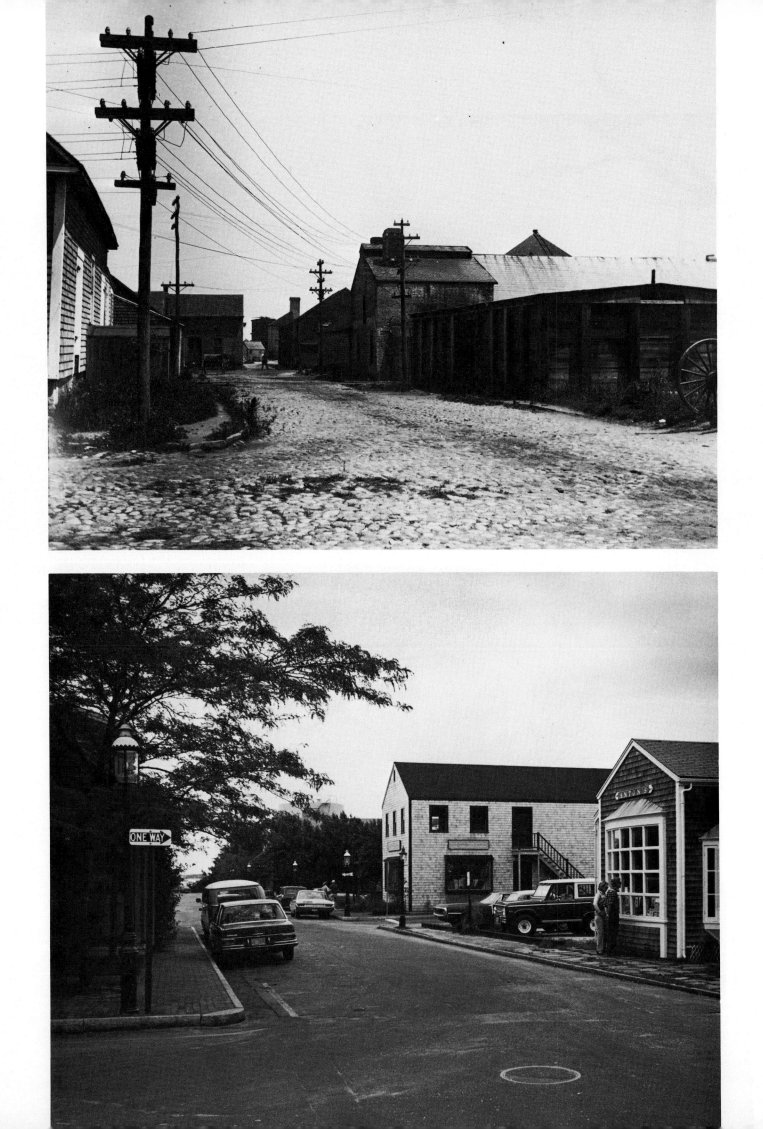

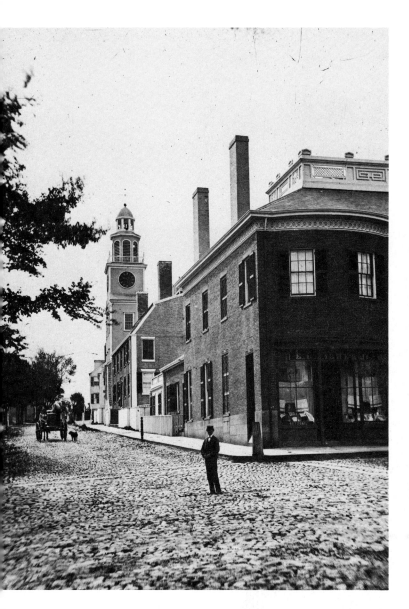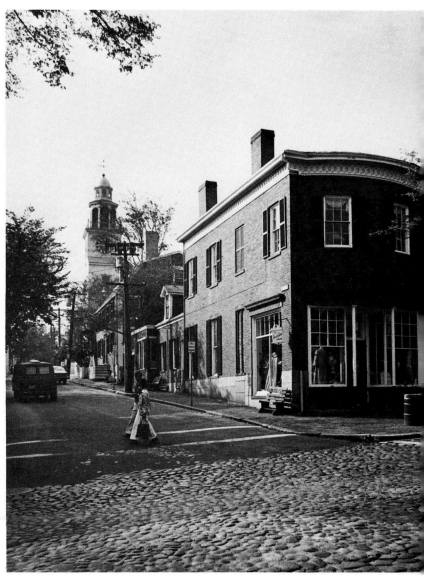

Opposite: **Head of Old South Wharf, 1920** (top) **and 1976** (bottom).
The effects of the waterfront restoration of the 1960s went as far west as Washington Street and are still continuing at the present time. Utilities have been buried, old-type street light installed, and a whole shopping plaza constructed.

Above: **Corner of Main and Orange Streets, ca. 1876** (left) **and 1976** (right).
The building in the foreground was once an elegant mansion, but by the 1870s it had already been converted to commercial use. Today, deprived of its tall chimneys, hip roof and unusual roof walk, it carries on as a commercial building. Many of Nantucket's streets were once paved with cobblestones; Orange Street, like many others, has been covered with asphalt.

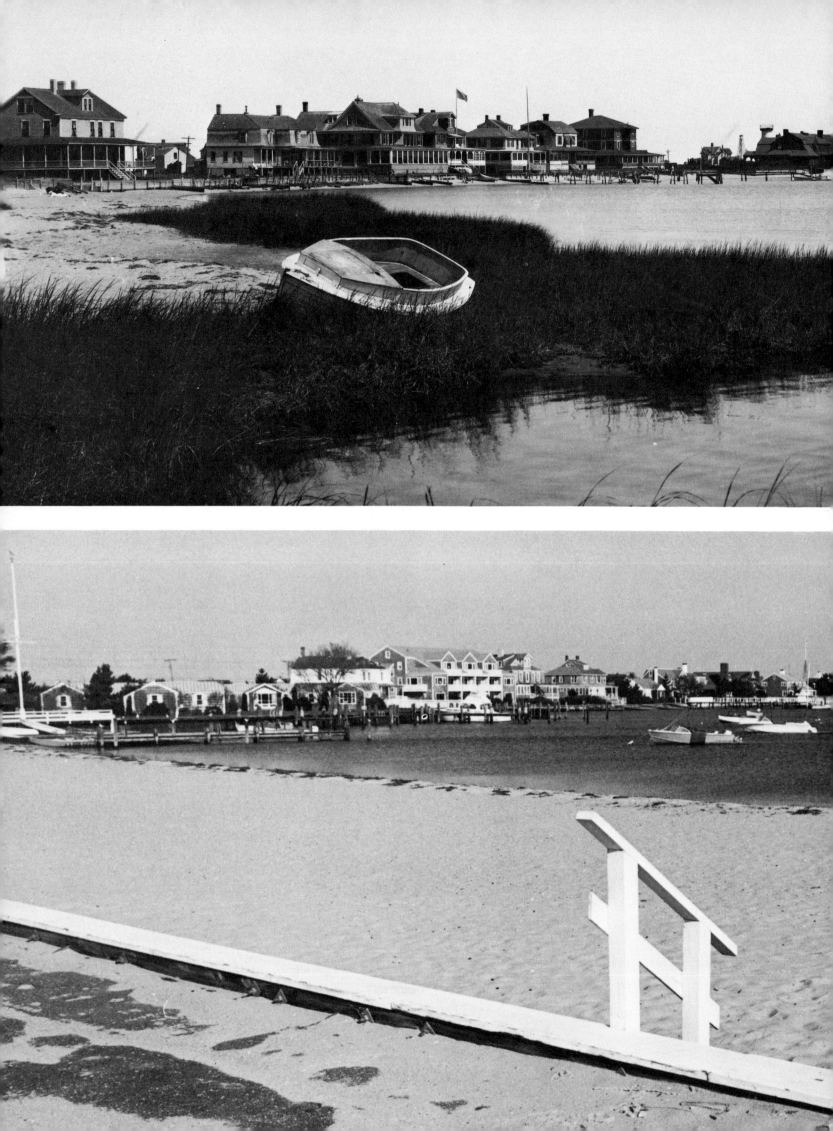

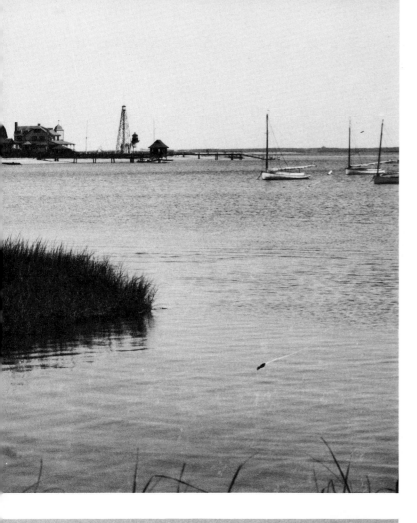

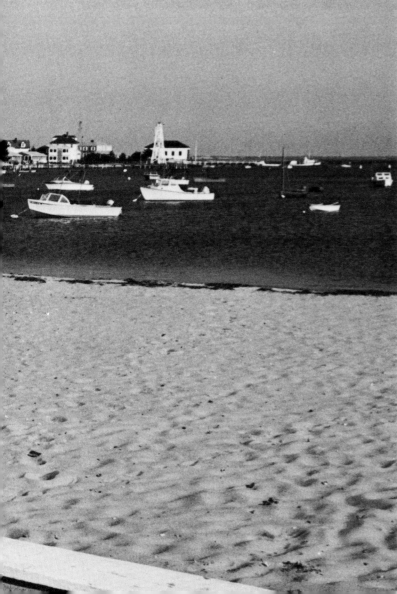

The Children's Beach, 1920 (top) **and 1975** (bottom).
The waterfront from the Children's Beach to Brant Point light was built up with summer homes, hotels and inns by the time of World War I. The beach has been bulkheaded and supplied with additional sand. A ramp, left middleground in the 1975 view, provides access to the water for pleasure boats in the summer and for off-season scallopers.

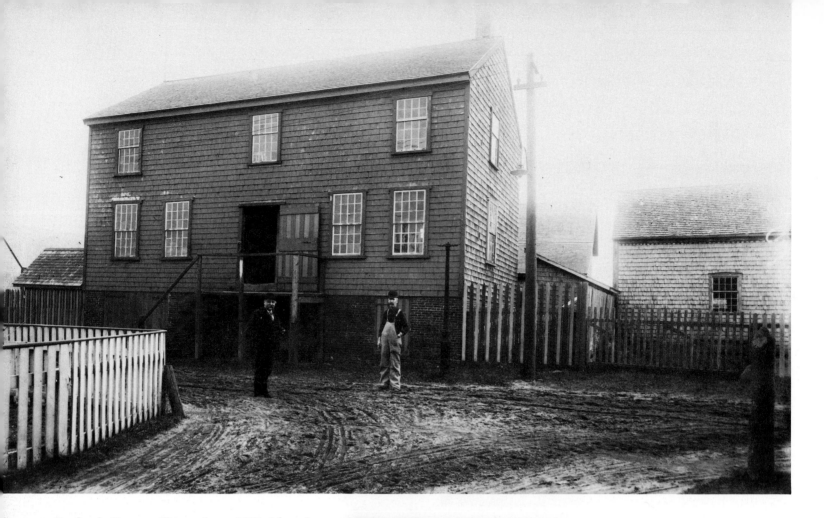

Starbuck Cooper Shop, about 1881 (above) **and 1975** (right).
Commercial, industrial and craft activities were housed all over the town and not limited to the waterfront and the town center. Cooperage (barrel making) was an important industry in the last century. Not only was whale oil stored in barrels aboard ships, but all manner of goods, from nails to flour to tar and even crackers, were shipped and stored in wooden barrels. This shop was built on Vestal Street, a kilometer from the waterfront. In a good state of preservation, with only the stairs changed from left to right, the building now serves as a residence.

Opposite: **Main Street from the head of Straight Wharf, ca. 1875** (top) **and 1975** (bottom).
Although the old picture was taken in the middle of summer, there is a noticeable lack of traffic. The new picture had to be taken in late October to gain a similar impression.

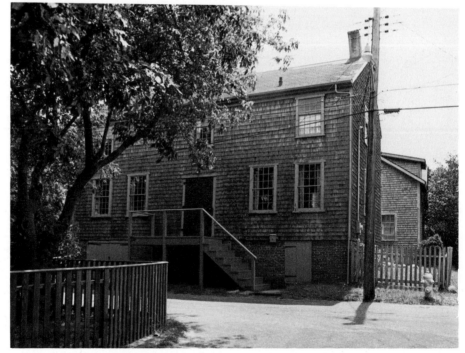

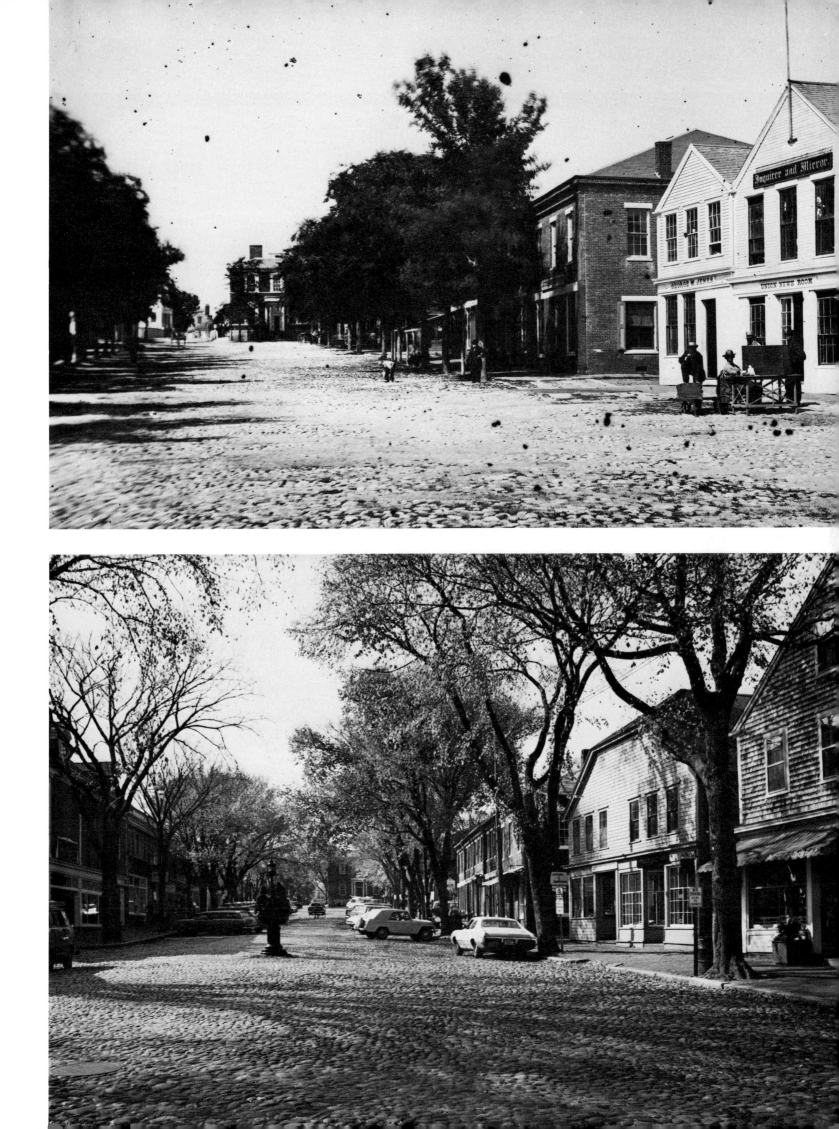

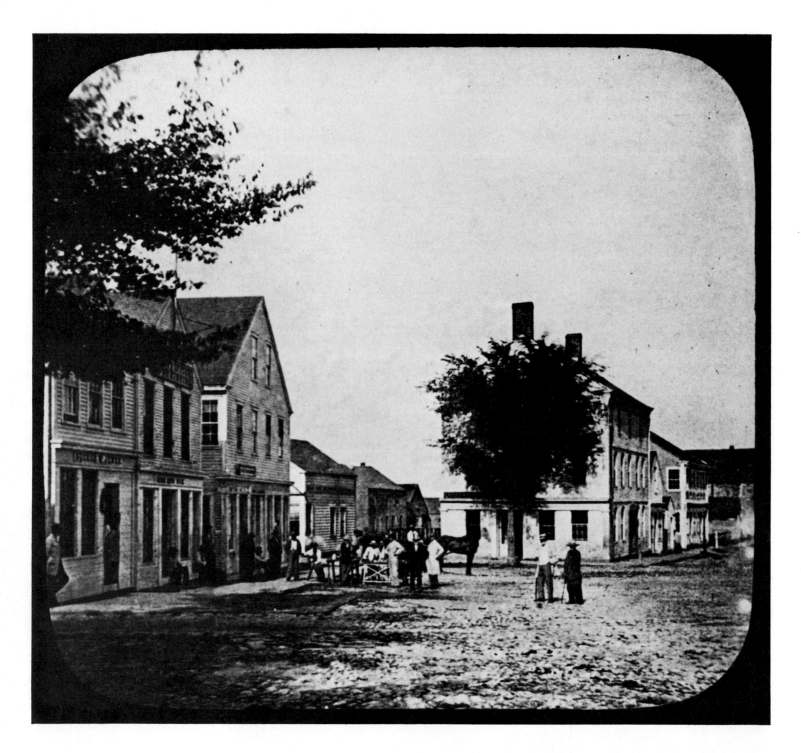

Lower Main Street, ca. 1870 (above) **and 1975** (opposite).
The Rotch warehouse (right center) was built in 1775. Two
Rotch vessels under charter to the East India Company took
part in the Boston Tea Party.

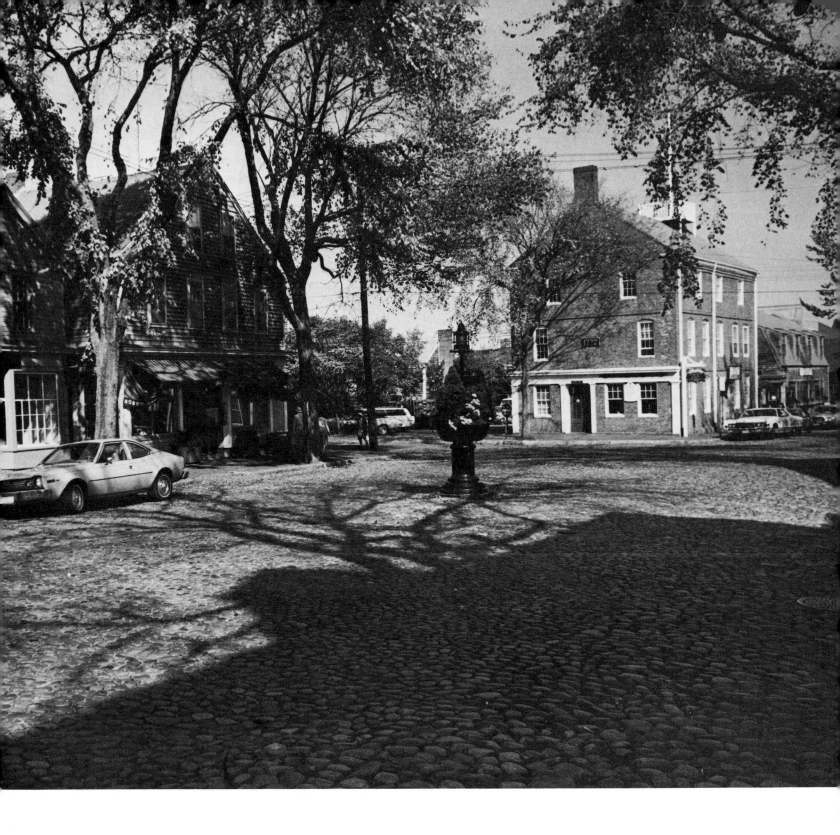

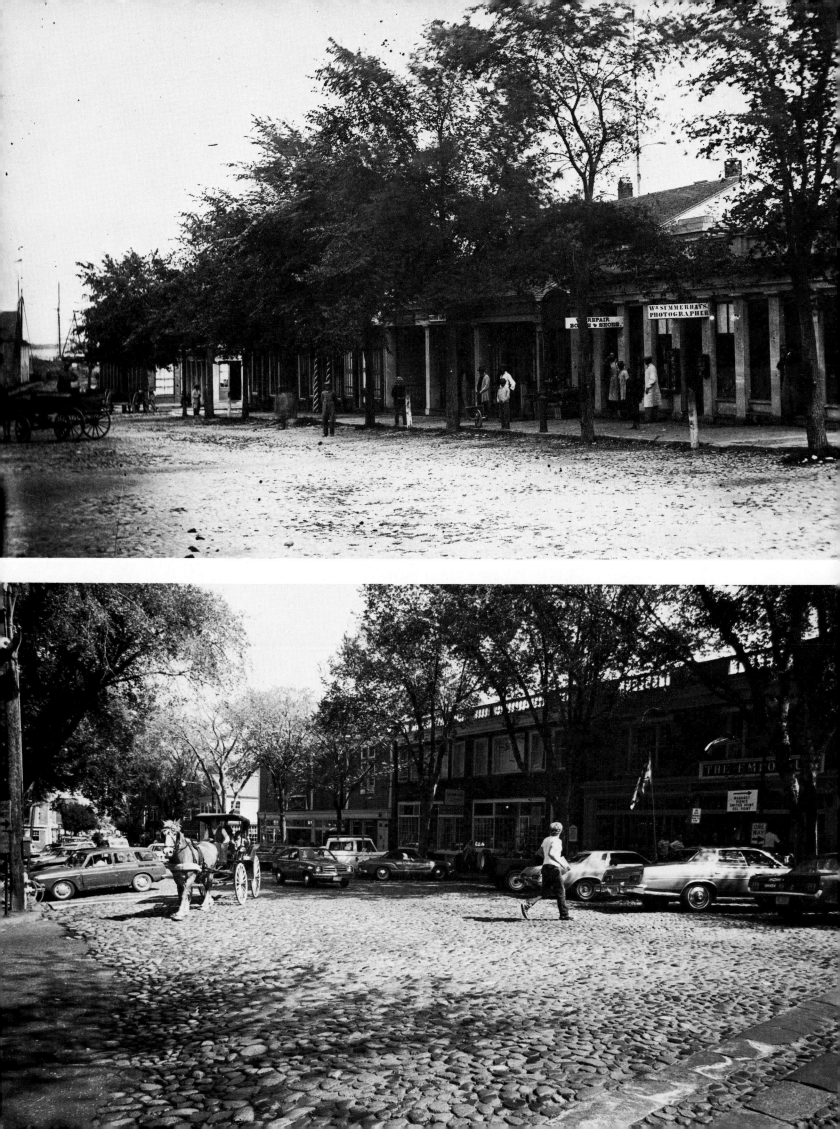

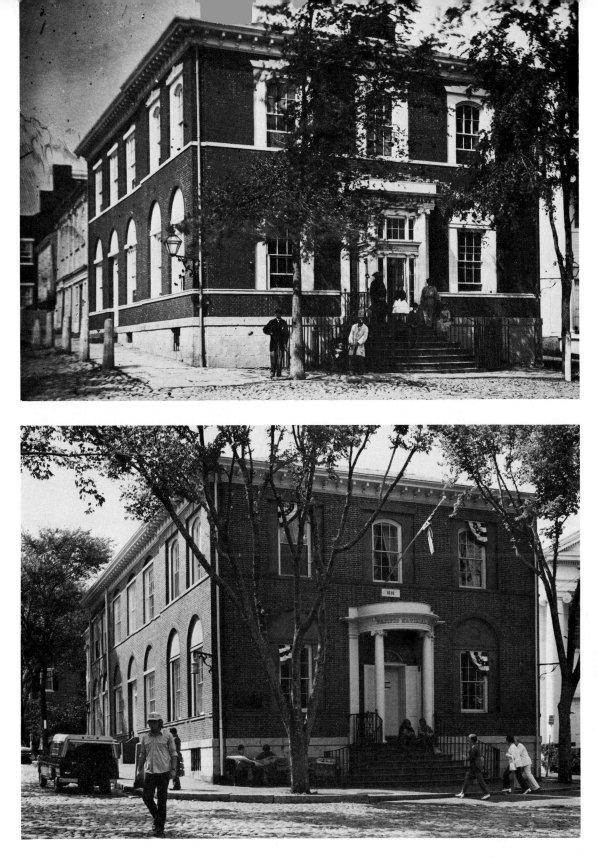

Opposite: **South Side of Main Street, ca. 1865** (top) **and 1976** (bottom).

After the fire of 1846 the south side of Main Street was rebuilt with "temporary" wooden commercial structures that survived for the many years of Nantucket's long depression. Summerhays, one of Nantucket's first photographers, had his shop in one of these buildings. Unlike the north side of the street, which was rebuilt with brick buildings, most of the wooden buildings on the south side were not replaced until the twentieth century; even today, a few of the "temporary" buildings

remain. Although clogged with automobiles, Main Street still sports a horse-drawn vehicle now and then.

Above: **West End of the Main Street Square, ca. 1868** (top) **and 1975** (bottom).

The Pacific National Bank (1818) and the Methodist Church (1822) dominate the upper end of the square. The bank building was later enlarged by the addition of two bays. The old Masonic Hall in the rear of the bank has recently been restored to serve as the bank's trust department.

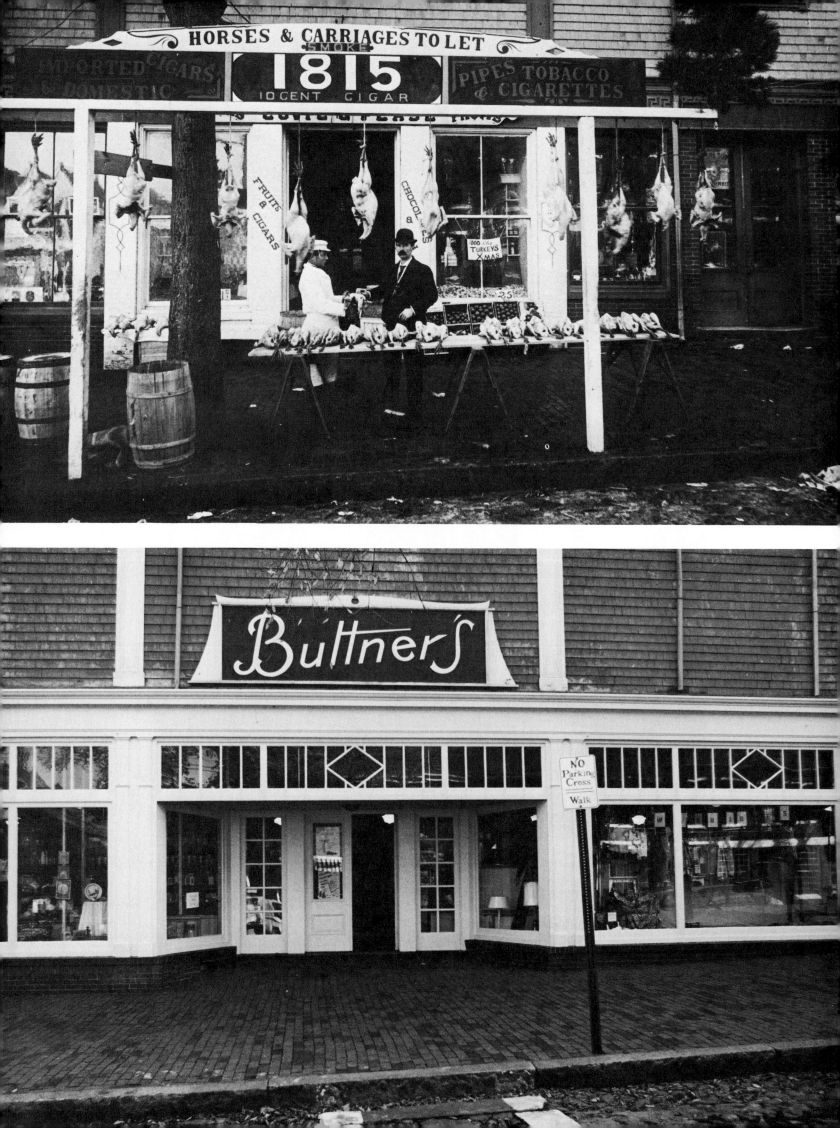

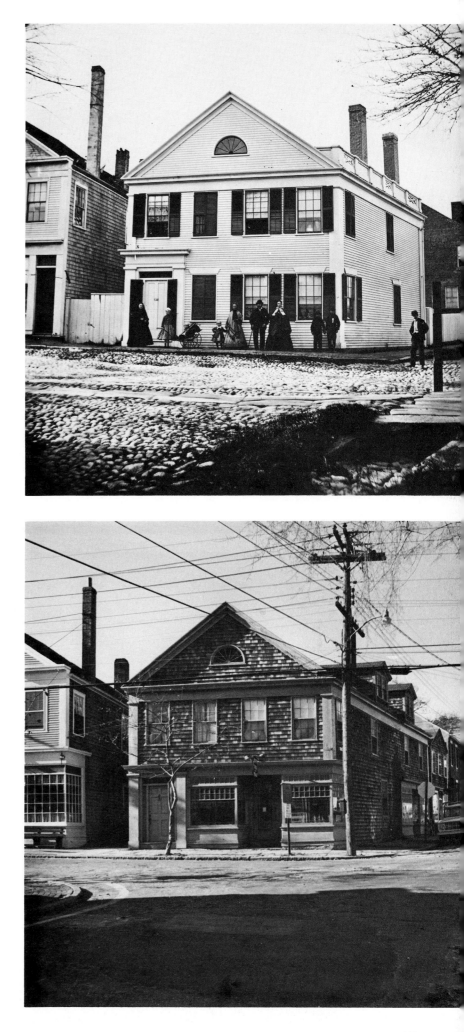

Opposite: **Pease's Store, Main Street, ca. 1900** (top) **and 1975** (bottom).
The "1815" is not the date of the building, but a brand of ten-cent cigar. Mr. Pease had 1,000 pounds of turkeys to sell for Christmas according to his sign. Note the barrels that were used in those days to package all kinds of food and merchandise. Today this building is occupied by a branch of Buttner's, a New England department-store chain.

Right: **28 Centre Street, ca. 1865** (top) **and 1975** (bottom).
Centre Street, as well as many other downtown streets, was cobbled in the last century. By the 1860s there was a considerable amount of grass growing in the streets. The once-proud home of the 1860 photograph well illustrates ravishment by commercialism. It was built in the popular Greek Revival style shortly after the fire of 1846 and originally had a substantial rear yard. Now the chimneys and balustrade have been lost and two dormers protrude from the roof. Shop windows cover the lower front facade as well as the side rear. A second commercial building has been jammed into what was the backyard. Many Eastern cities have lost most of their old homes to this kind of commercial "development"; Nantucket has been fortunate in having lost only a few, and most of those are not beyond restoration.

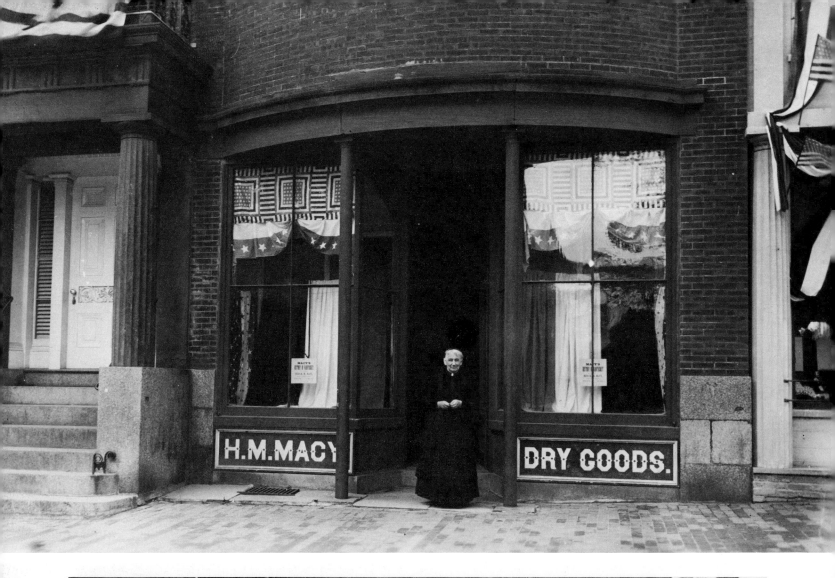

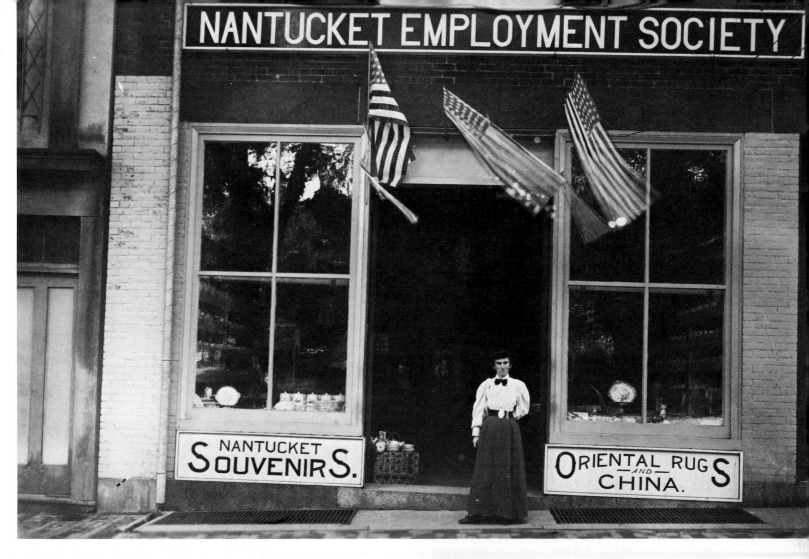

Opposite: **West Side of the Folger Mansion, Main Street, ca. 1881** (top) **and 1975** (bottom).
The Philip H. Folger mansion, built in the late Federal style on the corner of Main and Orange Streets in 1831, survived the fire of 1846, but not as a residence. It was converted for use as shops and other commercial purposes and has been used as such ever since. This is one of the few major Nantucket's homes that still cries out for restoration; it balances the Jared Coffin House at the other end of Centre Street and would greatly contribute to the appearance of the town if it were restored.

Main Street Gift Shop (Now Main Street Gallery), ca. 1895 (above) **and 1975** (right).
Resort centers like Nantucket are replete with gift shops and art galleries that are often short-lived. With each change of occupant the building is likely to be remodeled. There seems to be no record as to what the "Nantucket Employment Society" was; most likely it was an employment agency.

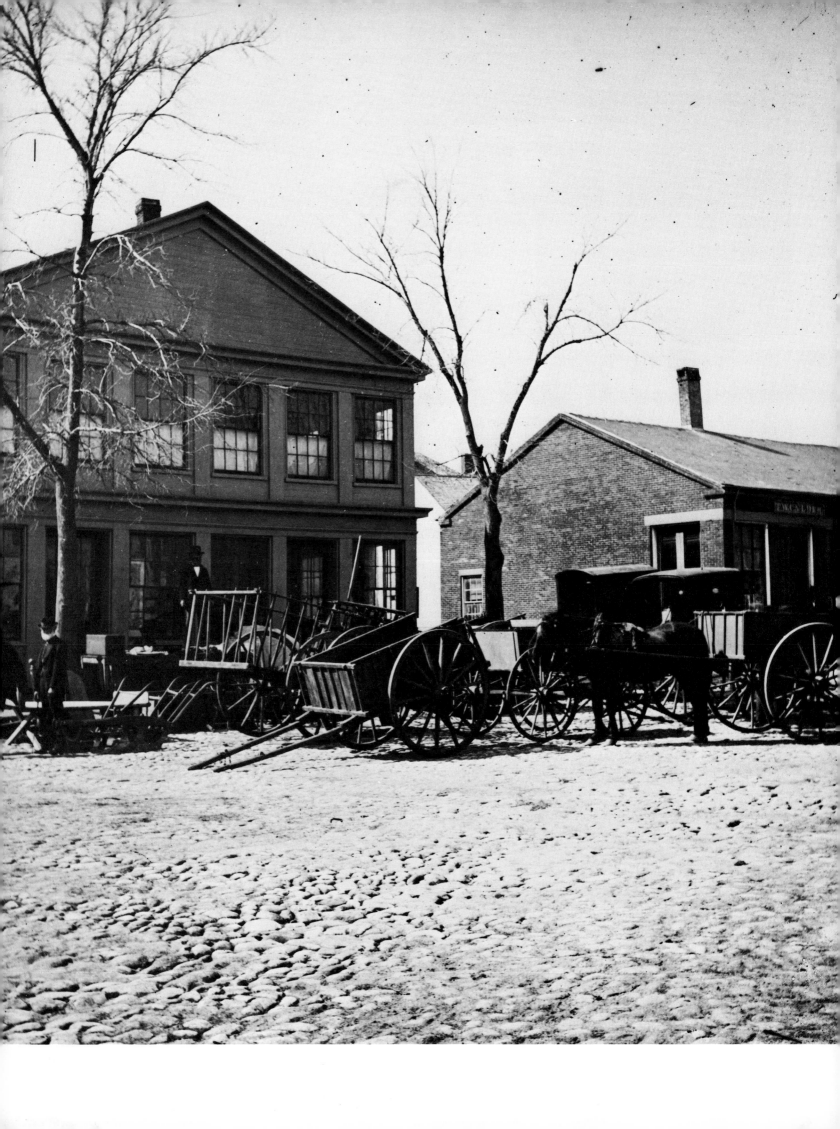

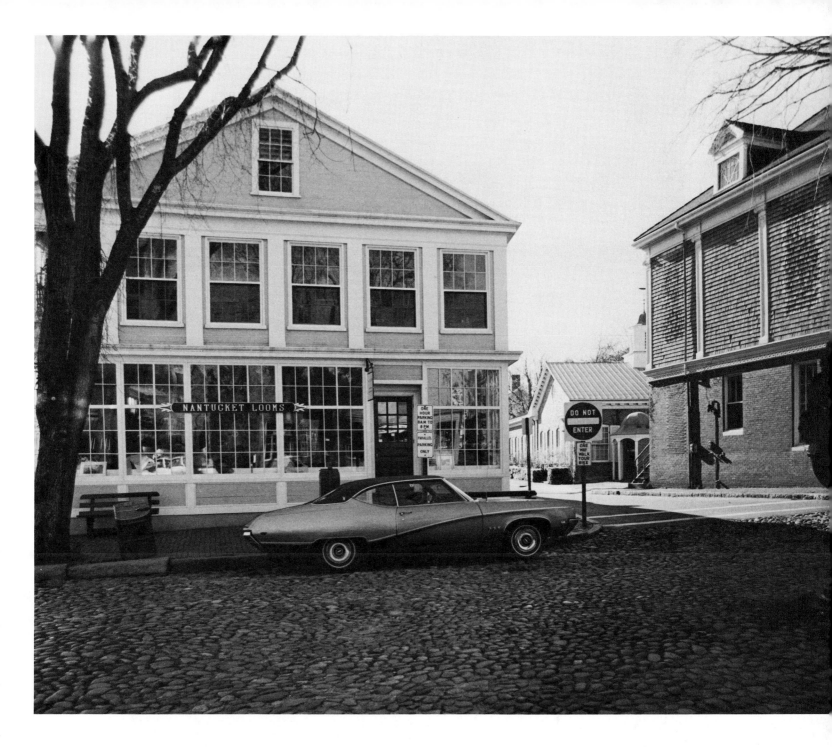

Commercial Building, Lower Main Street, 1880 (opposite) **and 1975** (above).
Some of the old commercial buildings have benefited from thoughtful restorations. This is now a center for handcrafted fabrics.

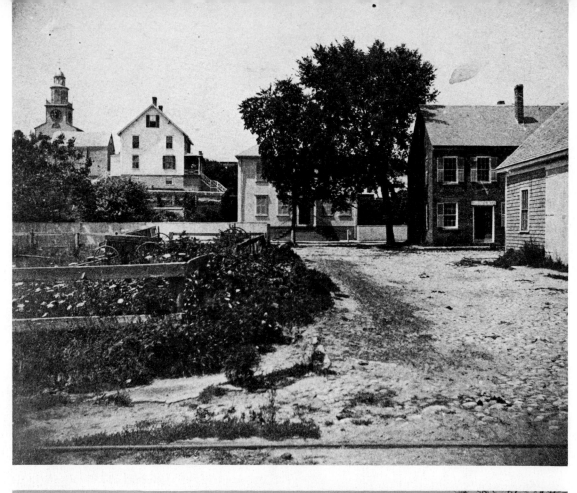

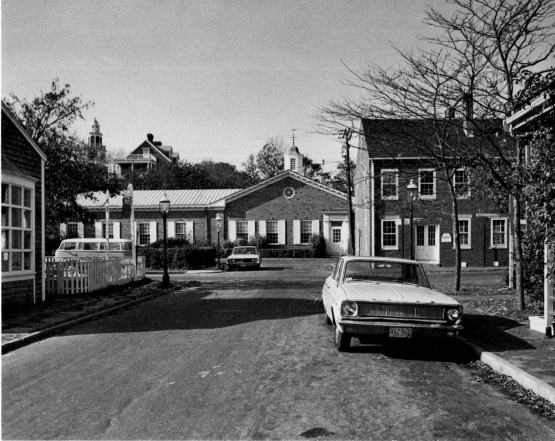

Washington Street at the Head of Old South Wharf, ca. 1890 (top) and 1975 (bottom).
The old and new can blend. The Old Town Building, right, was built in 1830 and restored in 1969–70. The New England Telephone & Telegraph Company Nantucket exchange center, which has replaced an old home, blends into the neighborhood. However, in the 1960s only Nantucket's Historic District Commission prevented the telephone company from erecting a tall microwave relay tower on top of the exchange building.

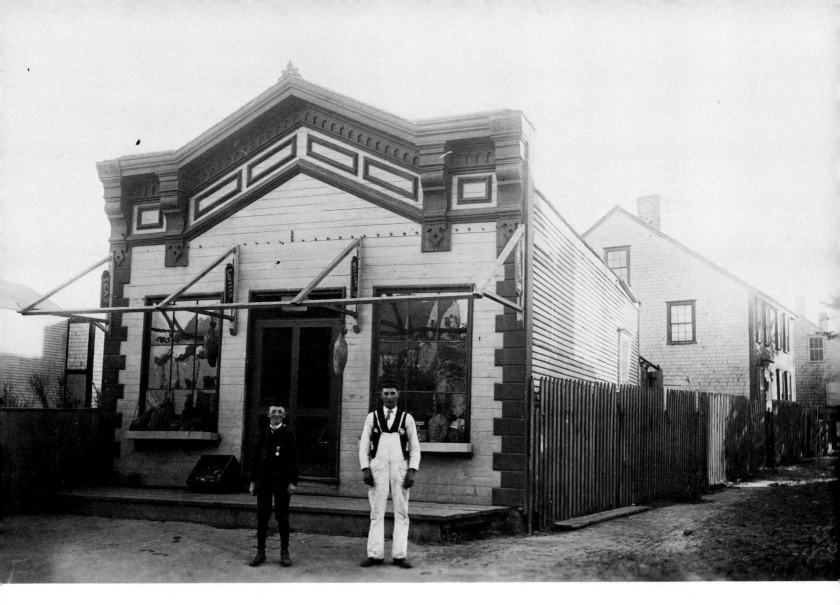

Shop on the Corner of West Dover and Orange Streets, ca. 1900 (above) **and 1975** (left).

At one time small shops were scattered throughout the town of Nantucket; a few remain today. In recent times this little shop has been Nantucket's bakery, the home of famous Portuguese bread.

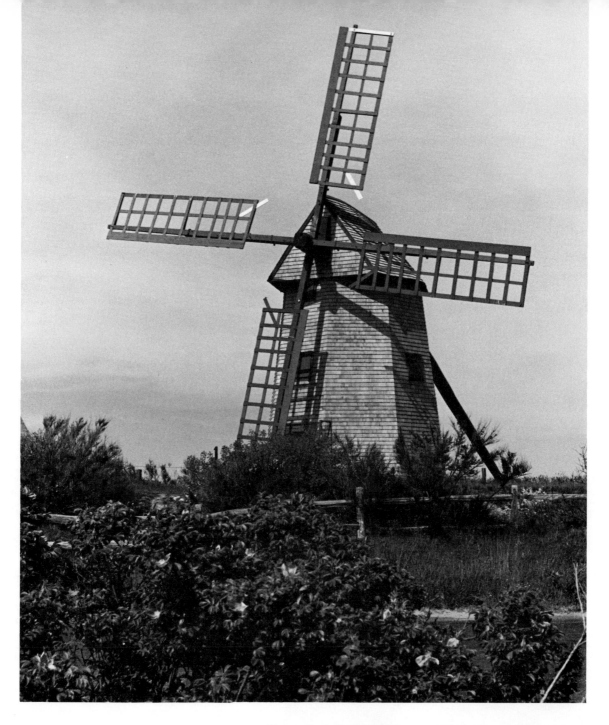

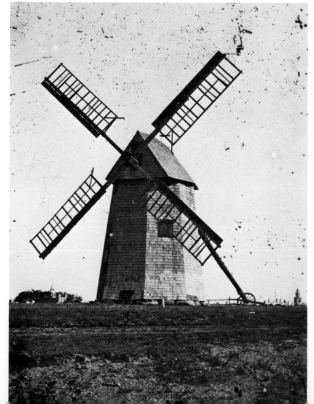

Nantucket's "Old Mill", ca. 1875 (left) **and 1975** (above). Nantucket's old mill, built ca. 1800, is one of the very few pre-Revolutionary industrial structures still standing and in operating condition. By 1822 the mill had lost its usefulness and was sold for $20 to be used for firewood. The buyer relented and repaired the mill. When the first photograph was made, the mill again was falling into disrepair. In 1897 the mill was bought and donated to the Nantucket Historical Association. The restored mill is open to the public and serves as a popular tourist attraction.

Chapter VI

OLD HOMES AND STREETS

On Nantucket Island one can trace the history of American architecture over a period of nearly 300 years, from early colonial farmhouses to contemporary vacation homes. Most of the houses in the old part of the town are over 100 years old; the oldest still standing was built in 1686. Nantucket's streets are medieval in lack of plan—crooked, short and fascinating, with lanes, courts and alleys branching everywhere. And Siasconset has what must surely be the shortest street in America—about ten meters long!

Nantucket's old homes and streets are characterized by a harmony that is found in few other places. Somehow houses more than a century apart in age fit together in a pleasing whole. There is no monotony; the rhythm is spritely with a mixture of old and new, plain and elegant, brick and cedar shingles. One is conscious of a balance as, moving down a street, the large houses are separated by small, and all are tied together with low fences along the street. No tall buildings or huge masses produce cacophonies as they so frequently do elsewhere. The harshness found in the past has been smoothed by thousands of trees, shrubs, vines and flowers.

But no purpose would be served here by discussing in detail the architecture of Nantucket. This has been covered superbly by Clay Lancaster in his *The Architecture of Historic Nantucket* (McGraw-Hill Book Co., 1972) which tells the story house by house and street by street.

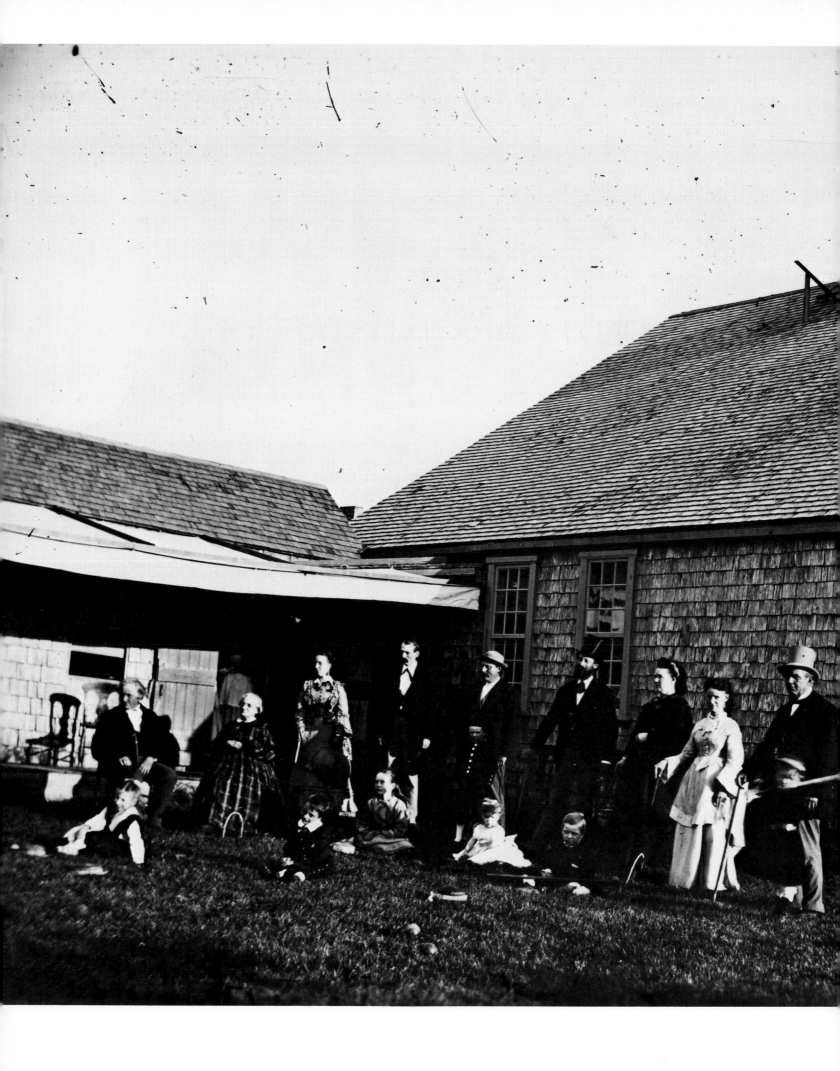

A Siasconset Farmhouse, ca. 1870.
Nantucket is most famous for its old homes, ranging from the simple ones built in the latter part of the seventeenth century to the elegant mansions of the nineteenth century. Here the photographer has interrupted a game of croquet.

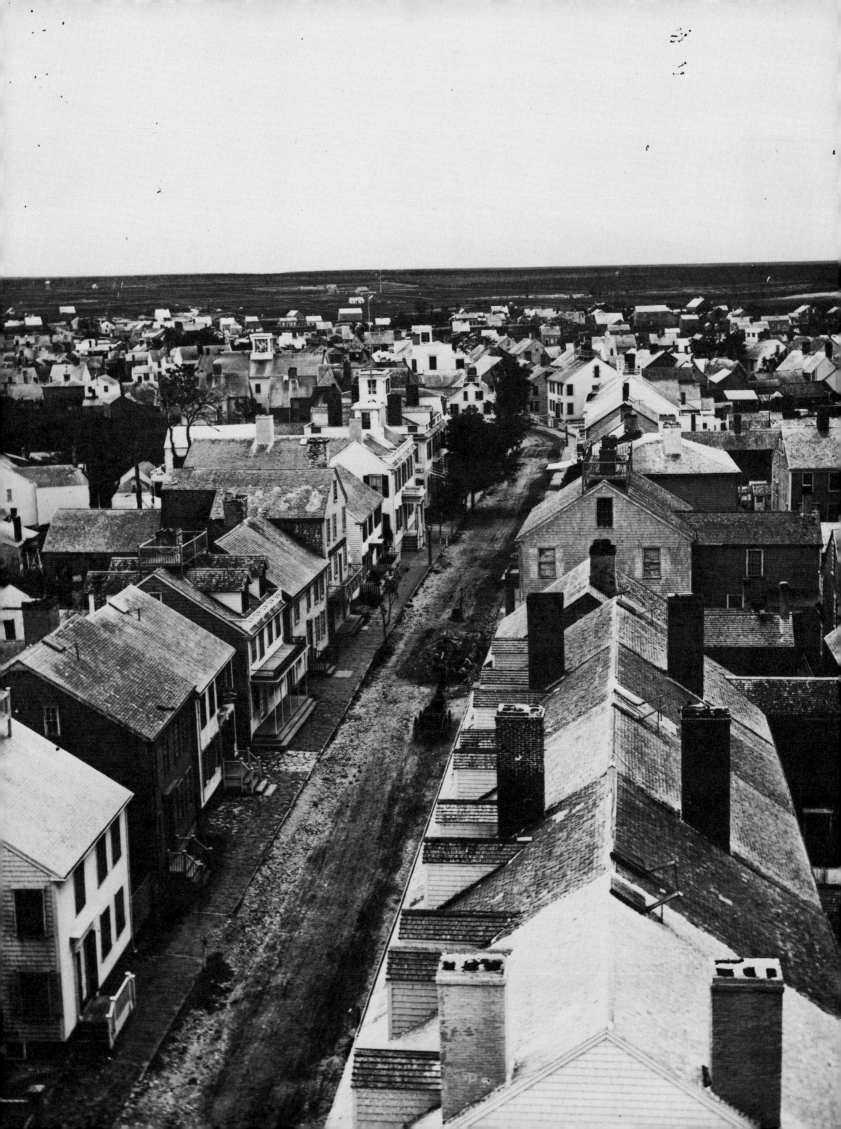

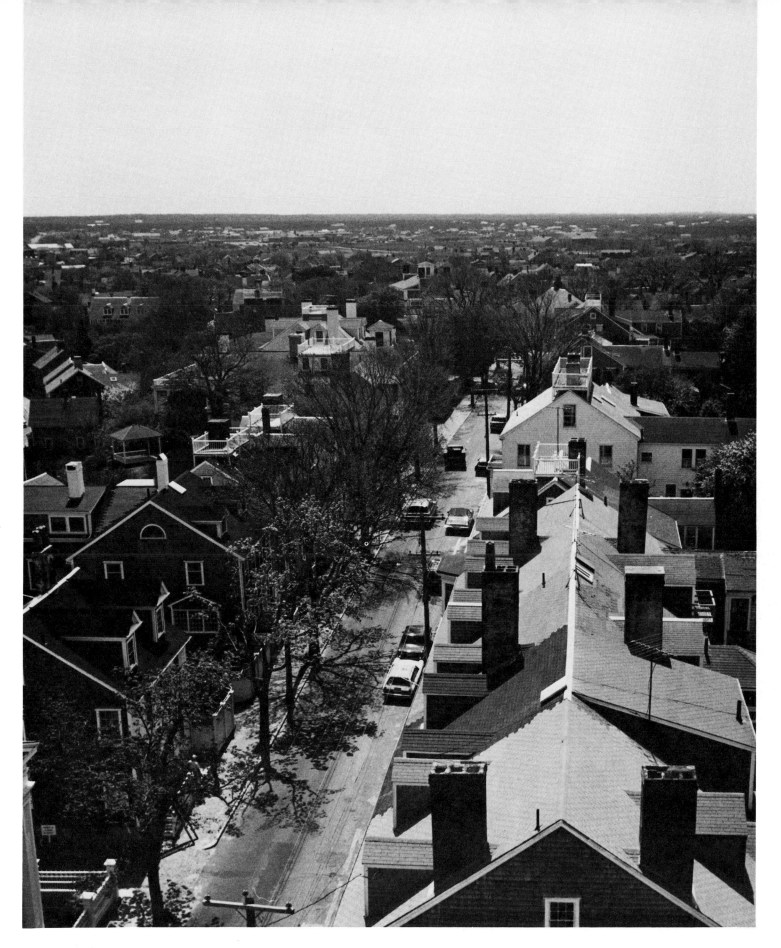

South on Orange Street from the South Church Tower, ca. 1870
(opposite) **and 1975** (above).
The rather dilapidated condition of the homes along Orange
Street is evident in the old photograph. The construction pro-
ject in the middle of the street is the excavation of a fire cistern.

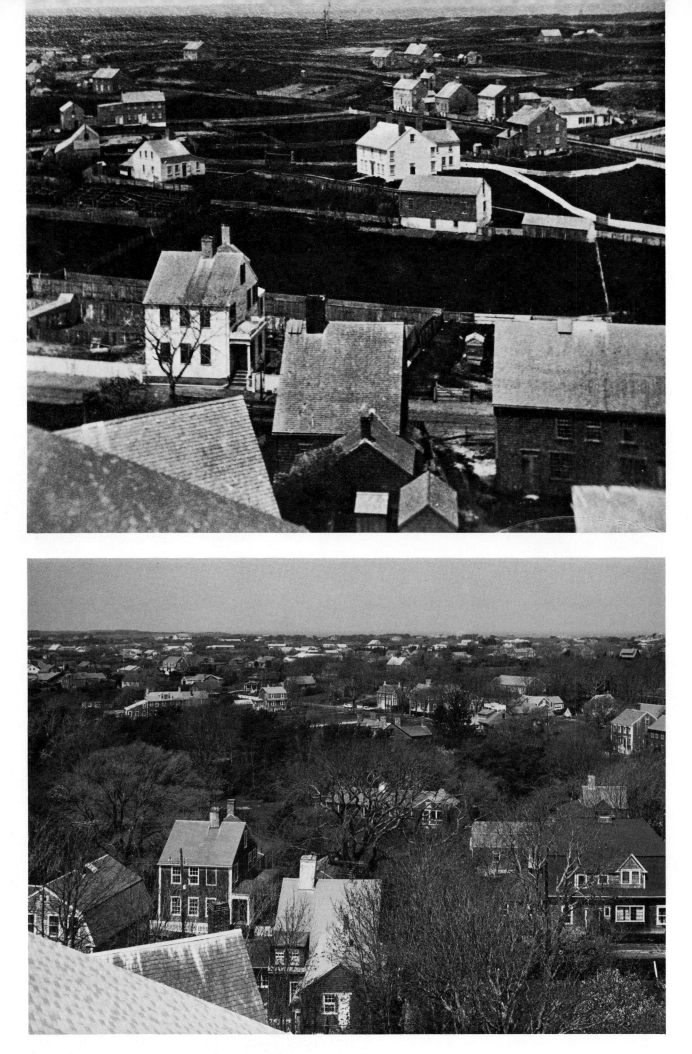

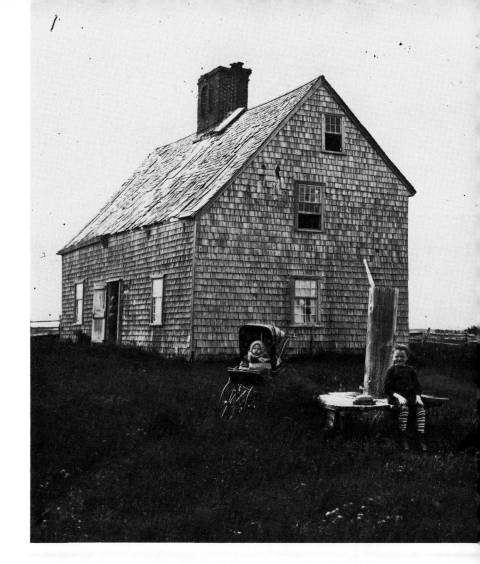

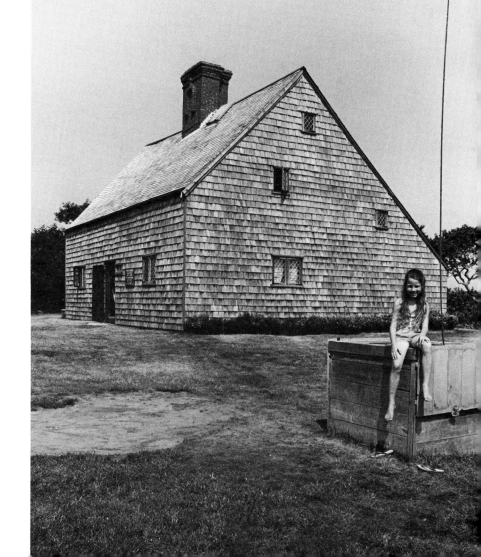

Opposite: **Northwest from the North Church Tower, ca. 1870** (top) **and 1975** (bottom).
This is part of the area known as the "Lily Pond." In the seventeenth century this area was a freshwater pond that drained into the harbor near the Children's Beach. Now it is mostly grass and trees with only miniature remnants of the old pond here and there. In the background are some of the oldest houses on Nantucket. The fences indicate that animals were pastured here.

Right: **Jethro Coffin House, ca. 1875** (top) **and 1975** (bottom).
Built in 1686, this house went through a number of changes, but it was never moved from its original site. At first the house was probably of the "English" type, with two gables on the front. Some time in the first half of the eighteenth century it was remodeled into the then-popular lean-to style, which was maintained in a restoration in the 1920s when leaded-glass casement windows, characteristic of the seventeenth century, were also incorporated. Nevertheless the building tells much about the second generation of houses on the island. Now owned by the Nantucket Historical Association, it is open to the public.

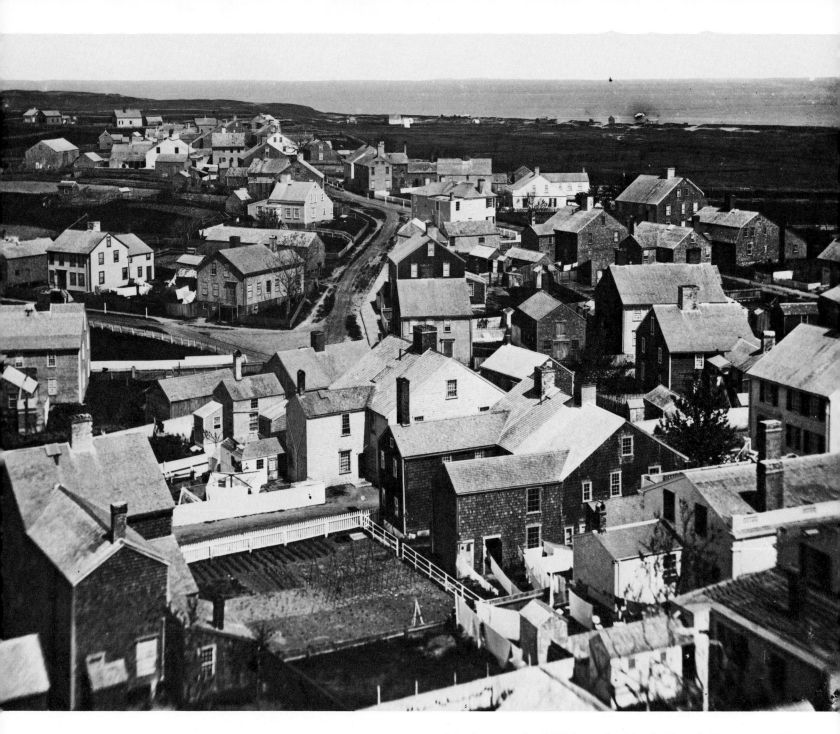

North up to the Cliff from the North Church Tower, ca. 1870 (above) **and 1975** (opposite).

On a Monday morning (all the clothes hung out to dry) in 1870 one can see that no summer homes or hotels had yet been built on the Cliff (left background), or Beachside (right background).

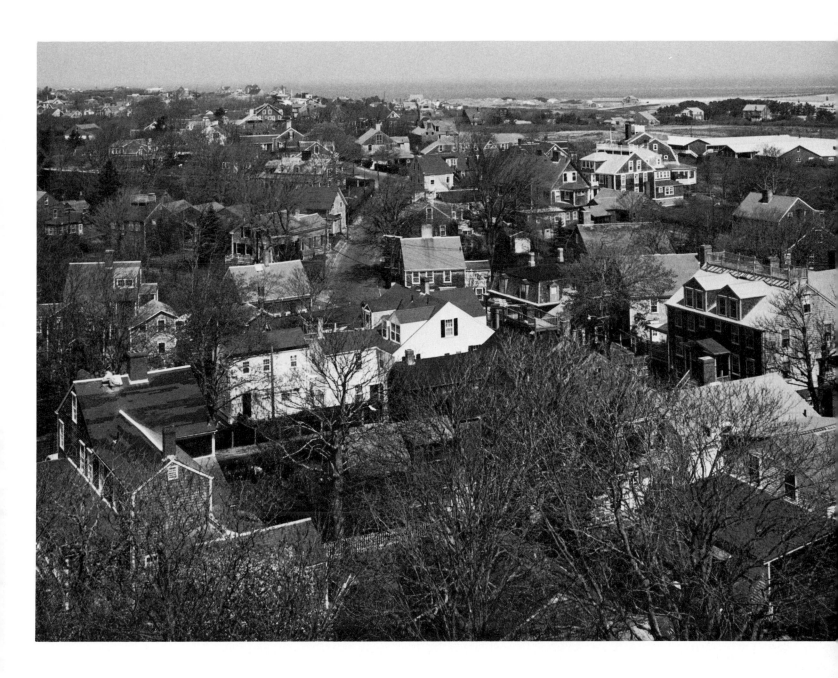

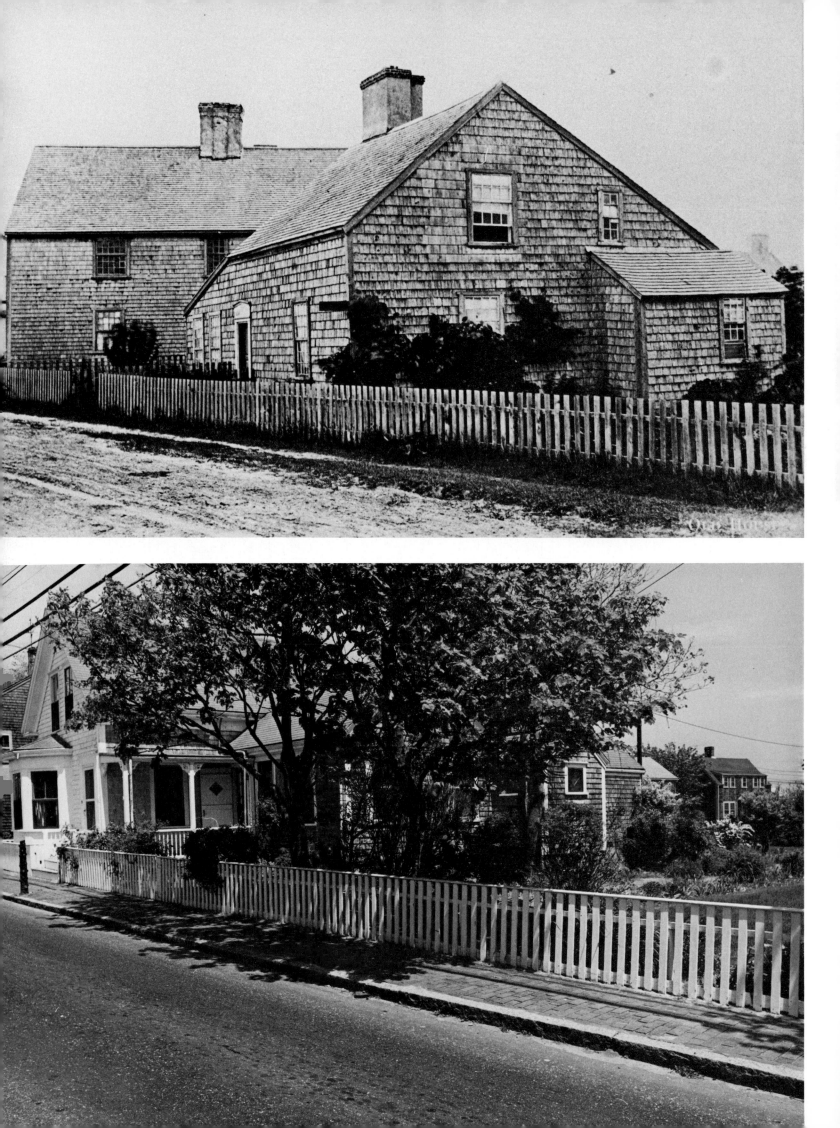

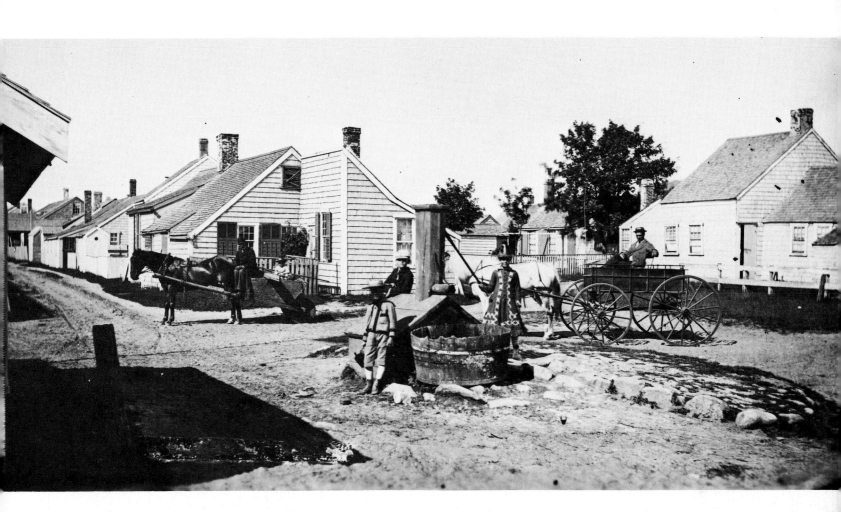

Opposite: **Lower Orange Street, ca. 1865** (top) **and 1976** (bottom).

Most of the houses lost during Nantucket's long depression were the very oldest. The two houses date in the 1865 view from the early eighteenth century. They were probably moved here, to what was then the newly divided "fish lot" section, from the older settlement in the western part of the island. The house in the background is set in the customary manner with its back to the north. The nearer house, which is probably the older, was obviously moved to this location and placed facing the street. Both were replaced by a modern house around the turn of the century.

The Old Pump, Siasconset, ca. 1884 (above) **and 1975** (right).
A number of community wells existed on the island in early times, a few of which have been preserved. Siasonset's well and pump once served a large part of the village. Now a guard rail around the old pump protects it from automobiles.

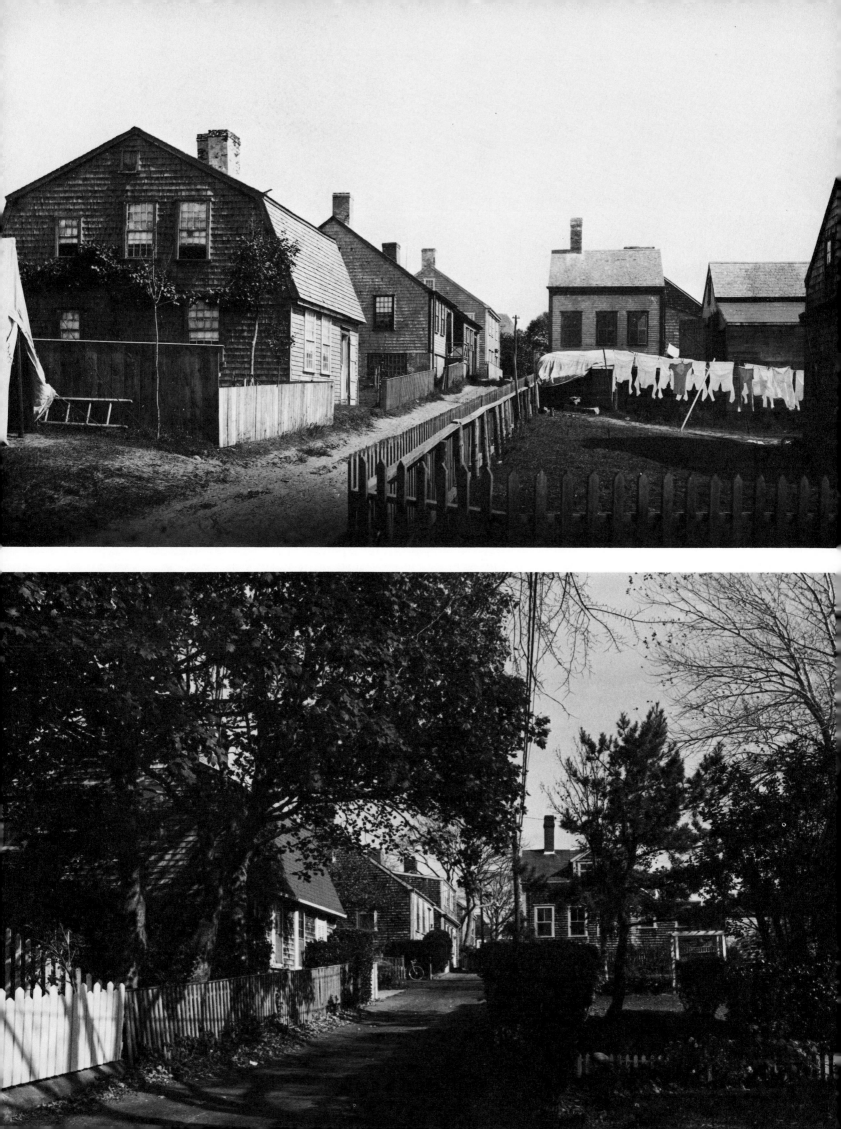

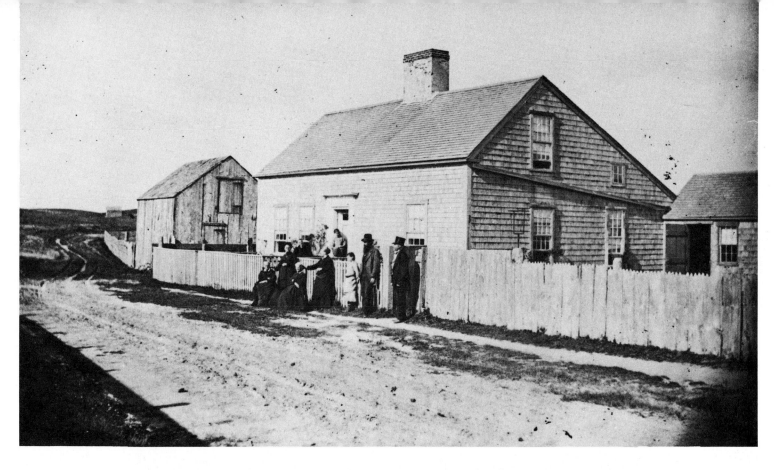

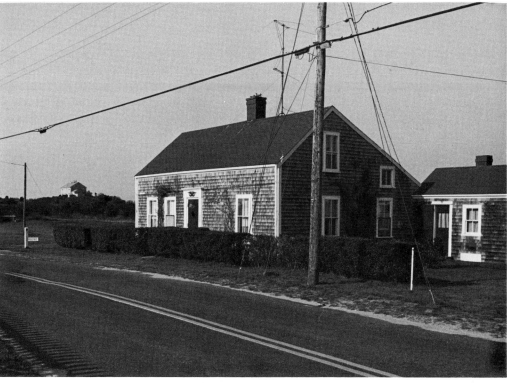

Opposite: **Farmer Street, ca. 1880** (top) **and 1975** (bottom).
These two pictures clearly illustrate why Nantucket is more
attractive today than it ever was in the past. The only changes
in the homes are the dormers on the two houses in the back-
ground. Trees, lawns, gardens and hedges all enhance what
before was a rather grim scene. The gambrel-roof house on the
left was built in about 1768. From the evidence of the laundry,
Nantucketers once must have worn "long johns" winter and
summer.

Above: **39 Milk Street, ca. 1870** (top) **and 1975** (bottom).
This house is typical of 1 3/4 lean-to cottages built on the out-
skirts of the town, often serving as farmhouses. It also is illus-
trative of the unfortunate changes that were made in the latter
part of the nineteenth century. The large chimney was taken
down and the fireplaces removed when stoves and/or central
heating was installed. Also the old multi-panes windows were
replaced by anachronistic 4/4 windows. When the old photo-
graph was made, a family of nine apparently lived in this small
house.

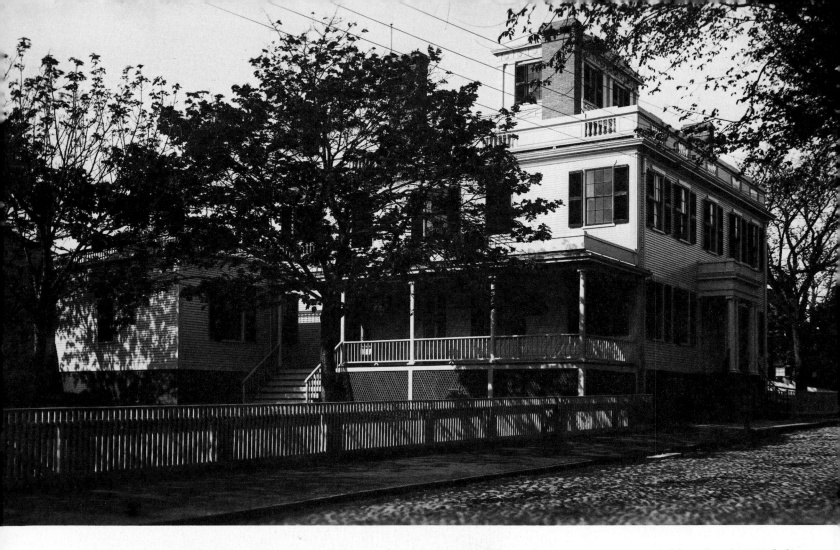

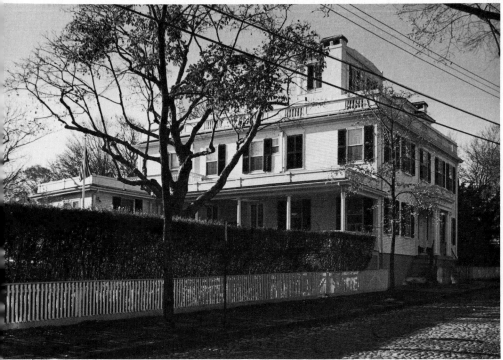

72 Main Street, ca. 1910 (above) **and 1975** (left). This is one of the earliest of the grand nineteenth century mansions on Main Street. Built in the 1830s, it has remained virtually unchanged.

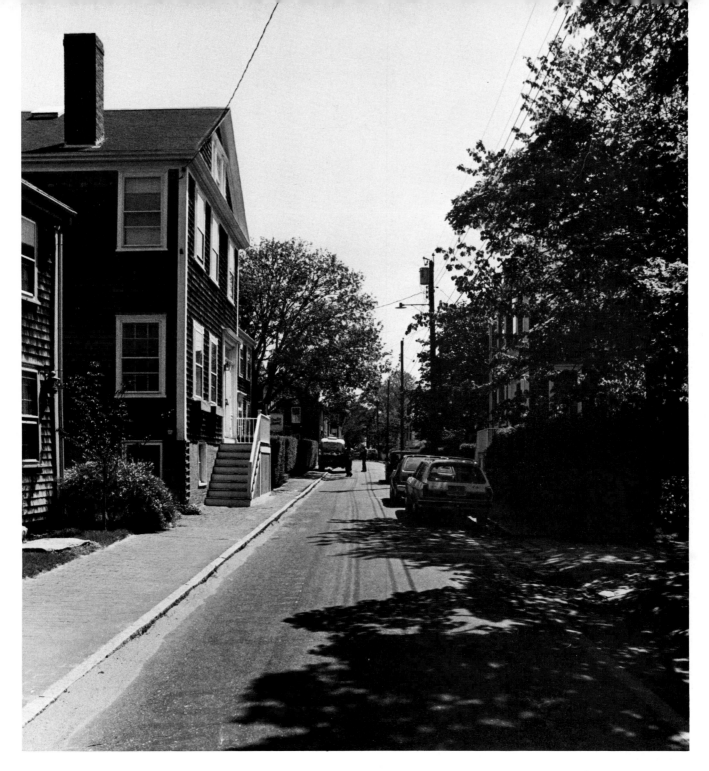

East on India Street, ca. 1870 (right) **and 1975** (above). Nearly all the homes on India Street that were there in 1870 remain today.

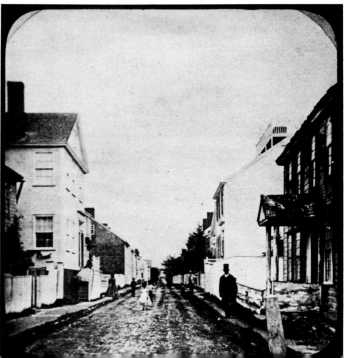

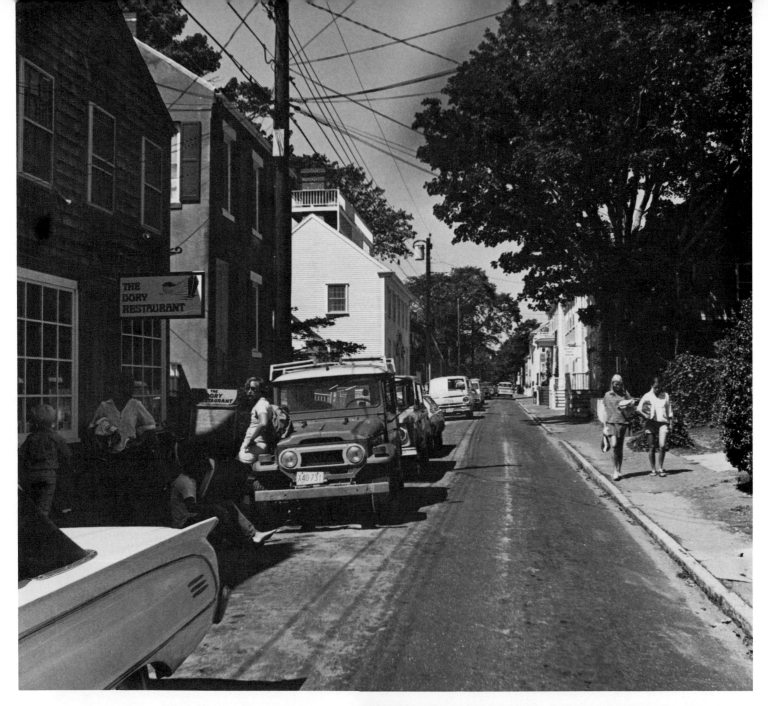

West on India Street, ca. 1875 (right) **and 1976** (above).
A few commercial enterprises have crept into the end
of India Street nearest the center of town, and the grass
growing in the street in 1875 has disappeared with
prosperity. Nantucket still suffers from fires that are
often total. The white house on the left side of the
street in the 1976 view replaces one that burned to the
ground in the early 1960s. The total loss occurred only
two blocks from Nantucket's central fire station. The
"balloon" plan of construction of old houses causes
them to be consumed quickly by fires. In the winter,
when the island's population is smaller, fires some-
times go unreported until they are out of control. Un-
like the past, Nantucket today is protected by an ef-
ficient fire department with modern equipment.

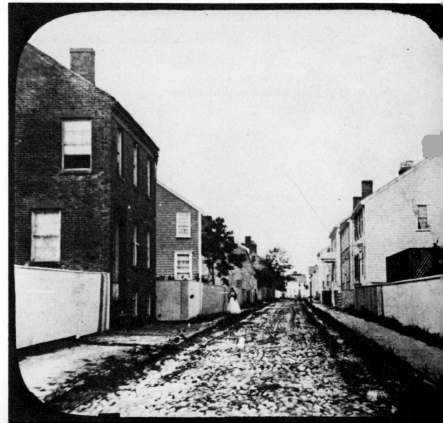

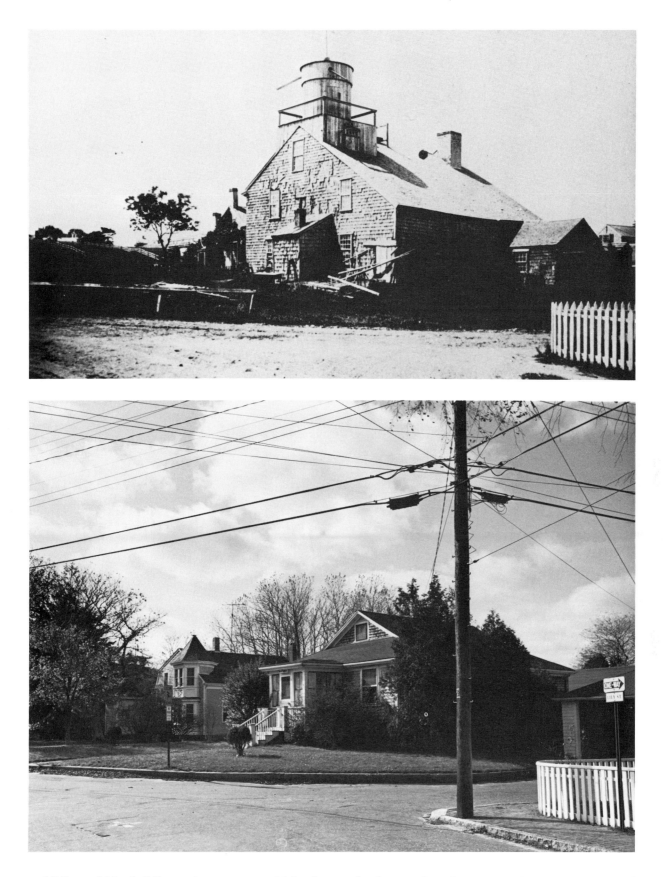

The Corner of Lily and North Liberty Streets, ca. 1885 (top)
and 1975 (bottom).
The past has its amusing aspects. Here once stood an old house,
probably built in the early 1700s, with its back to the north,
away from the street and sitting on a low foundation (evidence
that the house was on its original site). Before it went com-
pletely to rack and ruin, a mad inventor attempted to install a
horizontal windmill on the roof. It never worked. The modern
replacements are characteristic of bungalows built and occu-
pied by Nantucket natives when the resort business began to
grow.

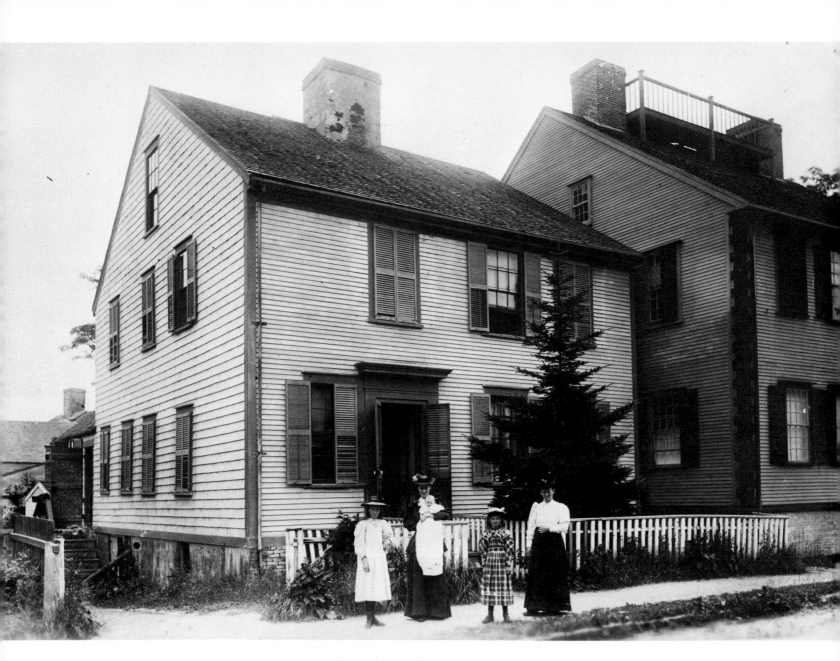

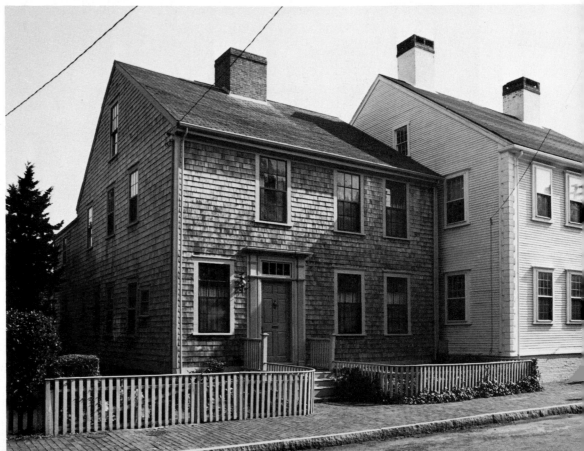

Opposite: **Nos. 16 and 18 Union Street, ca. 1900** (top) **and 1975** (bottom).

Many of Nantucket's old houses show only minor changes. Although No. 16's original lapstrake siding had been replaced by gray cedar shingles, it has gained a somewhat more elegant doorway with lights. No. 18 is one of the few early houses to be dressed up with wooden quoins. Its stoop and railing came from the original Pacific Bank building that burned in the fire of 1846. No. 18 has lost its "widow's walk." Contrary to tradition, these "walks" were not designed to provide widows with a view of the harbor or ocean; many are located in areas where no such view is possible. Their original purpose was to provide access to the chimney for cleaning and fire prevention, and they consisted of nothing more than a simple platform and railing around the chimney. Later they were enlarged and developed into rather elaborate roof ornamentations.

Fair Street, ca. 1870 (right) **and 1975** (below).

Although none of the houses has been altered substantially, it is evident that Nantucket has made major aesthetic improvements over the last century. It is also clear that parking of trucks and automobiles on the narrow streets and sidewalks forces one-way traffic and, together with the utility poles, detract materially from what would otherwise be an almost perfect setting.

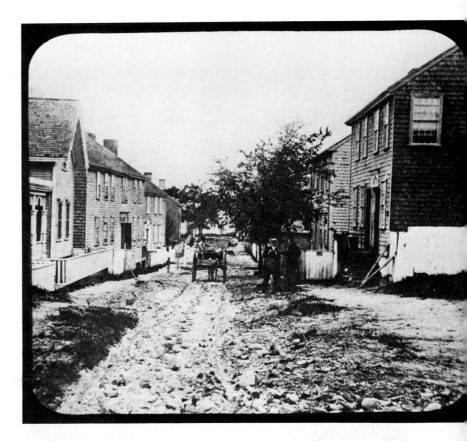

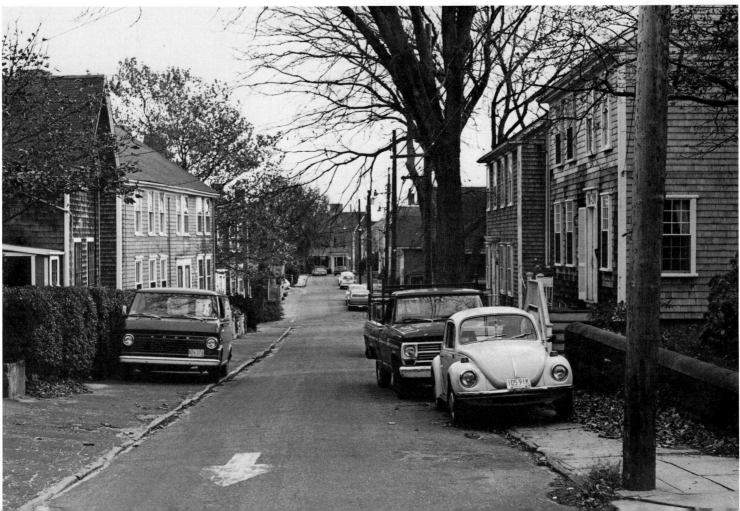

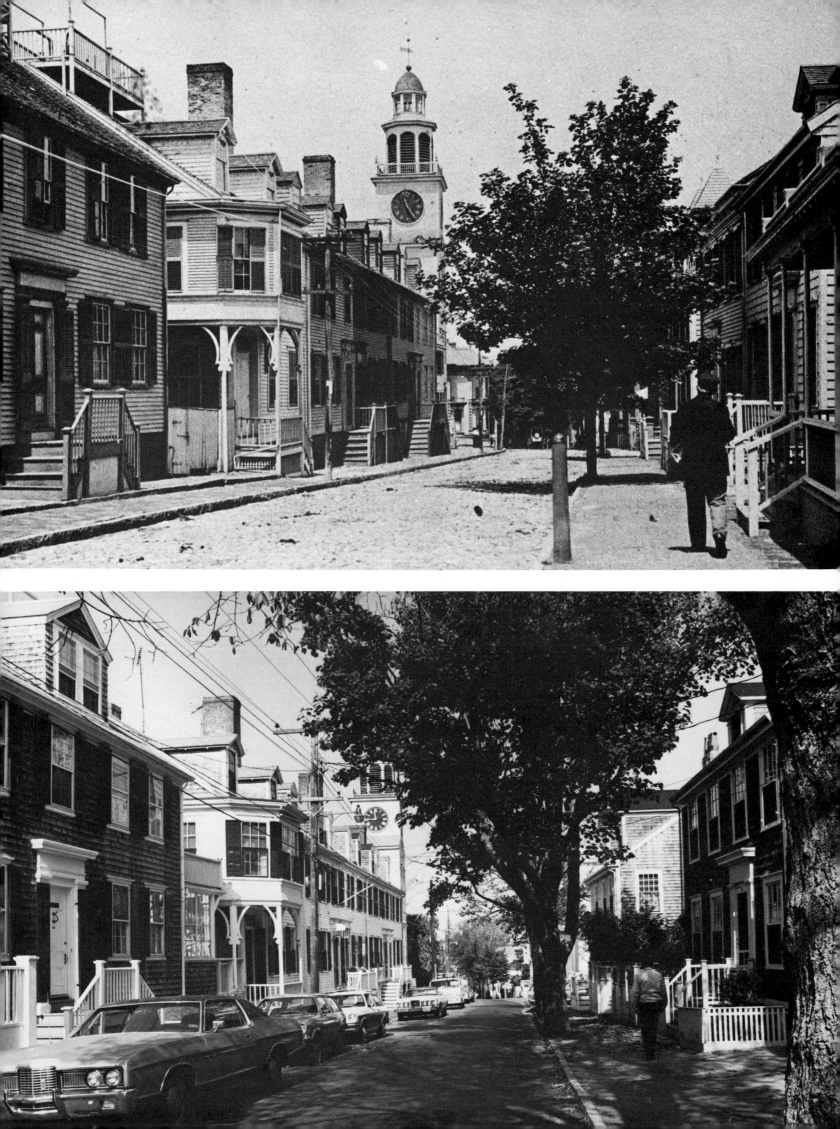

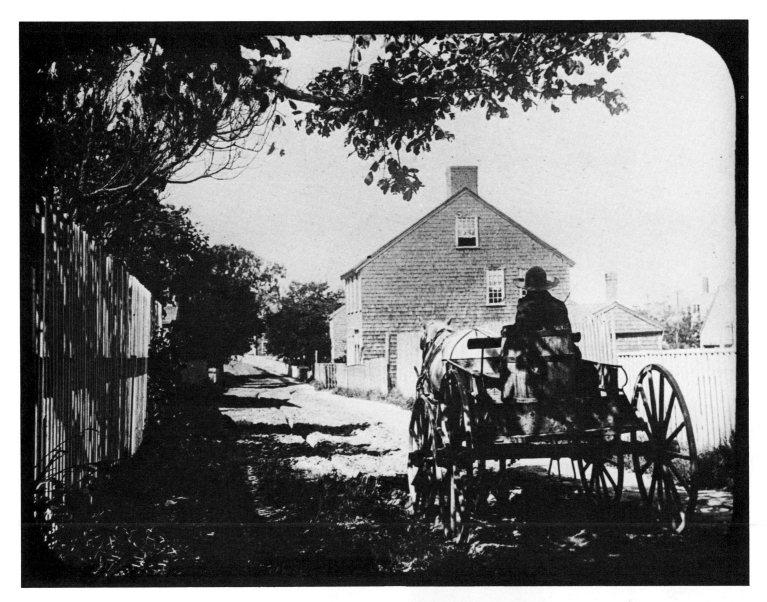

Opposite: **Orange Street and the South Church Tower, ca. 1890**
(top) and 1975 (bottom).
The principal changes are the incursion of automobiles and the
growth of the trees.

Mill Street, ca. 1870 (above) **and 1975** (right).
Many of Nantucket's quiet side streets generate very little
traffic. The only major change to the house in the center, which
was built shortly after the Revolution, has been the addition
of a second story to the wing. The preservation of traditional
fences has contributed to the harmony of the old part of Nan-
tucket.

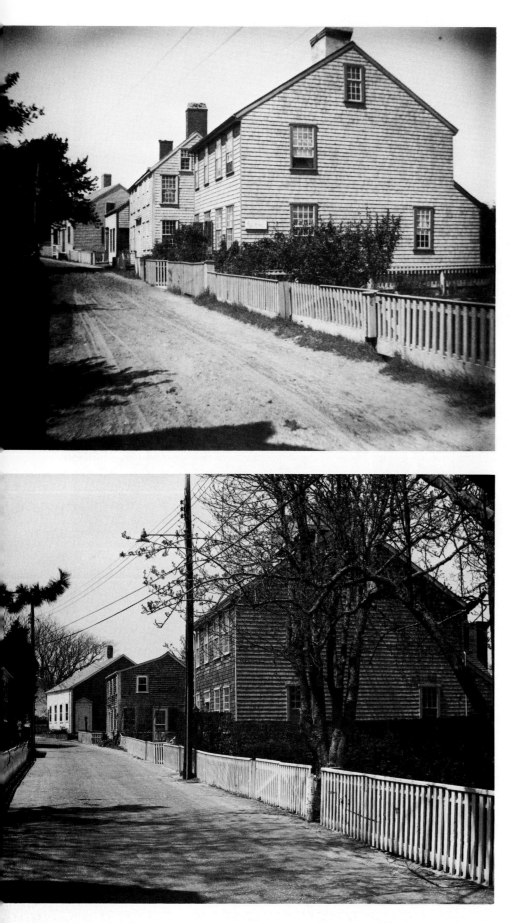

Left: **East End of Vestal Street, ca. 1890** (top) **and 1975** (bottom).

The closest house is the birthplace of Maria Mitchell, Nantucket's famous astronomer and professor at Vassar College. Next beyond stood a five-bayed, two-and-a-half story house with end chimneys, 12/12 fenestration, set low to the ground. Probably built before 1800, it is a type quite scarce in the town. It was taken down early in this century by the Maria Mitchell Association to provide room for a small observatory.

Opposite: **Nos. 11 & 13 Vestal Street, ca. 1880** (top) **and 1975** (bottom).

Saving a street or neighborhood often involves both preservation and renovation. The house in the foreground was little altered on the outside, but had been converted into two apartments on the interior. The interior was restored in the late 1960s to its original floor plan. The house in the background, No. 13, had been altered by the addition of an unsightly bay window over the front door. The house was enlarged one bay and carefully restored by its architect-owner in the 1920s. Trees, shrubs, vines and flower gardens in the rear complete the picture.

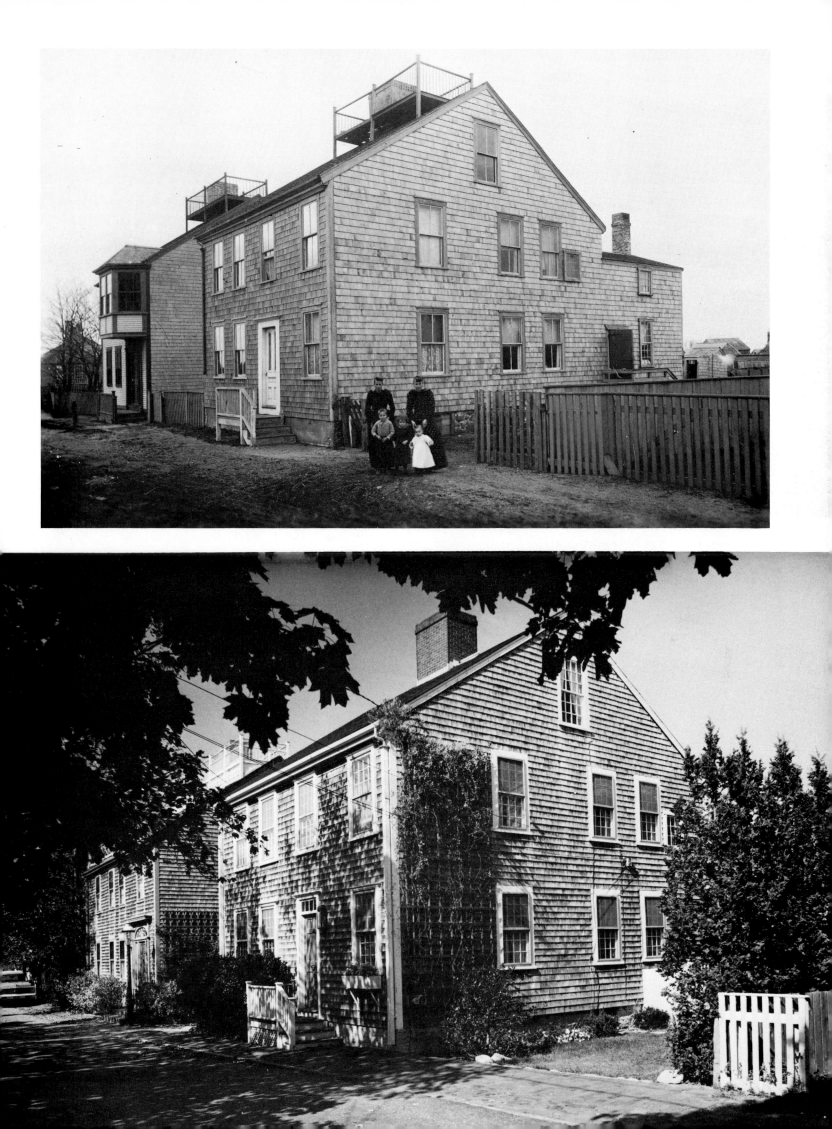

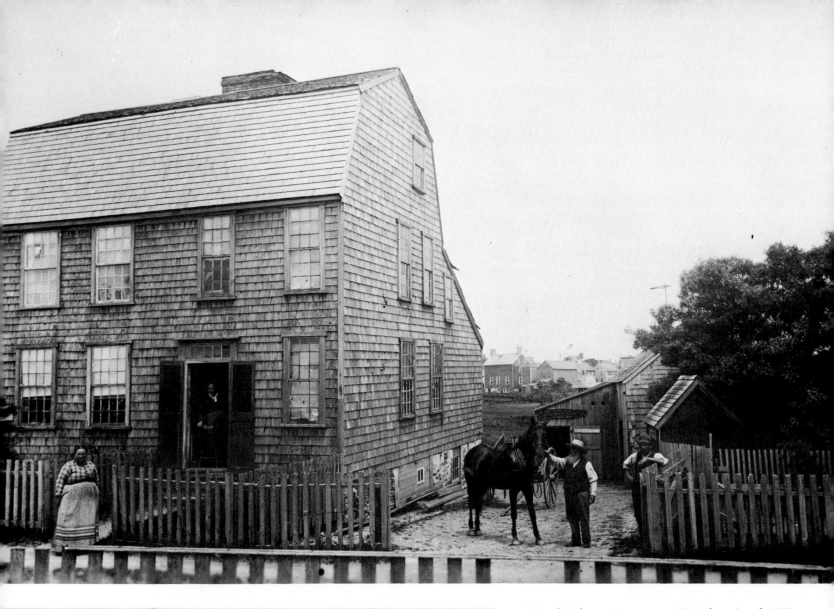

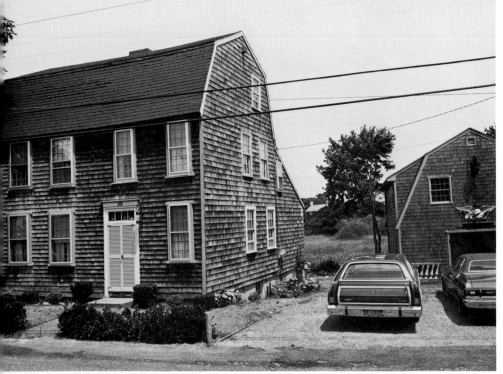

6 North Liberty Street, ca. 1880 (above) **and 1975** (left).
This unusual house was built in 1798 as a gambrel roof adopted to the lean-to style. The principal change to date seems to be in the mode of transportation.

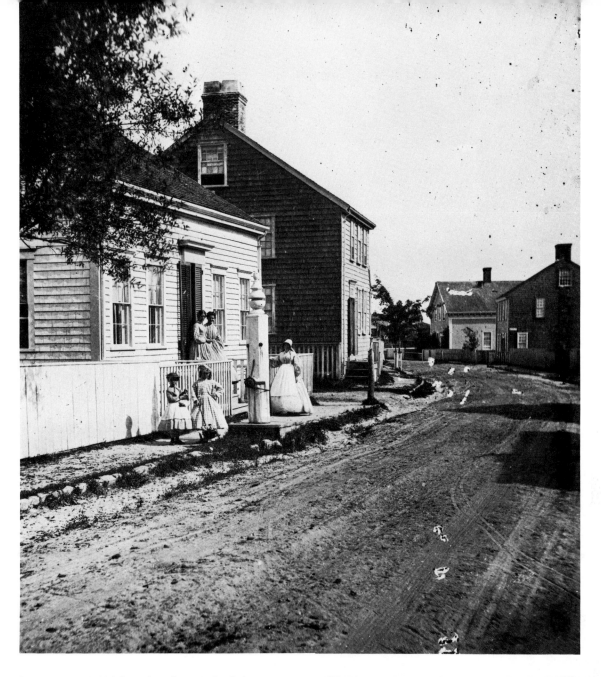

Lower Orange Street, ca. 1865 (above) **and 1975** (right).
One of Nantucket's community water pumps stood at the gutter
on Orange Street near the intersection with Beaver Street.
Today a street sign marked "children" stands like a tombstone
on the exact spot where, over 100 years ago, two small children
stood to be photographed in their Sunday best. Now utility
poles and wires dominate the scene in an area of Nantucket
that is ripe for renovation.

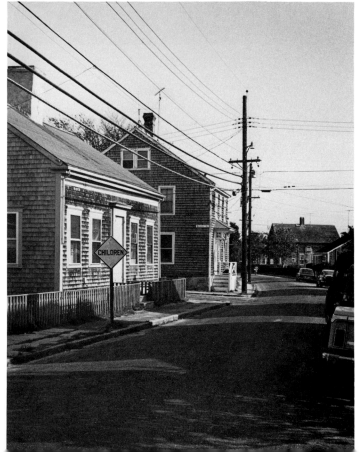

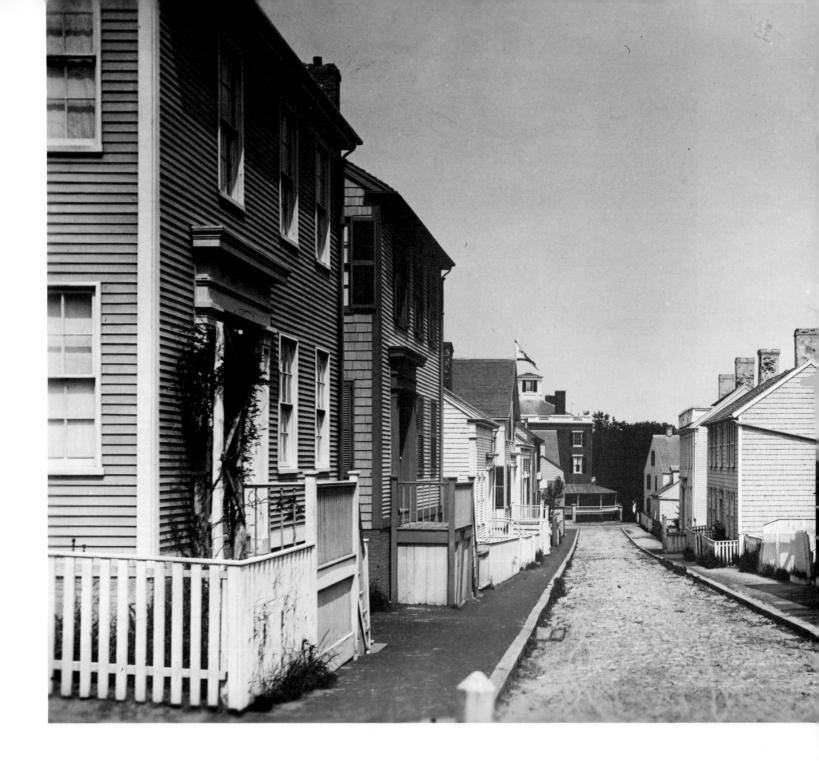

East on Gay Street, ca. 1880 (left) **and 1975** (below).
The double house (right foreground) was built in 1835 as a factory for the Atlantic Silk Co. The silk industry on Nantucket was subsidized by both the town and the state. Steam-powered looms provided employment for 20 "hands." The state offered a bounty of $1.00 for every ten pounds of cocoons raised and $1.00 for every pound of silk reeled. The town subsidized the planting of mulberry trees. After seven years, the subsidies ended. The mill closed a year later.

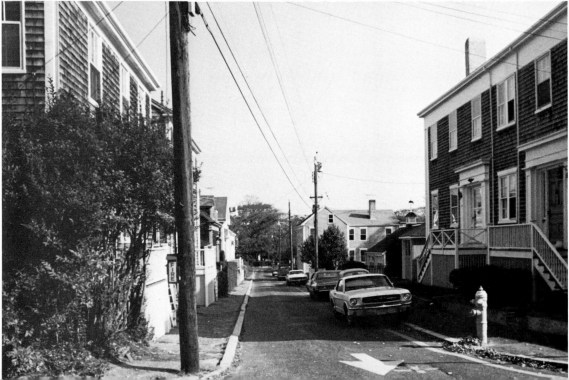

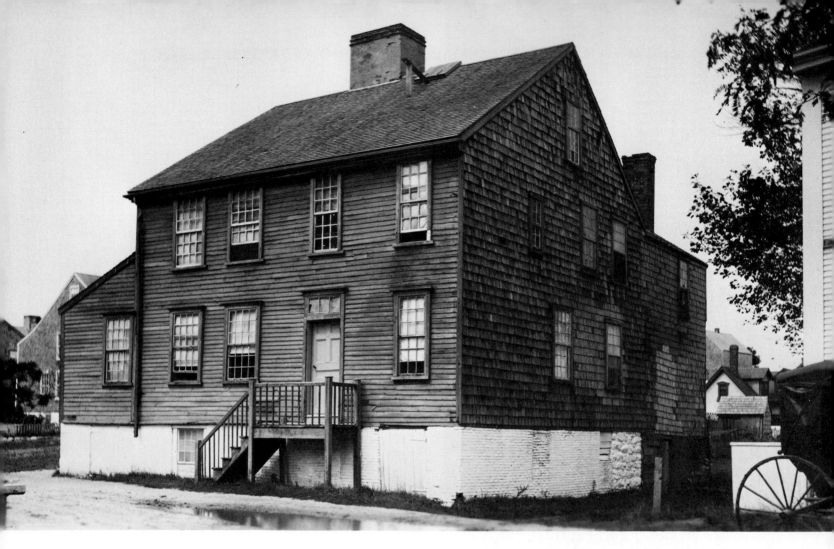

Corner of Cliff Road and Easton Streets, ca. 1880 (above) **and 1975** (right).

A typical Nantucket house once stood on this corner. It was taken down to provide room for a modern house about 1900. Unlike the older houses, most of which have been preserved as residences, many later houses have become commercial rooming houses.

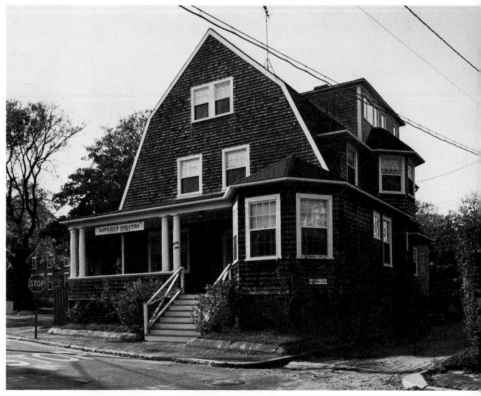

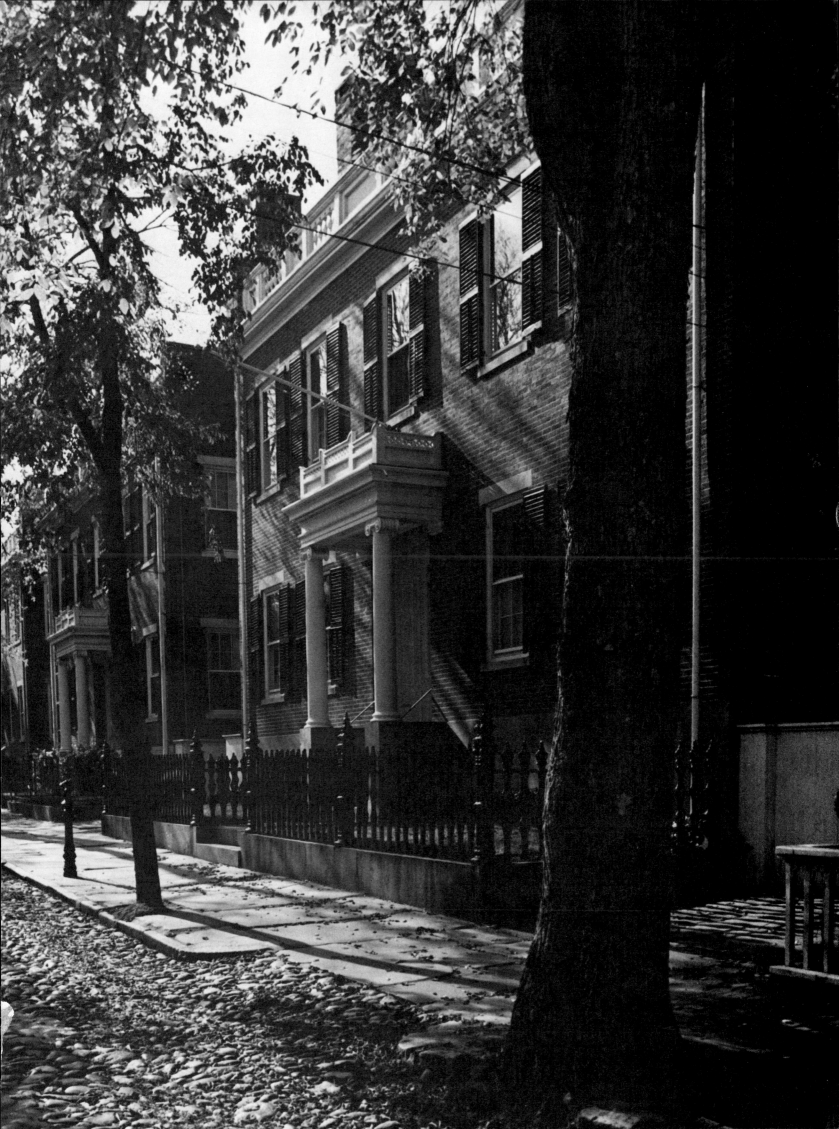

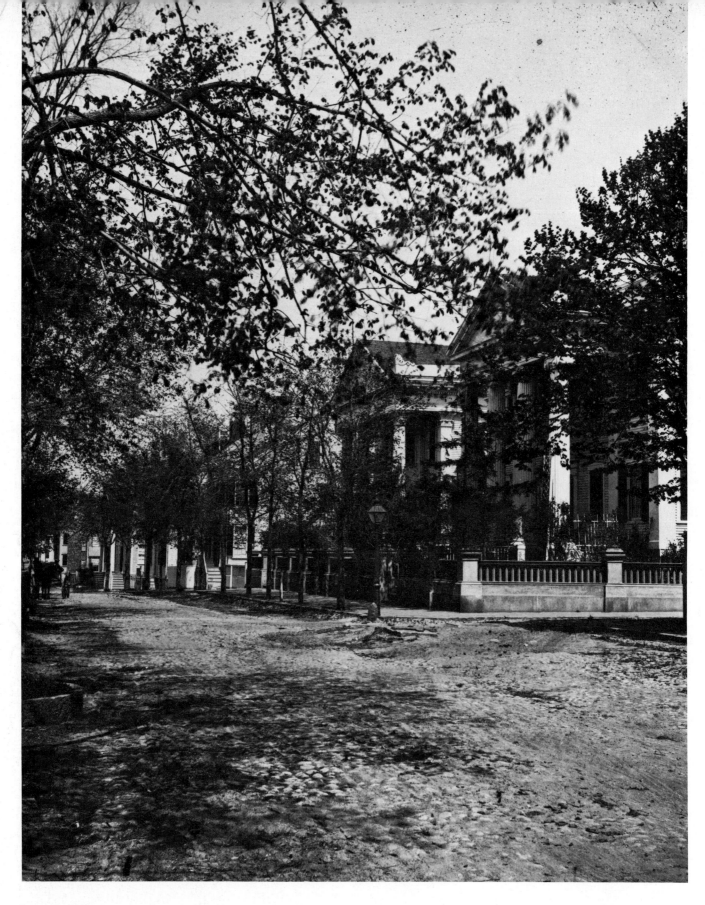

94 and 96 Main Street, ca. 1875 (above) **and 1975** (opposite).

Two beautiful examples of the Greek Revival style grace Main Street. Commissioned by the same man and built by the same master builder, they are actually quite different in plan and style. No. 94 is a private residence, but 96 now belongs to the Historical Association and is open to the public. The two photographs illustrate the ideal yet to be reached: underground utilities, restriction of automobile traffic, restoration of appropriate street lighting and the removal of anachronistic additions to old houses such as the two-story addition to 92, center rear.

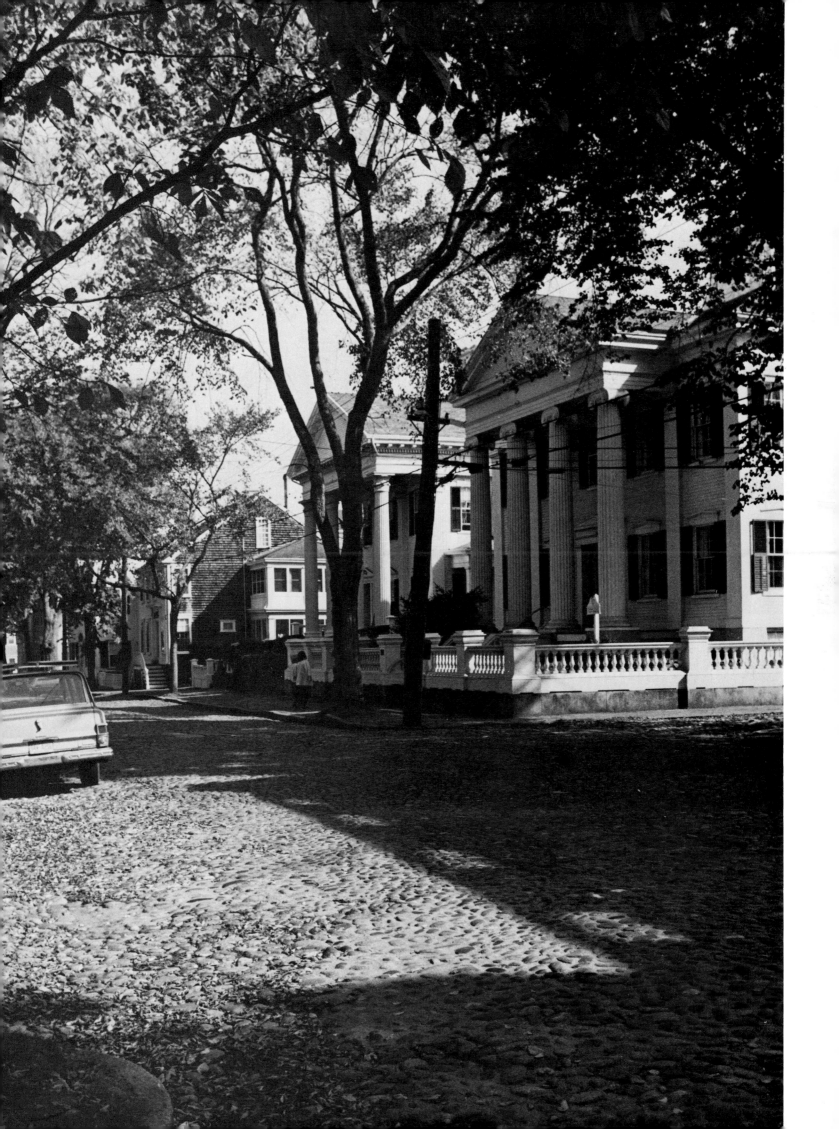

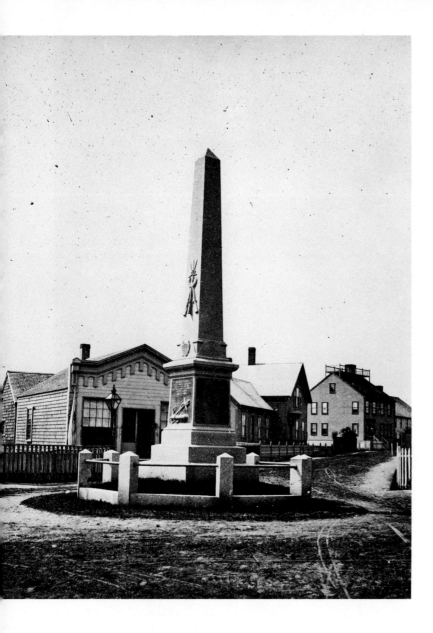
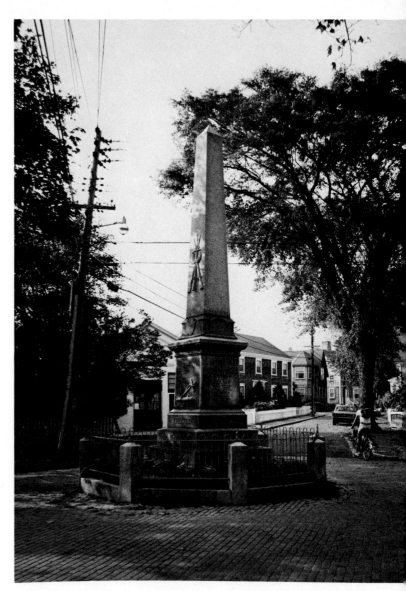

Civil War Monument, Main Street, ca. 1880 (left) **and 1976** (right).

Dedicated on Memorial Day, May 30, 1875, this monument was just 101 years old when the new photograph was made. The base of the monument was fashioned from a millstone taken from the Round-top Mill (page 69). An exception that proves the rule that all commercial buildings are expendable but homes are saved, the little commercial building standing behind the monument (left) has survived for many generations. The structure has served various commercial enterprises; at one time it was an A & P grocery store. And to continue the exception, all the houses are replacements of older structures. How much more graceful and appropriate is the lamppost and lantern in front of the little store than the modern street light jutting from the listing utility pole.

Chapter VII

THE COUNTRYSIDE

Nantucket's attraction as a resort did not come only from the preservation of old homes and other buildings, its seventeenth-century street system, the museums and other man-made attractions, important as they are. The development and success of the whaling industry caused a concentration of the island's population into a small area on the harbor. Most of the remaining 50 square miles remained open countryside. The effect of all the economic and social forces working on the island resulted in what is known today as "cluster zoning." This was not a planned development, but it has worked to the good fortune of Nantucket because the island has not been seriously afflicted with "urban sprawl." Today one can still walk to the countryside from any place in town in a matter of minutes.

During Nantucket's period of depression many tried to earn a living by farming. Land was planted in many areas of the island, but with little success. The soil was poor, fertilizer was expensive, the growing season was short and the only market was a local one. Truck crops could be sold in the summer to hotels, restaurants and other consumers, but the volume was much too small to provide a satisfactory income. Most farming ventures ended as failures or, at best, subsistence operations. As the resort industry expanded, more food and other goods were imported from the mainland and many farms were abandoned. As formerly cultivated land was returned to natural ground cover, the island countryside again took on the appearance it had during the early period of sheep raising. But it was modified in two ways: trees had been planted in several parts of the island, and they spread into small forest areas; and a scattering of summer homes supplanted abandoned farmhouses.

Thus the charm of Nantucket town was greatly enhanced by being set in a countryside of open lands, forest, ponds and, perhaps her greatest asset of all, miles of open, undeveloped beaches. Although all these natural resources were privately owned, for the most part they were not restricted or posted. They were used by vacationers and residents alike as if they were public property. These uncrowded, open lands and beaches made for excellent fishing, swimming, hiking, hunting, bird-watching, bicycling, horseback riding and exploring—all at no cost to the individuals enjoying Nantucket's natural bounty.

The photographs of the countryside show only minimal changes in many areas. Behind the unspoiled beaches are the dunes, beach grass and the salt marshes filled with bird life. Then come the rolling moors with their wild flowers and small animals. The moors are broken frequently by ponds, large and small, many of which reflect only the sky and nothing man-made. Farther inland are the hills and forests populated by hundreds of deer fenced in by the natural water boundries.

The countryside is reached by only a few public two-lane paved roads because most of the population is in the town, and there is no heavy traffic to other parts of the island. There are no traffic lights and few stop signs. One paved road leads west to Madaket, another east to 'Sconset and a third goes northeast through Polpis to Wauwinet with a branch to Quidnet. There are two short paved roads to the south shore and one to the airport. That is all. The remaining island roads are unpaved tracks in sand or dirt; some can be used only by four-wheel-drive vehicles.

Overleaf: **Pond North of West Chester Street, ca. 1910.**
Although summer homes have been built along the Cliff (background), most of the island remains open. The split-rail cattle fences indicates that livestock were pastured here. Today, a remnant of the pond remains on land used to pasture riding horses.

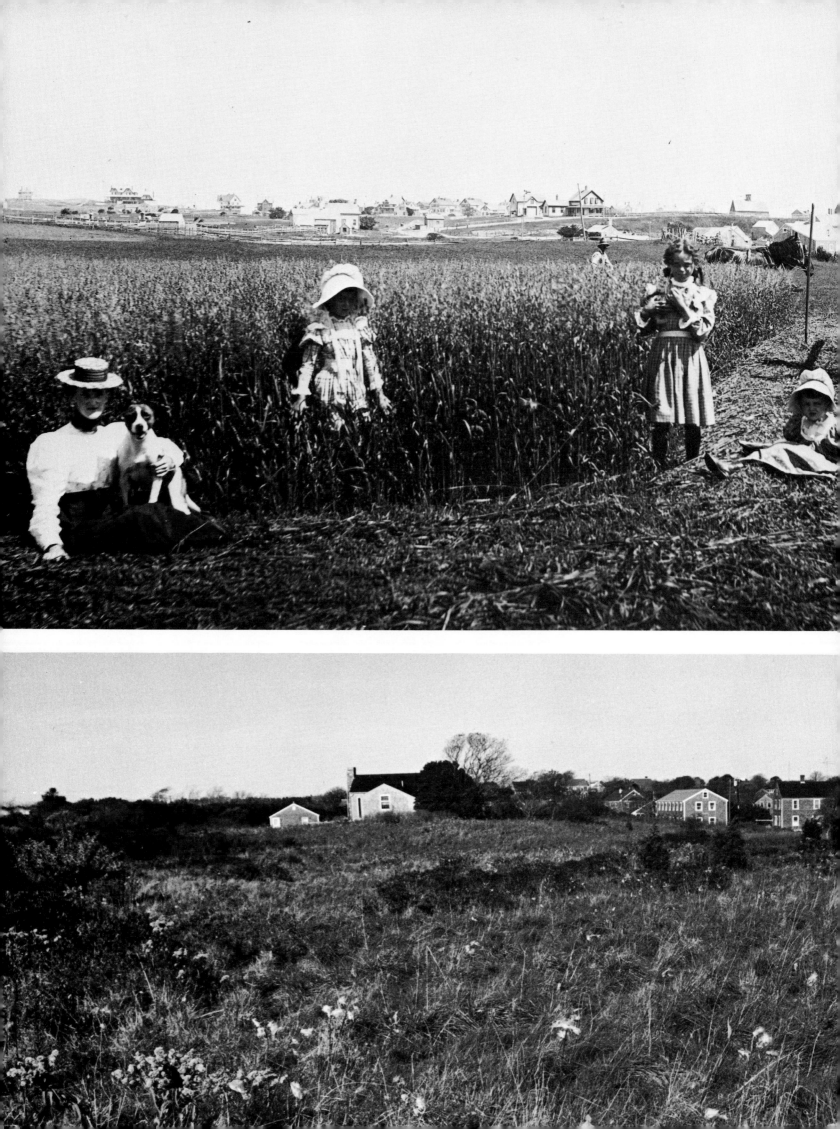

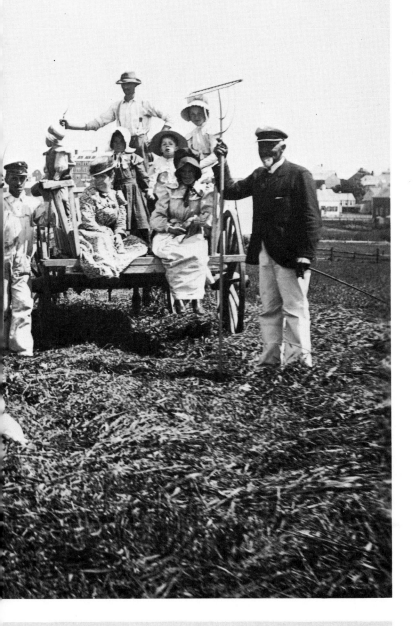

The Edge of Town, ca. 1914 (top) **and 1975** bottom).
This view is near the end of Lowell Place just a short distance
from Main Street, a part of the area known as Richard Gardner's
"Crooked Record," bounded by Main, Gardner, North Liberty
Streets and New Lane. Although crops have given way to hous-
ing on some of the tract, a large part has remained open since
the island was settled in 1659. Such open areas near the edges
of the old town belie the need to build housing developments
out on the moors, destroying Nantucket's characteristic open-
ness.

THE COUNTRYSIDE 141

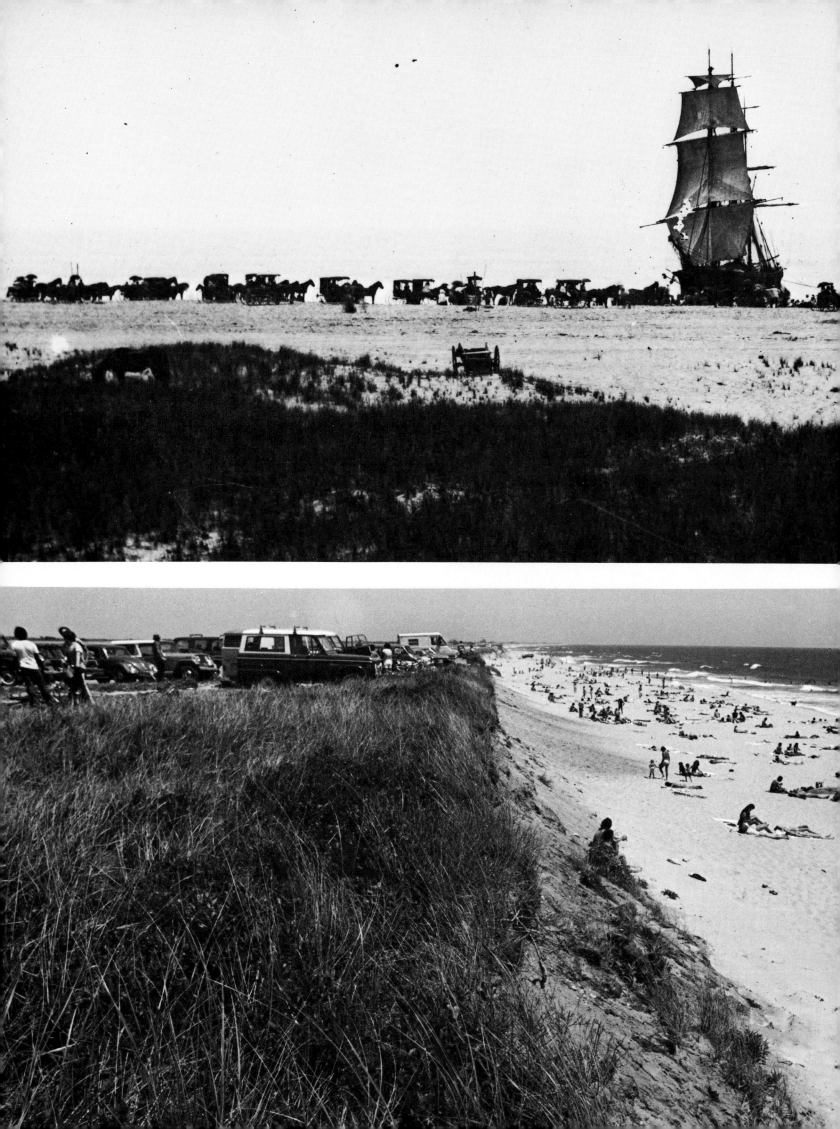

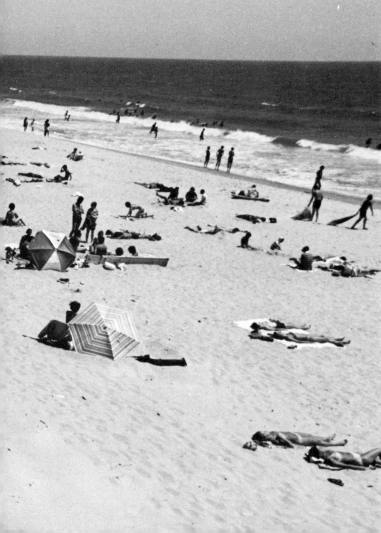

Treasure on Nantucket's South Shore, 1873 (top) **and 1975** (bottom).

On July 30, 1873, the British bark *Minmanoeth*, out of Rio de Janeiro, Brazil, was stranded on the south shore on her way to Boston with a cargo of 4,000 bags of coffee. Nantucketers converged on the beach with wagons and carriages. After discharging about 1,000 coffee bags, the vessel was refloated. No doubt the island was well supplied with coffee that year. In mid-summer, this same stretch of sand is now covered with a near-naked, nubile pulchritude which has arrived in gasoline carriages in search of carnal treasure.

THE COUNTRYSIDE 143

The South Shore at Hummock Pond, ca. 1880 (above) **and 1975** (right).

One of Nantucket's greatest assets is its miles of open beaches. Although the ever-changing sand is in constant movement, the dunes seem always to reconstitute themselves in similar patterns. Only the difference between cart tracks and jeep tracks distinguishes these two pictures. But closer inspection shows the shape of things to come: dotted along the whole horizon in the 1975 view are the houses and condominiums of a large development extending inland from the ocean for three kilometers.

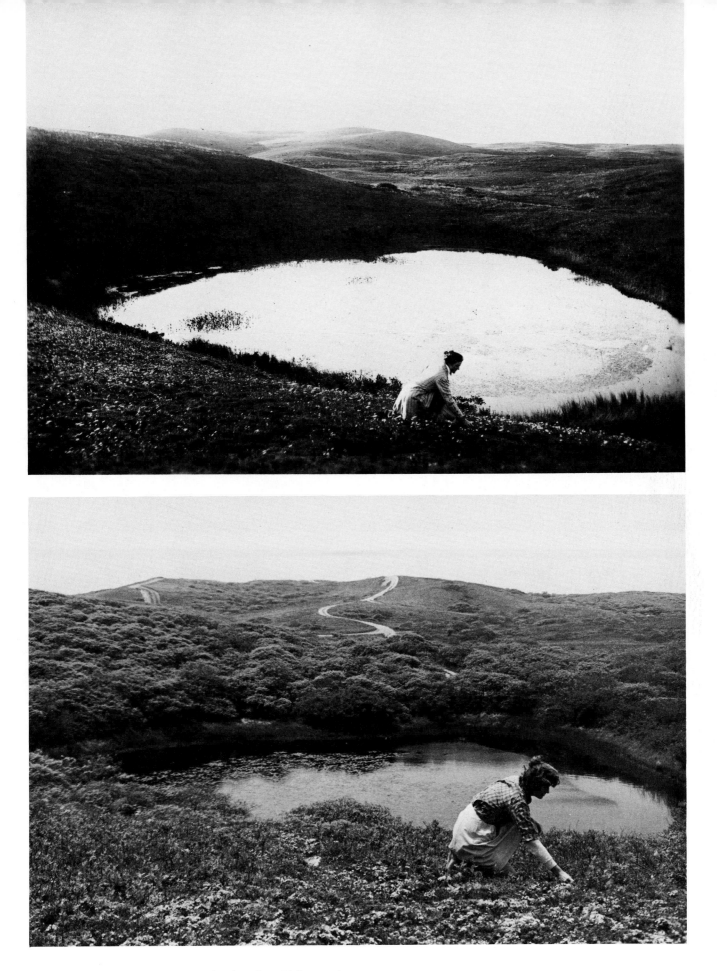

A Pond in Saul's Hills, ca. 1900 (top) **and 1975** (bottom).
Scattered throughout the hilly parts of the island are small
ponds surrounded by fields of wild flowers. Such fair
scenes are scarred today by the evidence of unrestricted
motor vehicles.

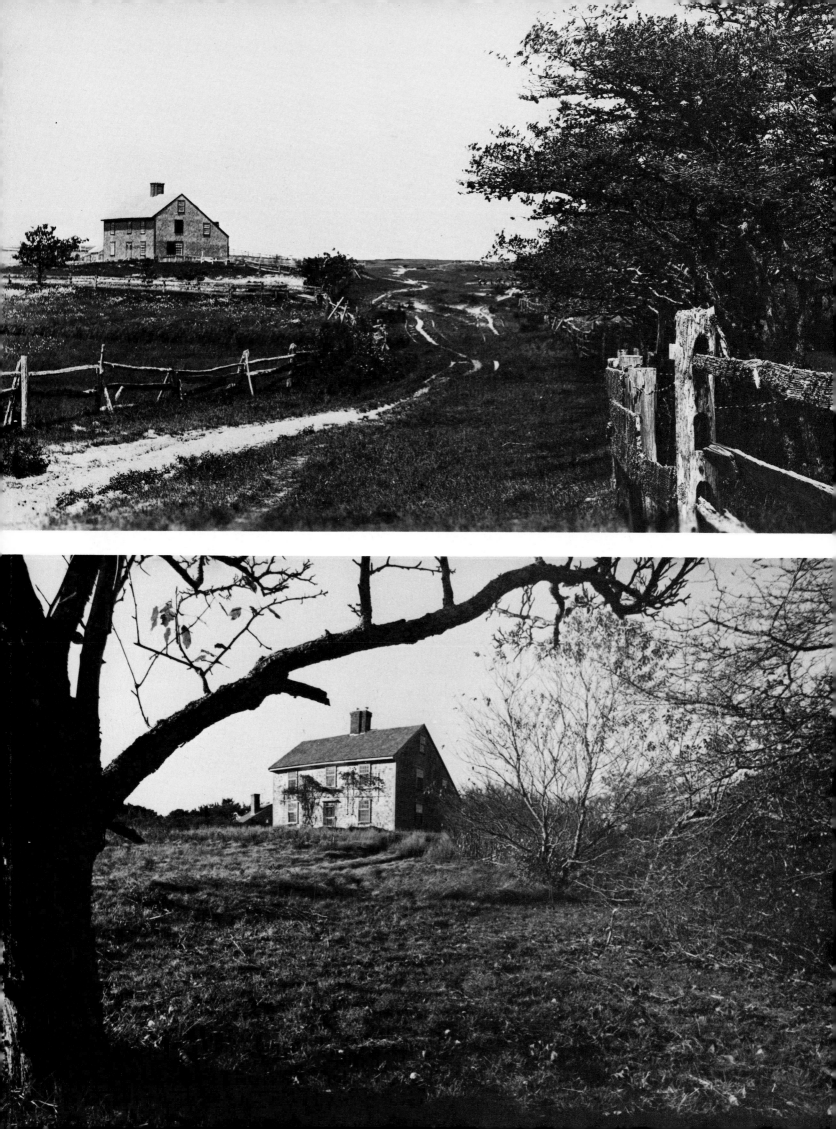

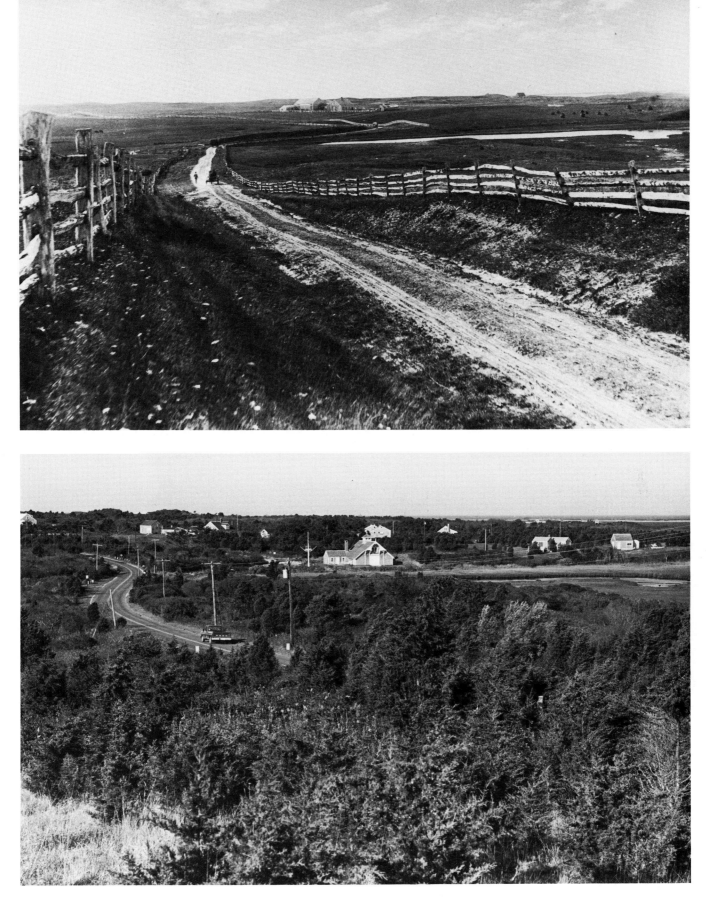

Opposite: **The Elihu Coleman House, Hawthorn Lane, ca. 1880** (top) **and 1975** (bottom).
Built in 1722, this was the last house in the original settlement area between Capaum and Hummock Ponds to be erected and is the last remaining. In a nearly perfect state of preservation, it is used today as a residence. In the 1880s the area around the Coleman house was still farmland and quite open; today trees have grown up along Hawthorn Lane (still a dirt road) obscuring the house.
Above: **View from Folger Hill on the Polpis Road, ca. 1890**

(top) **and 1975** bottom).
The clouds in the old photograph were painted into the negative to compensate for the plates, which were sensitive only to blue light. A cut has since been made through the hill, and shrubs and trees have reclaimed the open farmland. In the center background a copy of the Surfside Litesaving Station, (see page 53) serves as a museum. It stands on the edge of a tidal estuary populated by wildfowl and swans. The old farmhouse in the background is still occupied.

Above: **Milestone Road, ca. 1885** (top) **and 1975** (bottom).
The sharp, ironclad wheels of carts and buggies cut deep ruts into the sandy earth of the moors on what is the "road" to Siasconset. Most of Nantucket's roads outside of town remained unpaved until well into the twentieth century. Now a bicycle path parallels an asphalt two-lane road. The two-strand telegraph line has been supplanted by overhead power cables.

Opposite: **East Pond, Tuckernuck Island, ca. 1870** (top) **and 1976** (bottom).
Nantucket has a satellite island known as Tuckernuck. It is a miniature Nantucket, which once had several farms and its own school. Now it is a secluded summer colony without telephones or electric power. The only access is by small boat or very small private plane in fair weather.

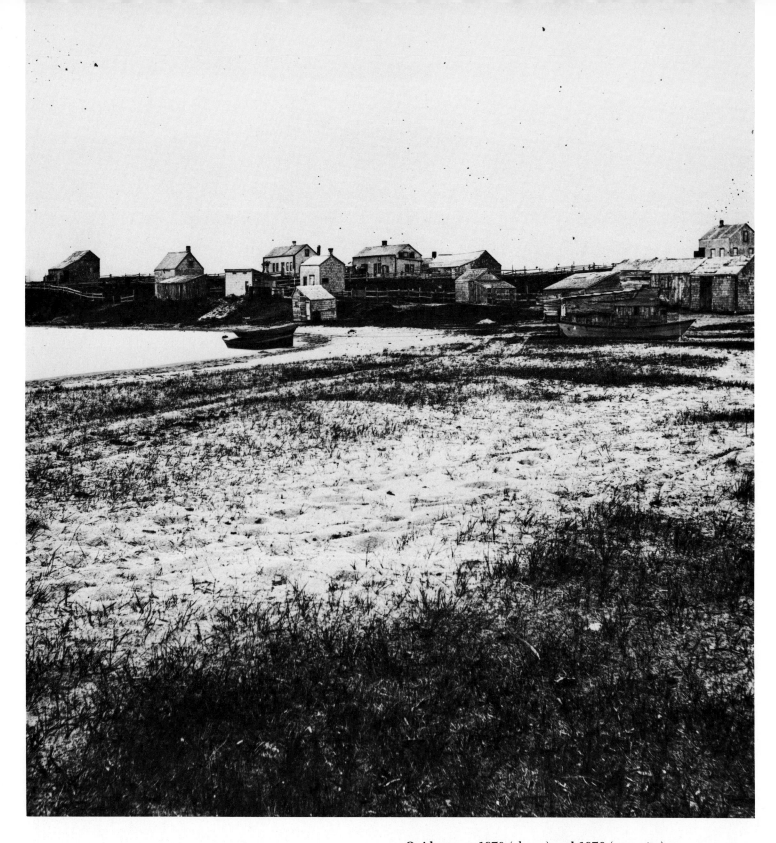

Quidnet, ca. 1870 (above) **and 1976** (opposite).
In the nineteenth century Quidnet was a small fishing village.
Today it is an even smaller summer colony with a handful of
year-round residents. Situated between a large pond and the
ocean, it provides ideal water sports for all tastes and ages.

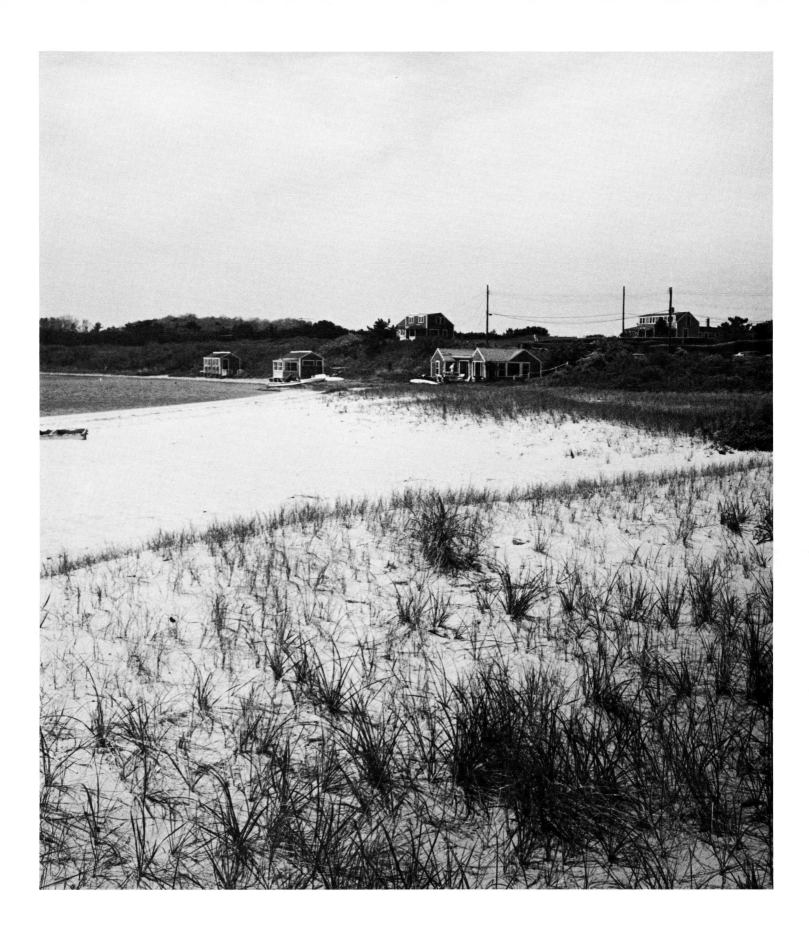

Chapter VIII

PRESENT TRENDS

The preservation of Nantucket was a historical accident. The loss of the whaling industry was followed by a quarter-century of depression and a loss of nearly two-thirds of the island's population. If it had continued, Nantucket would have become a ghost town, and if any other industry had been introduced other than the resort business, Nantucket would have developed along the same lines as other industrial communities. Her past would have been destroyed in the name of "progress."

Two things about the resort business made it possible to preserve Nantucket. In the first place, it was feasible to develop, service and profit from the resort business without increasing the island's diminished population. If the population had expanded, the island would have become crowded and the countryside could not have been preserved in a natural state. Secondly, many of the summer people who came to Nantucket were interested in, and willing to buy and renovate, the old houses. If the summer residents had all built new homes (as not a few did) the old houses would have fallen into disrepair and would have eventually been lost.

The importance of the island's demography in preserving Nantucket's past and in keeping the countryside natural cannot be overemphasized because this holds the key to the island's future. Nantucket's population fell from about 10,000 to less than 4,000. What is remarkable is that for more than 100 years it never rose above this level, even though a successful resort industry was bringing riches again to the island. A century of relatively static population meant that the town could house both its year-round natives and its summer residents and visitors without incurring any structural changes or major additions to the town or the summer colonies. In short, since the resort business began in the 1870s, there never was a building boom. The population remained for the most part within the boundaries that had been established for the town by 1850 and for the summer homes by 1900.

But this static socioeconomic situation is a very fragile one. Any substantial population pressure could destroy it utterly just as it has done in many other parts of the United States. Any significant expansion of the population would make it imperative that the open countryside be developed for housing because there is little room for expansion within the town. But if the countryside should be built up, most of Nantucket's raison d'être would vanish. The open moors would be gone, the beaches enclosed and restricted, the ponds surrounded by private homes, and a whole new automobile ecology would come into being.

By the mid-1950s many Nantucket residents, having become concerned about the preservation of the old homes and buildings, drafted and approved legislation creating two prescribed Historic Districts. Five commissioners were given the power to pass on the appearance of new structures and any future modifications of old ones; they also had authority to prevent the razing of old historic buildings. With the expansion of building in the countryside in the 1960s and 1970s, the bounds of the Historic Districts were enlarged to include the whole island. Belatedly, the town passed a zoning ordinance in 1972 to bring some order to the use of land and buildings.

Two private trusts have been organized by devoted Nantucketers and their works have gone a long way to preserve the island. The Nantucket Historical Trust has funded the restoration of historic homes and commercial buildings which might otherwise have been lost. The Nantucket Conservation Foundation has been instrumental in the purchase and preservation of open lands. At the present time the Foundation owns about 5,000 acres, representing 17 percent of the island's area. These organizations are making significant progress toward the interrelated goals of saving old historic structures and keeping a substantial portion of the countryside open. Fortunately, the Conservation Foundation is aware of the

necessity of controlling the automobile and has restricted its use on Conservation lands.

Insofar as controlling a community's environment is concerned, such institutions as zoning boards and historic district commissions can only serve as holding actions against more fundamental forces. Such control agencies are not so much limited by their legal powers as they are by the character and courage of their members. In most cases it becomes exceedingly difficult to oppose changes and projects that are defined as necessary for "progress." This is particularly true since such projects usually affect the employment of many wage earners and the wealth of community leaders. Moreover, the private trusts are limited by the amount of money that can be raised from concerned individuals, and that often falls far short of what is necessary for effective protection.

Beginning in the 1970s, Nantucket came under increased population pressure: land speculators, for the first time in a century, began to operate on the island. Unlike a century ago, when the speculators failed, they have now met with some degree of success. Recently, large tracts of land have been cut up into subdivisions and "development" housing and condominiums have been sold—often to investors rather than those who intend to make a home on the island. Paved roads and parking lots have been built to serve these developments.

Today's changing environment can not be blamed entirely on population growth. The real culprit is the automobile. Other island resort areas have clearly demonstrated that a resort community can be highly successful with a population density much greater than Nantucket's, provided automobiles are either prohibited or carefully restricted in number and size. Vacationists are seeking, fundamentally, a change in the quality of their lives, even if only temporary. Most Americans today work and live in cities and towns that are subservient to the pervasive demands of the automobile: superhighways, enormous parking lots, shopping plazas, traffic congestion, commuting and, above all, air and noise pollution. The easiest way for a vacationer to change the quality of his life is to step out of the automobile culture into a community designed largely to do without it. One way to ensure the continuing success of Nantucket as a resort is to make certain that the automobile neither dominates its environment or determines the character and direction of the island's growth.

The photographs show the extent to which the automobile has changed Nantucket's environment. In the old pictures we see practically no vehicular traffic, but considerable pedestrian movement. That is the way the town was designed. Only a few vehicles are parked in the streets—some of them seem to have been posed for the photographer just to prove that some people did, indeed, own horses and carriages. The new pictures were all made "off season" when traffic was relatively light. Nevertheless, the streets are lined with parked cars (in the narrower streets, parked on the sidewalks) forcing nearly all of Nantucket's streets to be designated one-way. By permitting parking on public streets, private off-street parking is not encouraged, and the flow of traffic is impeded. Because of the automobile, the streets are replete with unsightly metal signs designed to regulate traffic and parking. Together with the aboveground utility poles and wires, these signs are the most disfiguring, anachronistic and unnecessary elements in the Nantucket scene today. During World War I, Nantucket banned autos; perhaps it is time to reconsider.

Opposite: **The Jetties Beach, ca. 1890** (top) **and 1976** (bottom). Nothing has changed so much as the denizens of the beaches. In the 1890s beach goers shunned the sun and dressed to leave only their faces uncovered. Moreover, awnings were set up to provide shade on the beach. The water was treated gingerly; wading seldom gave way to swimming, and the ladies rarely went into the water at all. Today authoritarian types must make an effort to prevent nude sunning and bathing.

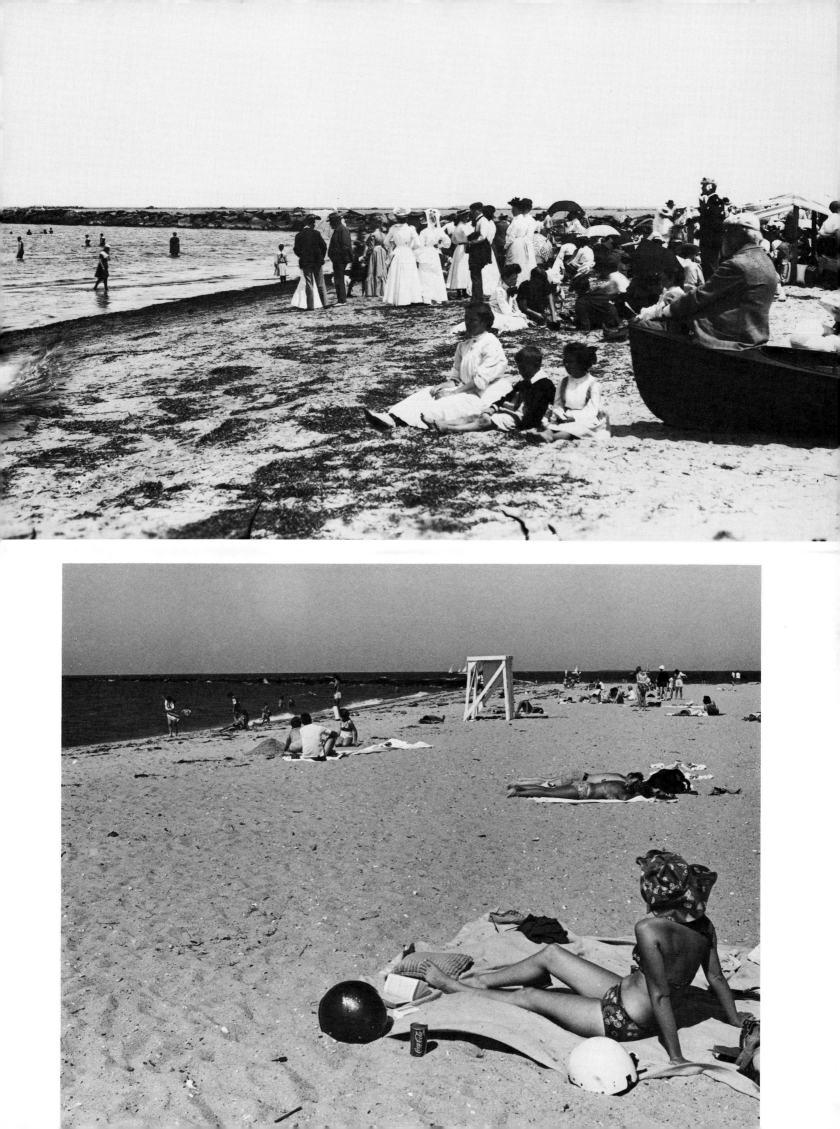

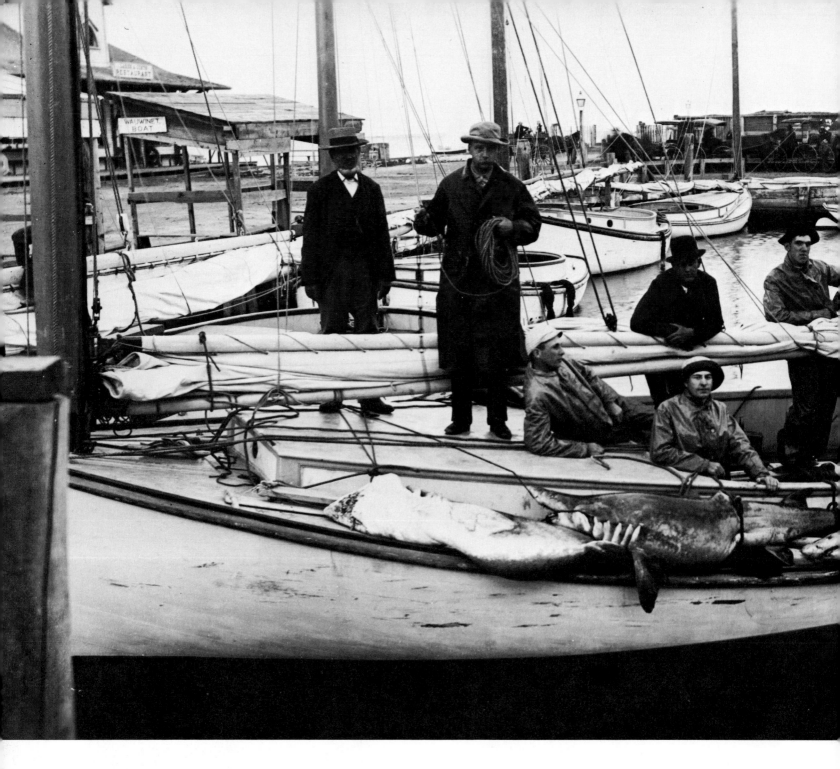

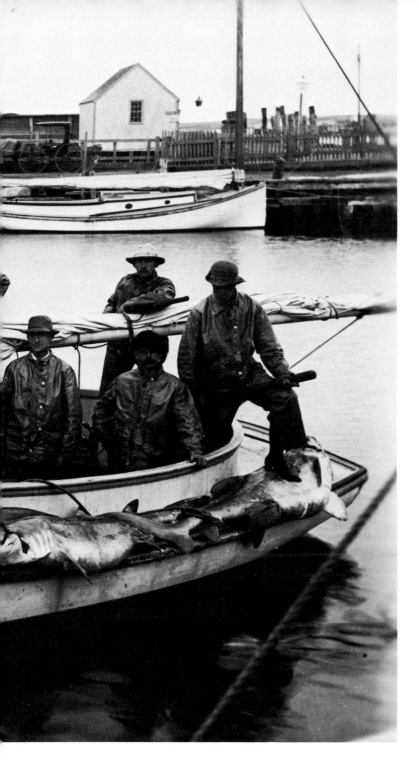

Return of the Shark Fishermen, Catboat Basin, Steamboat Wharf, ca. 1890 (left) and a Tennis ensemble, ca. 1890 (below). As Nantucket began to develop as a summer resort, sports gained importance. These two pictures provide a harbinger; today Nantucket provides excellent facilities for nearly all outdoor sports and recreational activities—with the exception of that branch of the entertainment industry which is known as "spectator sports."

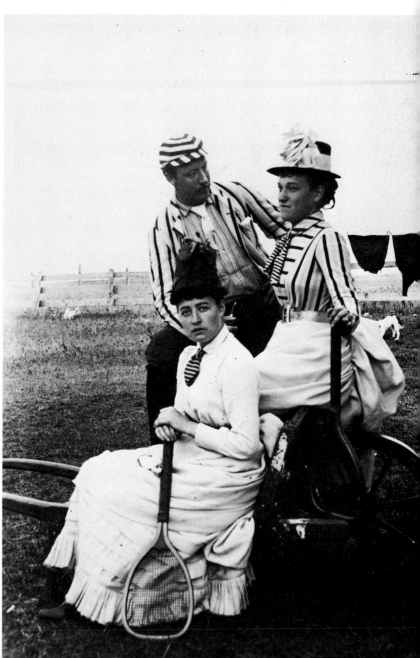

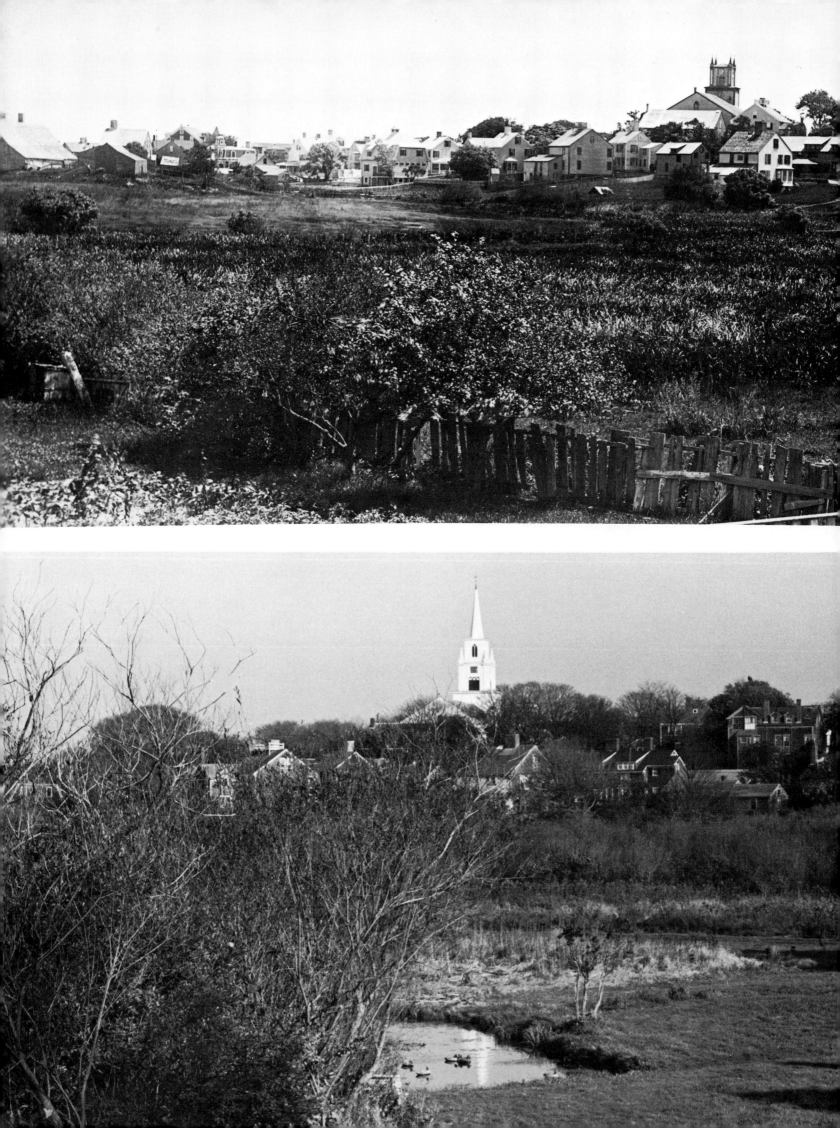

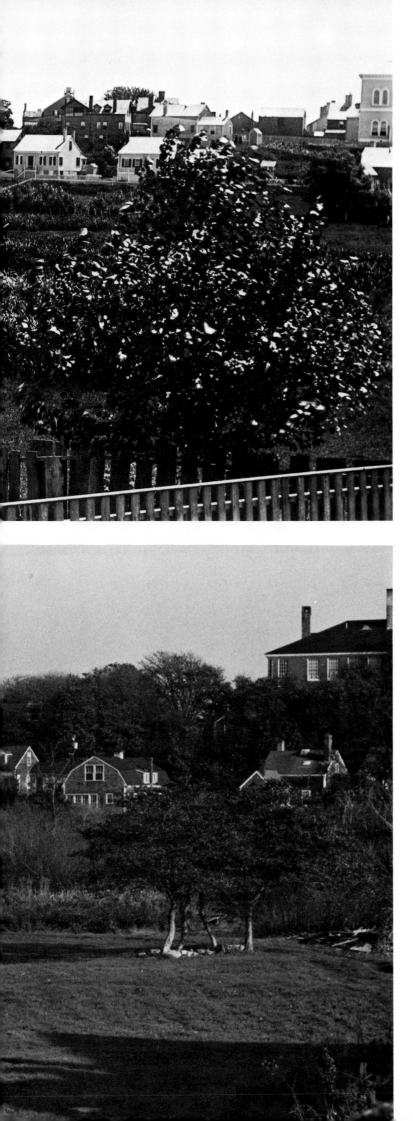

The Lily Pond, ca. 1900 (top) **and 1976** (bottom).
The Lily Pond has not been a true pond since at least before the Revolution, and probably some time before that. There is some evidence that it may have been a tidal pond with a creek opening near the Children's Beach as the entrance. Presently there is a small creek that runs through the pond bottom and drains under Centre Street and underground to the beach. There is a natural valley where Centre Street joins Cliff Road which was probably filled in early in the eighteenth century to dam the pond at about the time the population moved into the area around the harbor. Several very old houses were located on the edges of the pond; a few have been preserved. The town has long since surrounded the pond.

PRESENT TRENDS 159

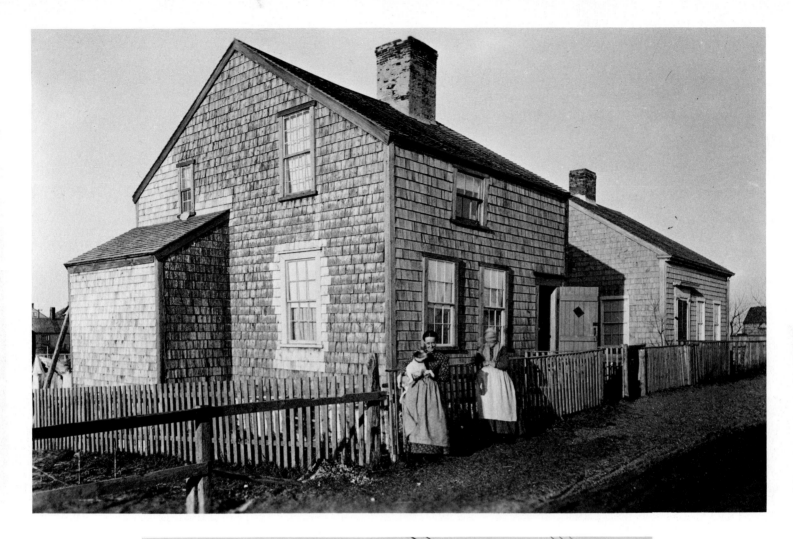

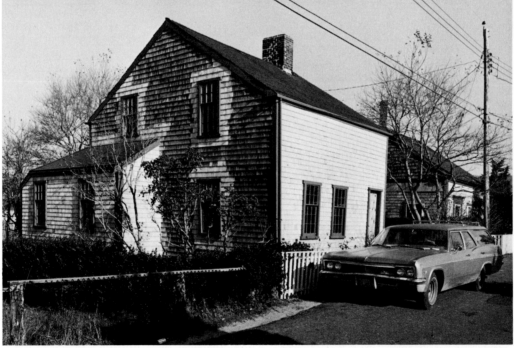

Nos. 7 and 3 Cherry Street, ca. 1885 (top) **and 1975** (bottom). In West Monomoy, an area of town that was laid out in 1726, there exists a large number of small cottages that have been much neglected over the years because they were not the grand and fashionable homes of sea captains. These cottages, many dating from the eighteenth century, appeal to present-day small families because of their size. Some including No. 7, are now being restored. With careful renovation, West Monomoy could become another Siasconset.

The Swain House, Rear View, Polpis, ca. 1870 (above) **and The Donald Craig House, Front View, Polpis, 1975** (left).

Until it collapsed in a winter storm, the Swain House was the oldest house on the island, the central part having been built in about 1675. In recent years there has been a commendable movement to build new houses that are near-copies of the old, preserving the appearance of the whole community. The Craig House was built in 1945 as a copy of the Swain House and serves today as a charming residence.

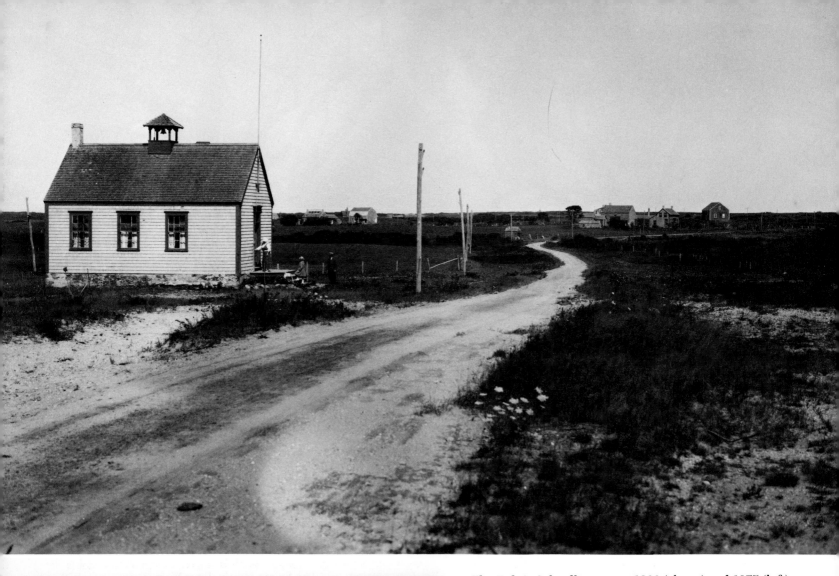

The Polpis Schoolhouse, ca. 1900 (above) **and 1975** (left). Nantucket had a number of one-room schools before the automobile era. The Polpis school was moved a short distance and incorporated into a residence. The center part of the house in the modern view was originally the school building. When a structure can no longer serve its original purpose, it often can still serve other functions in an attractive way. Many Nantucket homes were built incorporating parts of older structures. Often the amalgamation was harmonious.

Appendix

SOME NOTES ON THE PHOTOGRAPHERS

In August of 1839 Louis Jacques Mandé Daguerre revealed the first practical photographic process to a joint meeting of the Academy of Sciences and the Academy of Fine Arts in Paris. Within weeks, the daguerreotype process was being tested around the world; it burst into full commercial use in 1840. By 1842 a "Mr. Dewey" had a photographic shop on Nantucket's Main Street. He and at least two other itinerant photographers advertised in the local newspaper over the next decade.

The demand for photographs was limited nearly entirely to portraits during the 1840s and 1850s. Only in rare instances were documentary photographs made. However, one of these early photographers did make a daguerreotype of the north side of Main Street sometime before the great fire of 1846 (*Frontispiece*) Nantucket's first permanent resident photographer was William Summerhays who set up a shop producing daguerreotypes in 1854. He adopted the ambrotype method later in the decade. Summerhays' shop on Main Street is clearly shown on page 92, his showcase filled with small ambrotypes. It is quite likely that it was Summerhays who made the earliest photograph of Nantucket's waterfront, page 68, the original of which was probably an ambrotype. This rare picture has been dated to 1862. Unfortunately, the original has been lost and we have today only heavily retouched copies.

During the first two decades of photography it was possible to make a living doing portraits, but by the 1860s photographers were casting about for other sources of income. Josiah Freeman, a New Bedford photographer, set up a photographic business on Nantucket in 1864. By then the stereograph, which gave a three-dimensional view, was sweeping the country. Freeman photographed Nantucket with his stereo camera and left for future generations and the historian a remarkable record. Unlike the earlier work in photography, stereographs are mainly records of events and places.

Most of the photographs in this book made in the 1860s and 1870s were taken by Freeman, and were reproduced by enlarging one half of a stereo pair. Stereoscopic photography was in many ways an ideal technique for the historian. The power of the camera to convince was much enhanced by the three-dimensional effect. Moreover, the stereo cameras used small plates (about 8×10 cm.) and short-focal-length lenses which were much faster than those employed on larger cameras. As a result, stereographs could actually stop moderate motion, and the street scenes show people and animals in unposed activities. It was also possible to carry the small stereo camera to such awkward places as the steeples of Nantucket's churches where Freeman made historically invaluable views of the town as early as 1868.

A number of Freeman's stereo negatives have been preserved by the Nantucket Historical Association. Others, which have been lost, were made into lantern slides, probably in the early part of this century. A collection of these slides is also owned by the Association. Probably without intention, Freeman made the most useful contribution to the documentation of Nantucket's past of any single individual.

In about 1880 the gelatin dry-plate process supplanted the collodion wet-plate method of making photographic negatives. With the introduction of the dry plates the modern age of photography was born. The photographer was freed from the need of immediate access to a darkroom since the dry plates could be exposed any time after their manufacture and then could be developed whenever convenient. Also the dry plates were much more sensitive, and it became possible to make "snapshots" with exposures of about 1/25th of a second in sunlight. The speed of the dry plates made hand cameras feasible, freeing the photographer from the necessity of always using a tripod.

Unfortunately for the historian, with the introduction

of the dry-plate negative it became possible and popular to "doctor up" the negative by retouching and other methods. Portrait subjects had their youth restored by the photographer working with brush and pencil on the negatives. But the practice did not end with portraits. Photographers added clouds to pictorial views, removed unwanted subjects that compromised idealistic scenes, and frequently added material from their imaginations. After 1880, the historian cannot be sure of the validity of a photograph unless he has access to the original negative.

In 1881 Henry S. Wyer returned to his native Nantucket after operating a photographic business in Yonkers, New York. In addition to the usual portraits, Wyer made many photographs of scenes in town and other parts of the island. Sold as prints and postcards, the views were also incorporated into small picture books bought by tourists as souvenirs. Although Wyer was a founder and active member of Nantucket's Historical Association, publishing a short history of Nantucket in 1906 with a title-page motto "the truth without fear or favor," he frequently doctored his negatives to serve a purpose and sometimes published the work of other photographers without giving them credit.

The frontispiece in Wyer's little history is the above-mentioned view probably taken by Summerhays in the early 1860s. Wyer made a copy of the original and retouched it heavily. He copyrighted the photo in 1899 and sold many prints, including some enlargements of substantial size. Today it is impossible to determine how much of this early waterfront scene is real and how much was Wyer's fancy. In the *Nantucket Historical Association Bulletin* No. 5, published in 1906, there is a photograph taken by Wyer of Nantucket's oldest house, the Jethro Coffin house, which shows the house as it would eventually appear after restoration in the 1920s. Wyer's earlier "restoration" was done entirely on his negative! It is, however, to Wyer's everlasting credit that he did make an extensive documentary of Nantucket houses, in most cases with their occupants standing in front. Taken in the 1880s and 1890s, these photographs are of great historical interest, but lack the candid quality to be found in Freeman's stereo views made two decades earlier.

The early twentieth century was well documented by the photographs of J. H. Robinson. Over 100 of Robinson's photographs were published in 1911 in a souvenir booklet. Robinson was able to use a hand camera for many of his photographs (although his negatives were 5" × 7" glass plates) which permitted him to photograph areas outside the town, including Tuckernuck and Muskeget Islands. It is in Robinson's pictures that we first see recreational activities on the island (page 157). Robinson also photographed the town from the steeples of both the North and South Churches, providing us with an early twentieth-century historical benchmark that can be compared with Freeman's views taken a half-century earlier.

The author began his photographic career in 1940 as a scientific photographer for the University of California. During World War II he served in the navy and was engaged in photographic research work. After the war he joined the economics profession but continued photography as an avocation. Since moving to Nantucket in 1960, he has operated a photographic business, known as Studio 13, which copes with the diversified photographic needs of the island community.